MONET

IMPRESSIONS OF LIGHT

HENRI LALLEMAND

TODTRI

DEDICATION
THIS BOOK IS DEDICATED TO NETHANEL AND DINA KALUJNY.

This book was designed and produced by
Todtri Productions Limited
P.O. Box 572
New York, NY 10116-0572
Fax : (212)695-6984

Printed and Bound in Singapore

Library of Congress Catalog Card Number 94-60368

ISBN 1-880908-13-1

Printed and bound in Singapore

Producer: Robert M. Tod
Book Designer: Mark Weinberg
Production Coordinator: Heather Weigel
Photo Editor: Ede Rothaus
Editors: Mary Forsell, Joanna Wissinger, & Don Kennison
DTP Associates: Jackie Skroczky, Adam Yellin
Typesetting: Mark Weinberg Design, NYC

CONTENTS

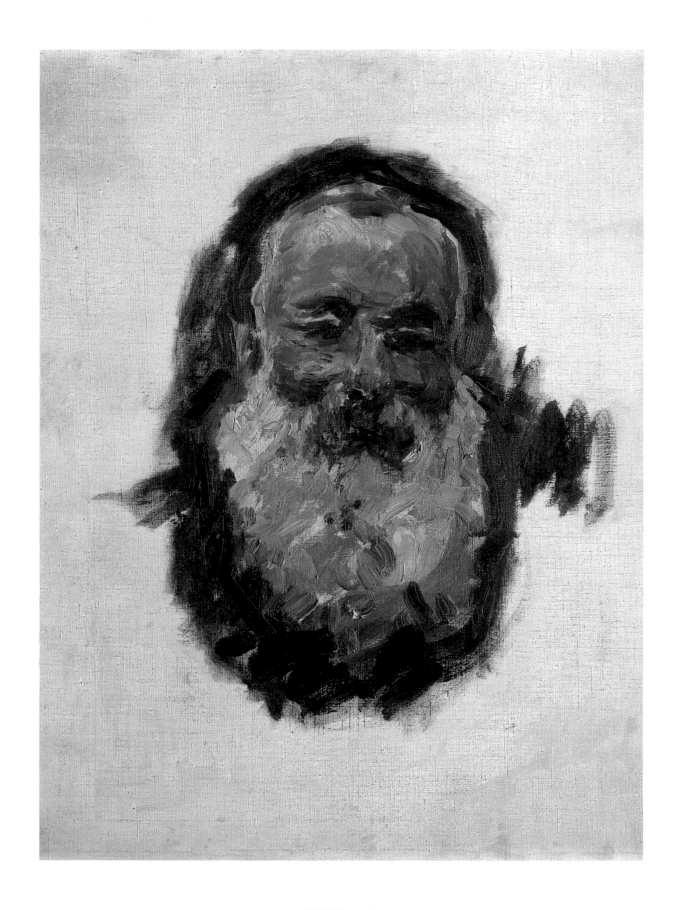

Self-Portrait
1917; *oil on canvas;* 27 1/2 x 21 5/8 in. (70 x 55 cm.). Paris, Musée d'Orsay.
*During World War I, while he was secretly painting his water lilies series, Monet also
executed this self-portrait. Although unfinished, it captures the state of mind of the artist, who
after a life of intense work and a long struggle for recognition had nearly lost his eyesight.*

INTRODUCTION

Monet once declared to Lilla Cabot Perry, an American painter who lived not far from his home in Giverny, that "he wished he had been born blind and then suddenly gained his sight so that he could have begun to paint...without knowing what the objects were that he saw before him."

Taken at face value, this dictum, like his other remarks about the relationship between the painter and nature, have long determined today's understanding of Impressionist art in general and that of Monet in particular. The ideal of the artist going back to nature is often envisioned in terms of a tabula rasa, a beginning from zero: the artist as 'Creator' before a blank canvas or piece of paper, on which he would paint or draw, intuitively and without conscious control, "impressions" received from nature. A closer look at the history, working conditions, and painting methods of Impressionism reveals a different reality, clarifying Monet's original intentions and correcting misconceptions in the understanding of his works.

Monet presented himself in many different guises throughout his long life: as a bohemian artist during his early years in Paris, as the leader of the Impressionist movement in the 1870s, with all its political and social implications, and in the privacy and reclusiveness of his old age, as the patriarch of his family and gardens in Giverny.

Monet's Early Life

Born in Paris in 1840, Monet moved with his family to Le Havre on the Seine estuary around 1845. There his father Adolphe joined the wholesale grocery business of his brother-in-law, in which he eventually made enough profit to lead a reasonably comfortable life. Monet's mother died in 1857, and thereafter the young Claude spent much time with his aunt Jeanne-Marguerite Lecadre who, unlike his father, sympathized with his artistic inclinations. He gained a certain reputation for his caricatures of local figures. The painter Eugène Boudin, who worked on the coast of Normandy, introduced the aspiring artist to landscape painting out-of-doors. With his aunt's encouragement Monet spent a year in Paris between 1859 and 1860, where he encountered Constant Troyon and other painters in the Realist circle, as well as the young Camille Pissarro.

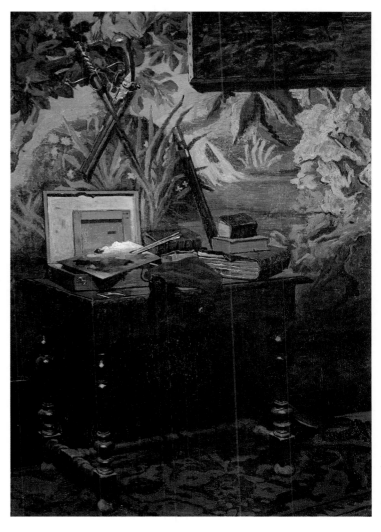

A Corner in the Painter's Studio
1861; *oil on canvas; 71 3/5 x 50 in. (182 x 127 cm.).* Paris, Musée d'Orsay. *This early work depicts a traditional subject, the artist's tools in his studio. Paintbrushes and other unassuming utensils are displayed in a casual way. Monet must have painted this canvas shortly before leaving for Algeria, where he served in the army.*

In 1861–1862, Monet performed his military service in Algeria with the Chasseurs d'Afrique. The clear light of Northern Africa, which had fascinated many artists before him such as Eugène Delacroix, no doubt encouraged his ambitions as a landscape painter. Upon his return to France, he went to study painting in Paris in the studio of the celebrated academic teacher Charles Gleyre. Although Gleyre offered a rather traditional training, his studio attracted a number of young students interested in the realist tradition and in *en-plein-aire* (outdoors) painting, which Gleyre encouraged. Gleyre's belief that nature was not everything and that Monet should always consider style put up an immediate barrier between him and his teacher. It was in Gleyre's studio, however, that Monet encountered his colleagues Frédéric Bazille, Alfred Sisley, and Pierre-Auguste Renoir. The four artists rapidly became close friends, working together during visits to the Fontainebleau forest or the city of Paris.

All four members of the group regularly submitted paintings to the annual Salon exhibitions, with mixed results. Works that were deemed "unorthodox" or simply not painted with the traditional slick academic touch were usually rejected from the shows.

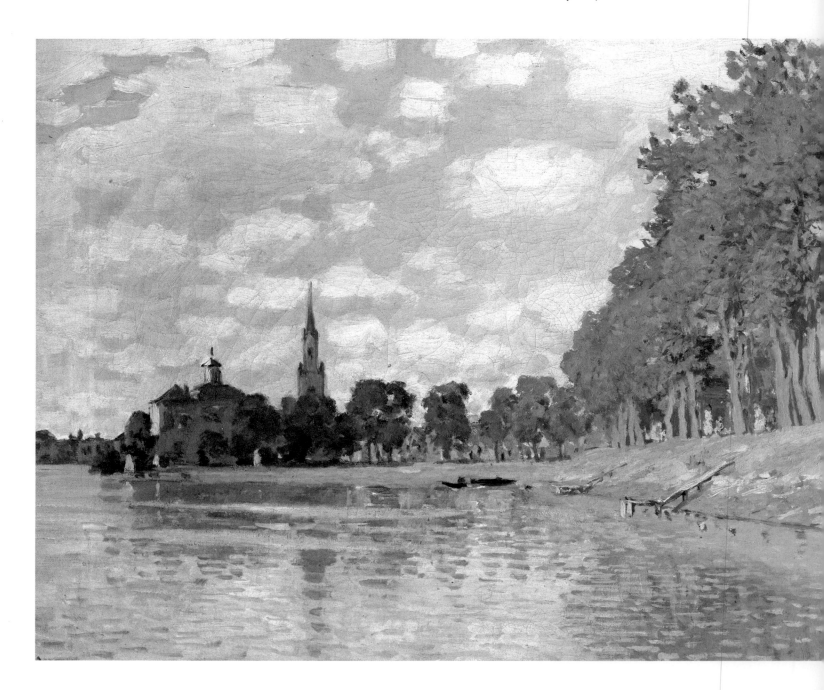

Nevertheless, the young group, including Monet, painted their works with the Salon in mind, since it was the only relevant showcase of contemporary art at the time. Modern art galleries and dealers began to appear only slowly on the scene, but it was ultimately through them alone that recognition and success for the avant-garde was available. In 1866, two of Monet's paintings were accepted at the Salon, *Camille* and *The Pavé Chailly, Forest of Fontainebleau*.

Probably in 1865, Monet met Camille Doncieux. They lived together from time to time, when his finances permitted it. (Monet's father had withdrawn his support on several occasions because of Monet's reluctance to study and his unpredictable behavior.) The following year he worked on *Women in a Garden*, a group of portraits of Camille. It was rejected at the Salon of 1867 upon presentation. In August of that year, Camille gave birth to their first child, Jean, but since the couple was virtually penniless, Monet stayed with his family in Le Havre. Luckily, the artist met the local collector Louis-Joachim Gaudibert, who commissioned a portrait of his wife (*Portrait of Mme. Louis-Joachim Gaudibert*). These sales enabled him to set up a temporary home in Etretat on the Channel coast. The couple was married in the summer of 1870 in Paris. During their honeymoon at Trouville (*Beach at Trouville*) the Franco-Prussian War broke out, Monet avoided the threat of conscription by leaving for London. There he met Camille Pissarro, who had gone there for the same reason, as well as the art dealer Paul Durand-Ruel, who would be of crucial importance not only in the development of Monet's career but also in the cause of Impressionism in general.

The Beginnings of Impressionism

Monet returned to France via Holland, and the young family set up housekeeping late in 1871 at Argenteuil, a short train ride from Paris, his main base until early 1878. A brief period of prosperity, during which Monet was able to sell paintings to Durand-Ruel, was followed by meager years as a result of the poor French economy. Although Monet would repeatedly cry poverty over the next twenty years or so, he was never too poor to give up maidservants or to lower his living standards, which might be considered those of a middle-class person. By the 1890s his reputation and economic success allowed for a comfortable lifestyle, and his income was equal to that of a prosperous lawyer or medical doctor.

Together with Renoir and Edgar Degas, Monet was one of the leading organizers of the first "Impressionist Exhibition," held in 1874 in Paris, which included his *Impression–Sunrise*. Ironically, the title of this painting, picked up by a critic in a devastating review of the show, eventually gave the new movement its name. Other efforts by the young Impressionist artists to sell their work, such as auctions, were equally unsuccessful, and it was not until the late 1880s that the new style became established.

View of Zaandam
1871; *oil on canvas;* 18 7/8 x 28 3/4 inches (48 x 73 cm.). Paris, Musée d'Orsay.
On his way back from London, where he had taken refuge during the Franco-Prussian War of 1870-71, Monet traveled through Holland, where he painted this view of Zaandam. The low horizon and the vast sky show the influence of Dutch landscape painting. Through the trees on the right one can see the green façades and red roofs of the local houses.

In 1869, Monet and Renoir visited La Grenouillère, a bathing resort on the Seine outside of Paris, where the two artists painted together out-of-doors. The paintings executed there can be considered the first truly Impressionist paintings (*At La Grenouillère, Bathers at La Grenouillère*). The more Monet developed his interest in landscape painting, however, the more he distanced himself from the bohemian lifestyle and his friends in Paris. He wrote to Bazille in December 1868 from Etretat in Normandy: "One is too preoccupied with what one sees and hears in Paris, however strong-minded one is, and what I shall do here will at least have the merit of being unlike anyone else, at least I think so, because it will simply be the expression of my own personal experiences." Nevertheless, through his friendships with Édouard Manet, Renoir, and Pissarro, among others, Monet maintained important contacts to the art scene in the capital. For some time, he continued to attend the art-world gatherings at the Café Guerbois, and later those at the Café de la Nouvelle-Athènes in Place Pigalle. After Manet's death in 1883, it was Renoir who, until his death, became Monet's closest friend, apparently the only one to use with him the familiar "*tu*."

In the mid-1870s, Monet met the wealthy businessman Ernest Hoschedé and his wife Alice. He stayed with them at their country home in Montgeron to the east of Paris, painting a sequence of decorative canvases for their estate, including *The Turkeys*. After Hoschedé went bankrupt in 1877, his family and Monet's decided to live together, and in the summer of the following year they moved to Vétheuil, a secluded village over forty miles downstream from Paris. Monet continued to keep a modest pied-à-terre in Paris in order to receive prospective patrons, but his visits to the capital became less frequent.

In 1879 his wife Camille died, following the birth of their second son Michel (*Camille on Her Deathbed*). Ernest Hoschedé gradually distanced himself from his family and began to live a bachelor's life in Paris, while Monet and Alice Hoschedé were looking after his two and her own six children. This unconventional relationship and the rumors that surrounded it were probably the reason for Monet's isolation from his former friends and colleagues during this period. The two families moved in 1881 to Poissy, closer to Paris, and two years later to Giverny, where Monet continued to live for the rest of his life.

Jean on His Mechanical Horse

1872; *oil on canvas;* 23 1/3 x 29 in. (59.2 x 73.5 cm.). Chicago, Private Collection. *Jean Monet was born in August 1867, three years before Monet married Camille Doncieux in 1870. Taking up the traditional equestrian child portrait, Monet reinterpreted the subject in a more contemporary and perhaps ironic fashion by placing his small son on a mechanical horse made of steel and wood. The painting was done in the artist's garden at Argenteuil. Jean Monet died in 1914.*

Officially, Monet and Alice lived separate lives, which provided him with the independence to make extensive trips. During the 1880s, when his financial situation had become more stable, he traveled the length and breadth of France. He went twice to the Mediterranean coast, first to Bordighera, where he spent four months in 1884, and to Antibes in 1888. He paid extended visits to Etretat and to Belle-Isle, an island off the coast of Brittany, where he produced his first series paintings. These trips became far less frequent after he and Alice wed in 1892, following Ernest Hoschedé's death the previous year.

Monet and Impressionism

The 1880s are often considered a period of "crisis" and transition for the Impressionist movement. This is not entirely correct, and it

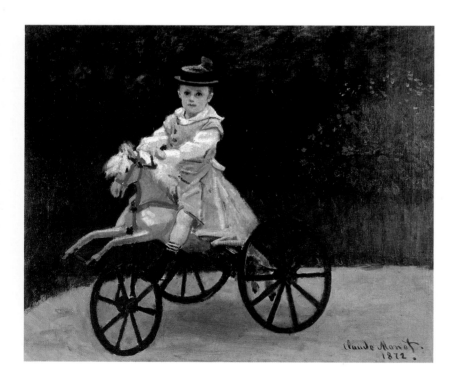

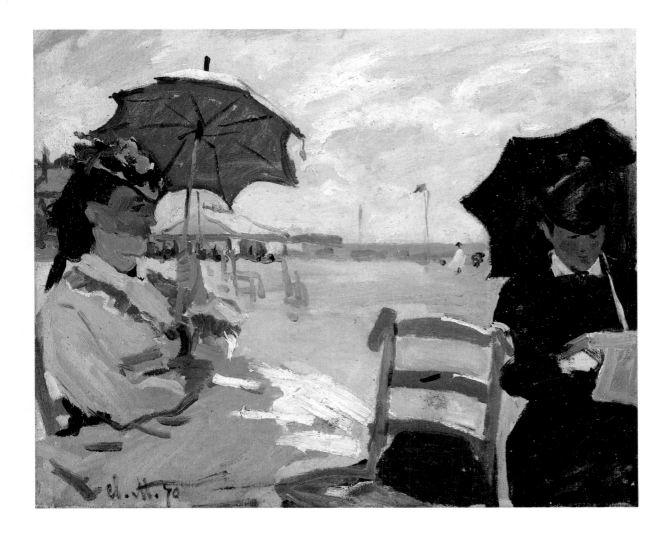

The Beach at Trouville

1870; *oil on canvas;* 15 x 18 1/8 in. (38 x 46 cm.). London, National Gallery. *Proud of the hardships he underwent in painting outdoors, Monet liked to tell his friends stories about canvases or paint brushes being blown away by the wind. One can indeed still detect the sand in the surface of this painting, executed on the beach at Trouville. His wife Camille is depicted seated on the left holding an umbrella. On the right a friend or relative is reading a newspaper.*

certainly applies less to Monet himself than to some of his fellow artists. During this decade, Durand-Ruel continually bought works from Monet for his gallery and he even convinced the painter to exhibit again in the Impressionist show in 1882, after Monet's disenchantment with the group exhibitions had led him to sever his links with his café-house friends. In 1880, Monet had exhibited again at the Salon, probably following the advice of the art dealer Georges Petit, whom Monet frequently played off against Durand-Ruel, since he had no exclusive contract with either of them. After 1887 he also sold through the firm of Boussod & Valadon, where Theo van Gogh, brother of the painter Vincent, was the branch manager.

The "crisis" manifested itself at the eighth and last Impressionist exhibition, held in 1886, when twenty-seven-year-old Georges Seurat presented his "scientific" technique of Neo-Impressionism with its pontillist application of paint in his large canvas *A Sunday on the Island of La Grande Jatte* (The Art Institute, Chicago). The Parisian art world was stunned and excited. Seurat's achievement had challenged the basic premises of the Impressionist's style and orientation. From now on, Impressionism was no longer an avant-garde style. A younger generation demanded that title for themselves. Pissarro embraced, at least for a number of years, this new movement, and its appearance certainly had repercussions on Monet's perception and understanding of his own art. However, he understood it more as a challenge to do better and excel rather than to emulate the new technique. He was enormously productive during that decade.

Monet never gave up on Impressionism. His extensive travels in the 1880s were aimed at broadening his knowledge and diversifying his artistic production. Leaving behind the

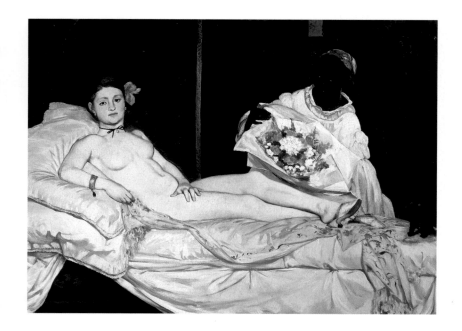

Olympia

1863; *oil on canvas;*
51 3/8 x 74 3/4 in.
(130.5 x 190 cm.).
Paris, Musée d'Orsay
*In 1889 Monet started
a subscription campaign
to collect money to buy*
Olympia *from Manet's
widow—who was in
financial need—and to
donate it to the state.
His carefully calculated
move was designed to
secure Manet's painting
for a French museum,
and to receive official
acknowledgement from
the government for the
Impressionist movement,
since Manet was consid-
ered to have been their
most influential supporter.*

hothouse of Paris with its urban subjects, he attempted to soften Impressionism by describing French rural life in his paintings. For Monet, Impressionism was a national French style, responsive to the country as a whole. His goal in the 1880s was to gain prominence for himself and his work, to strengthen the style's ties to the French countryside, and to broaden his market.

The Campaign for "Olympia"

These activities were interrupted late in 1889 when he initiated a subscription to purchase Édouard Manet's *Olympia* from the artist's widow and donate it to the French government. This task demanded all his attention; he not only gave up his travels but stopped painting for almost a year. He pursued his new mission with the same obsession and single-minded commitment he applied to his paintings.

Several issues were at stake: first, his honest feelings for Manet's widow and for the memory of his friend; secondly, patriotic concerns for the safeguard of the national artistic heritage played a major role, since the painting risked being sold off at auction to a foreign buyer, most likely an American collector. In June of the same year, Jean-François Millet's *Angelus* had been sold to an American dealer. This "national loss" of an icon of French rural life had been widely reported in the newspapers, and Monet was determined to avoid the same fate for Manet's *Olympia*.

However, these social and emotional concerns were accompanied by a selfish drive to achieve political advantage for himself and the Impressionist cause. His plan to offer Manet's once-controversial canvas to the government was in fact a clever strategy. If the French state accepted this painting, which in the past it had fervently opposed, it would be obliged officially to acknowledge and endorse an avant-garde movement to which Monet was the heir.

He started the campaign late in June or early July by sending letters to prospective contributors. By early October about 15,000 francs had been pledged; in November the sum climbed to 18,000. Monet wrote to everybody he knew and even to individuals he did not know personally. He admitted to his painter friend Berthe Morisot that this was not an easy task, given the government's expected opposition. However, when by February of the following year 19,415 francs had been collected, Monet felt that the moment was ripe to write a carefully worded statement to the Minister of Public Instruction, Armand Fallières, and officially offer the painting to France.

In this letter, Monet called Édouard Manet representative of a great and rich evolution,

Interior of an Apartment
1875; *oil on canvas;* 32 1/8 x 23 3/4 in. (81.5 x 60 cm.). Paris, Musée d'Orsay.
*The subject is unusual for Monet but illustrates well the variety of his pictorial search.
Framed by two palm trees planted in Monet's own blue vases, the viewer peers behind a sunlit
curtain into the darkness of a room where a little boy, the artist's son Jean, stands near a table.
The outlines of the objects are accentuated by the light coming from the window in the back.*

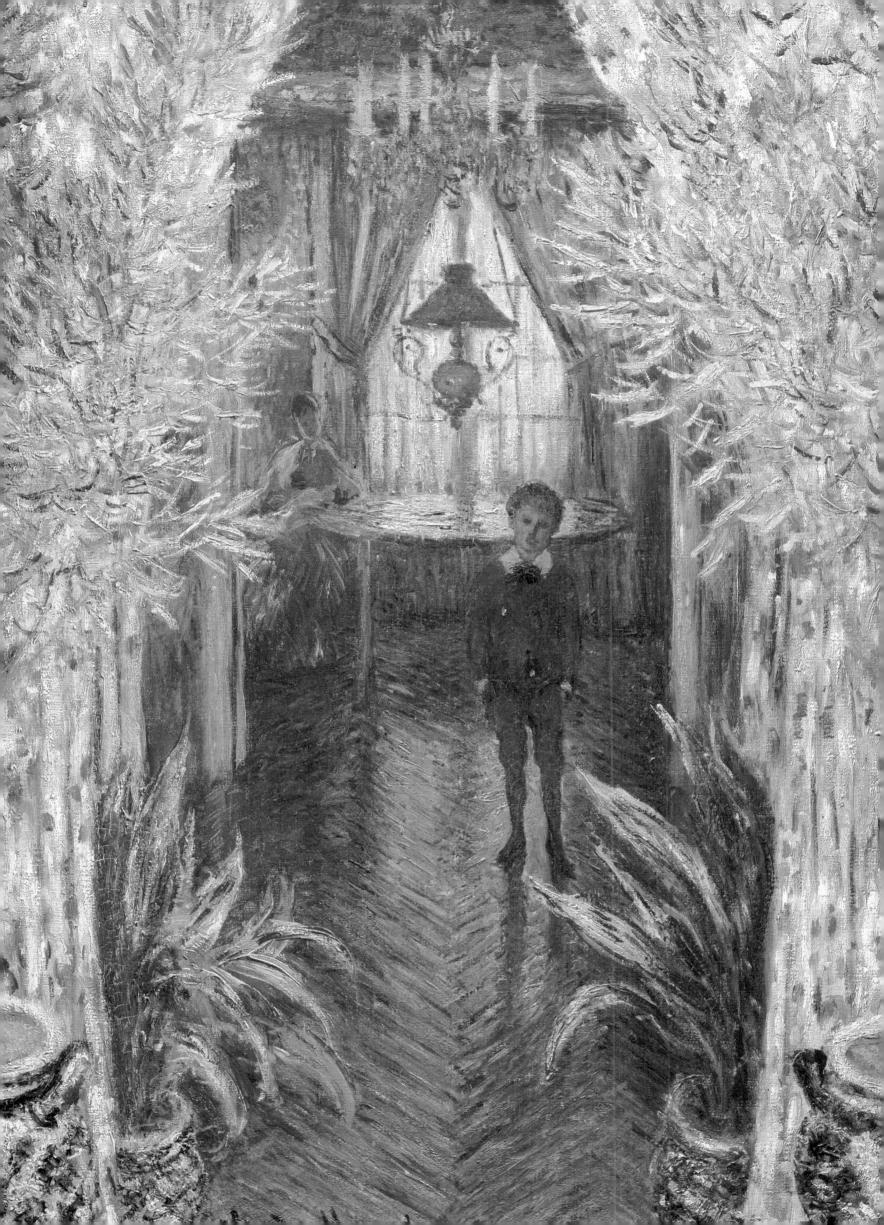

of which he tacitly saw himself as a part. Calling upon the minister's patriotic feelings, he depicted the possible sale of *Olympia* to an American buyer a loss to the glory of France, and urged him to accept the painting so that it could take its place among other masterpieces in the Louvre.

The day after he had sent the letter to Fallières, Monet had its contents published in the newspaper *Le Figaro* to publicize the affair. This tactic paid off, as verbal and visual warfare erupted in the Paris papers in the following weeks. In any event, the negotiations between Monet and the government took place over the next five months. Three more were needed for the legal paperwork to be completed, and before the final agreement between the parties could be signed. Monet's last condition, that the painting be accepted without any restrictions and placed in a museum in Paris, rather than in one of the government offices or embassies abroad, was accepted.

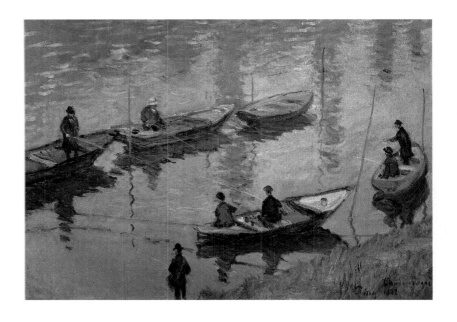

Fishermen on the Seine River near Poissy
1882; *oil on canvas;* 23 5/8 x 32 3/8 in. (60 x 82 cm.). Vienna, Austria, Kunsthistorisches Museum.
Between December 1881 and April 1883, Monet lived in Poissy with Alice Hoschedé and her children. There he painted this scene of fishermen in their boats on the Seine. It is decidedly less luminous than many of his other paintings from that period, though the flickering of the light on the water is rendered with great sensitivity.

Although exhausted from this unusual battle, Monet persevered because he knew what was involved. Not only did he want to see his friend's achievements officially recognized and Manet's widow endowed with the money she desperately needed, but he also wanted to ensure a toehold for himself in the lineage of French art history. When he returned to his series of "Grainstack" paintings, Monet knew that he had successfully defended Impressionism against Neo-Impressionism and the French state, which up till then had been reluctant to acknowledge the achievements of its artists.

Monet in Giverny

In November of 1890, Monet purchased the house in Giverny, becoming a landowner for the first time. The very fact of owning a piece of land may have influenced his drift toward pure landscape painting. About two years later he bought another piece of land adjacent to his property, on which he began to construct a garden pond. This pond with its Japanese-style wooden bridge was originally quite small, as his paintings of the *Water Lily Pond* attest. Only after 1900 did he enlarge it to its present size. Recent restorations have brought the garden back to its original state as Monet had designed it. It is particularly enjoyable during the months of late May and June, when the water lilies are in full bloom.

Monet later claimed that he did not build the garden in order to have a motif for his paintings, but he must have considered it at least as a possibility. "It took me some time to understand my water lilies. I had planted them for pleasure; I cultivated them without thinking of painting them ... A landscape does not sink in to you all at once." However, to the prefect of his Département he explained in a letter of 1893, while submitting his

Portrait of Mlle. Blanche Hoschedé
1880; *oil on canvas;* 18 1/8 x 15 in. (46 x 38 cm.). Rouen, Musée des Beaux-Arts.
Monet painted only a few portraits. Blanche was the daughter of Alice Hoschedé, with whom the artist took up residence in 1880 after the death of his wife Camille. Eventually, Blanche married Jean Monet, the oldest son of the artist, but after his death in 1914, she returned to Giverny to take care of the ailing artist, who had been living alone since Alice's death in 1911.

request for the building permit: "It is only a question of something for amusement and for the pleasure of the eyes, and also with a view to motifs for painting."

The continued success of his series paintings during the 1890s and his subsequent wealth allowed him a comfortable lifestyle. Initially Monet cared for the garden himself, but eventually he hired several gardeners, who supervised his creation following his instructions. He used to claim that painting and gardening were his only interests in life. While living in Argenteuil and later in Vétheuil he took great care of his gardens, where large blue and white flowerpots decorated the terraces around the house, as can be seen in *Monet's House at Argenteuil* or in *Monet's Garden at Vétheuil*. A note in his personal account book lists the color sequence for seven rows of hollyhocks: purple, white, red, violet, yellow, cream, and pink. In *Gladioli*, where rows of red and blue flowers alternate, his sense of color is also evident.

After visiting Monet, the German art historian Julius Meier-Græfe remarked: "Monet reveals himself best ... in the garden he has planted about his country house. He has made it on the same principles as his pictures ... Every individual blossom contributes to the mass of color."

Monet also took great pains in decorating his home, choosing for example various shades of yellow for the dining room, and different hues of violet for the living room. Many visitors described their experience. One of them noticed that a bowl of lemons had been carefully placed on the window sill in the dining room, thus completing the decoration with their matching colors. An extensive collection of Japanese prints and fans was displayed around the rooms of the ground floor, while in the suite upstairs Monet kept paintings by his friends on the wall, in particular works by Paul Cézanne and Renoir.

Before focusing almost exclusively on the motif of water lilies, Monet painted several series of paintings based on almost identical motifs. The first one was the "Grainstack" paintings, the subject for which he found in the fields surrounding his house in Giverny. Several times during the mid-1880s Monet painted haystacks, but more as a part of a decorative scheme than as the principle subject, as for example in *Meadow with Haystacks near Giverny*. It was not until 1889 that Monet finished his canvases of grainstacks, which in the past have often been identified as haystacks. The pressure and competition which Monet sensed from the younger generation of Neo-Impressionists like Seurat spurred his efforts to create ever more complex effects in his paintings. During his visit to the island of Belle-Isle in 1886 he had already worked on a single motif presented in different versions of light and color.

In 1890 he began to explore and expand the artistic possibilities of this idea. Nature in these pictures became magisterial, a powerful source of wonder and excitement. The artist's individual feelings about a landscape can be relived by the viewer, very much unlike nature in Seurat's landscapes, which is constructed with almost mathematical and scientific precision. But Monet's selection of motifs and their simplistic composition were also very much products of his reflective thought, his knowing will. Monet focused not only on the overall atmospheric effects, rigorously painted, but also emphasized tapestry-like qualities, stressing the effect of patterns and the materiality of nature itself. Similar concerns were expressed in the series of paintings of poplar trees, a motif he found not far from Giverny along the Epte river, and also in his series of the Rouen Cathedral.

Travels Abroad

In 1895 Monet visited his oldest step-son Jacques in Norway, where he painted a number of canvases of Mount Kolsaas. London once more became the focus of his attention between 1899 and 1901. As his son Michel was studying English there, Monet, accompanied by Alice and his step-daughter Suzanne, used the occasion of

an extended visit between September and October 1899 to paint views of the Thames River with its effects of early morning fog. He returned in February of the following year and again in 1901, producing a considerable body of work. To Durand-Ruel however, he wrote that London was "not a place where one can finish on the spot; one never finds one's effects over again." Many of these canvases were eventually finished in his studio in Giverny.

The desire to see the works of Velázquez took him to Madrid in 1904, accompanied by Alice. During a visit to Venice in 1908 he was again more concerned with painting. Atmospheric color was the dominant subject of these canvases, but the light of the laguna turned out to be problematic. After the exhibition of his Venetian canvases in 1912 Monet undertook only summer subjects, all within the confines of his own gardens.

The Legacy of Monet

Monet has often been described as a reclusive, monosyllabic personality, completely absorbed in his own world of gardens and painting. But as the affair of Manet's *Olympia* illuminates, he was capable of astute political maneuvering. He was also informed about events in the Parisian art world as he subscribed to two newspaper clipping agencies. His biographer, Gustave Geffroy, asserts that until his death Monet was preoccupied with what the press might say about his works. He owned a considerable library and read aloud to his family on quiet evenings.

Monet's life indeed became more isolated, though, after the death of his second wife Alice in 1911. Cataracts in both eyes worsened his eyesight over the last decade of his life and made painting difficult. In 1914 he lost his elder son Jean, who had married Alice's second daughter Blanche. In her widowhood, Blanche returned to Giverny and supported the painter during his last years until his death in 1926. By then, Monet's works were already famous throughout the world and his last legacy, the *Water Lily Decorations*, had become the property of the French state in 1922, when they were installed in the Orangerie of the Tuileries Gardens, and where they can be admired to the present day.

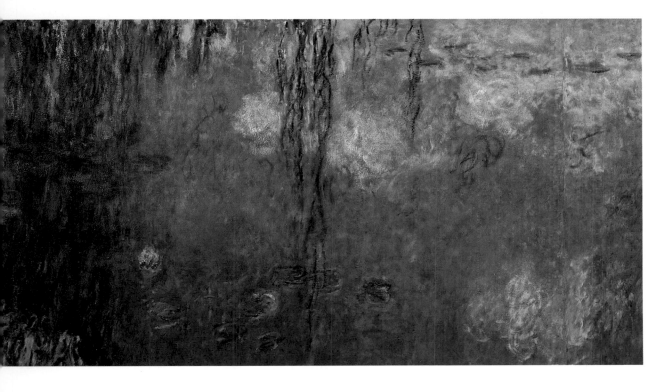

Water Lilies, Morning with Willows
1916–1926; *oil on canvas*; 78 3/4 x 502 in. (200 x 1275 cm.). Paris, Musée de l'Orangerie. *The water lily pond at Giverny, with its Japanese wooden bridge, was originally quite small but Monet enlarged it to the form in which it appears in this large canvas, one of the water lily decorations of his last years. Taking up his earlier interest in the water reflections, here Monet materializes the water solely through lily pads floating on the surface.*

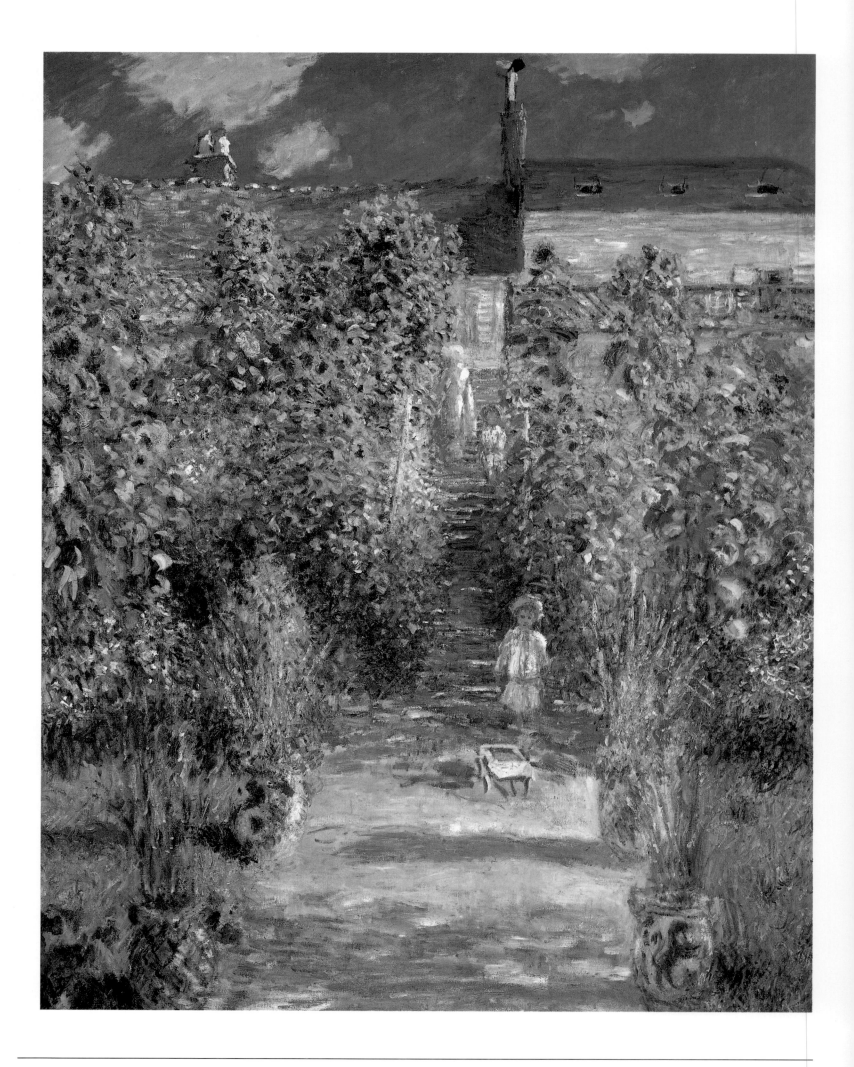

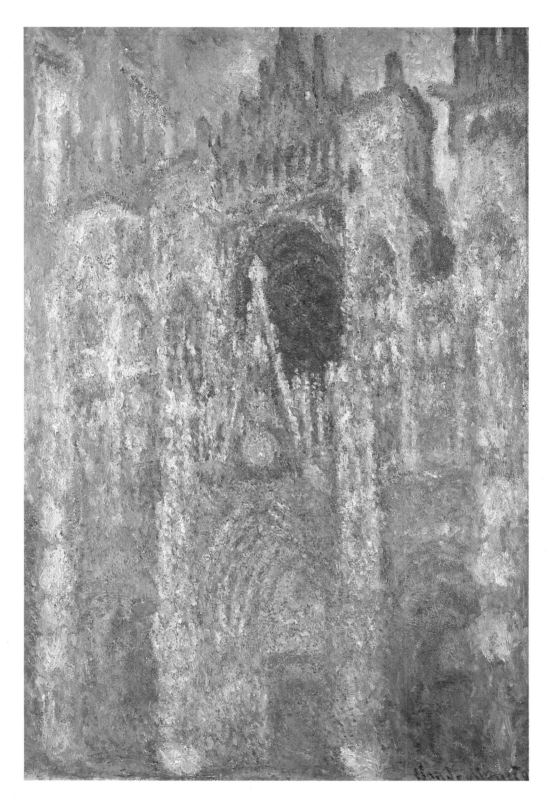

**The Artist's Garden
at Vétheuil**

1880; *oil on canvas*;
59 5/8 x 47 5/8 in.
(150 x 120 cm.).
Washington, D.C.,
National Gallery of Art.
*Based on a smaller version
with an identical point
of view, Monet added the
figures of his family on the
steps and the blue flower
pots along the path in order
to give the scene a more
monumental character.
The strong vertical effect
is balanced by the roof of
the house. Monet was very
proud of his gardens and
depicted them many times.*

Rouen Cathedral, Morning Sun
1892-1894; *oil on canvas*; 35 3/4 x 25 in. (91 x 63 cm.).
Paris, Musée d'Orsay.
*In the early morning, the sun rises behind the left tower
of Rouen cathedral, the so-called Tour d'Albane, creating
a bold silhouette against the sky. This oblique view
appears in numerous other canvases of the same series.*

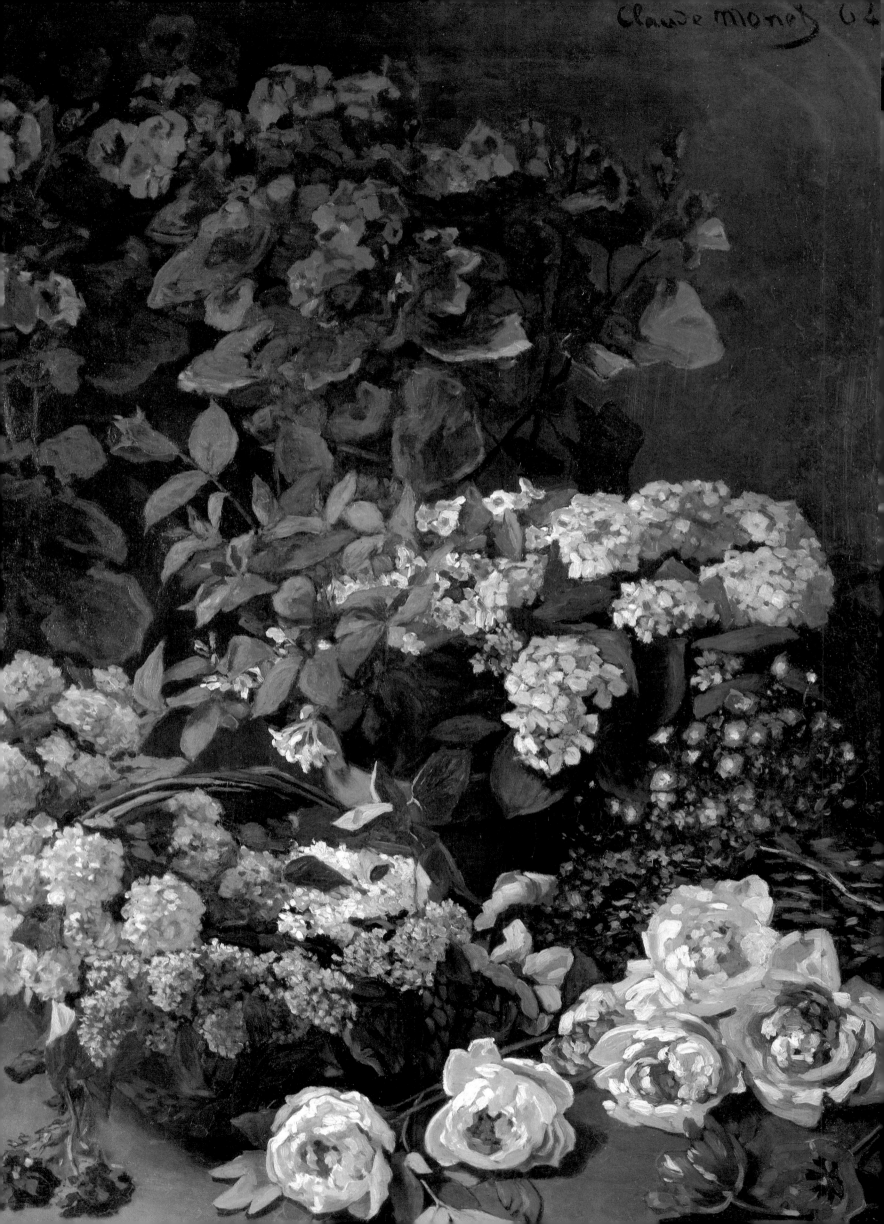

CHAPTER 1

BEGINNINGS

The coast and landscape of Normandy, with the city of Le Havre in particular, was the environment in which the young Claude Monet grew up and where he made his early debut as a caricaturist of local notables, which earned him a certain reputation. His artistic inclinations did not gain his father's approval; however, he was eventually allowed to pursue his art.

Around 1856 Monet met the local painter Eugène Boudin (1824–1898), who opened his eyes to the possibilities of landscape painting. Boudin practiced nature studies out-of-doors and he often made quick sketches of the changing light and atmospheric effects along the Normandy coast. His commitment to out-of-doors painting should not be overestimated though; outside he produced mostly pastels or watercolors, while his larger oil paintings are most likely the result of studio work.

Early Work and Influences

In the fall of 1862 Monet encountered the Dutch painter Johan Barthold Jongkind on the coast of Normandy, with whom he stayed in close contact for the following years. Together with Boudin, Jongkind was responsible for popularizing paintings of the Channel coast. He worked outside on small oils occasionally, but his outdoor painting was generally limited to the watercolor technique. In the light of works by the British artists John Constable (1776-1837) and J.M.W. Turner (1775-1851), who made oil studies of clouds and extreme atmospheric weather conditions, such practice seems unexceptional. Jean-Baptiste-Camille Corot's (1796-1875) Italian oil sketches of the 1820s belong to the same category of studies, which were only rarely dignified by being exhibited. Like the artist's sketchbooks, they remained personal notes not intended for the public eye.

In any event, Monet's first Salon submissions in 1865 consisted of studio enlargements from smaller paintings partially executed out-of-doors, thus reflecting his experiences with Boudin and Jongkind. Later, Monet told his biographer, the Duc de Trévise, that "when I began, I was like the others; I thought that two canvases were enough, one for dull weather, one for sunshine." In *Farmyard in Normandy* and in *Lighthouse at Honfleur*, two early topographical subjects, this statement appears confirmed. They lack for the most part the very specific effects of light and shade which make his later work so compelling. *Spring Flowers* (1864) is a still-life painting in the tradition of Courbet and his realism without the liveliness of the brushwork which characterizes his developed style. All three works attest, however, to the diversity of his approach.

Spring Flowers
1864; *oil on canvas*; 46 x 35 7/8 in. (117 x 91 cm.).
Cleveland, Ohio, Museum of Art.
This early work is executed in rich but dark colors, not unlike those of Gustave Courbet, while its vigorous rendering reveals the influence of Jongkind and Boudin. Painted during a summer stay at Honfleur, the picture was eventually sent to an exhibition at Rouen. Excited about his work, Monet encouraged his friend Frédéric Bazille in Paris to paint flower still-lifes as well.

Farmyard in Normandy
1863; *oil on canvas*; 25 3/8 x 31 7/8 in. (65 x 81 cm.).
Paris, Musée d'Orsay.
In composition and subject this early work reflects the style of Barbizon School painters Charles-François Daubigny and Constant Troyon, both of whom Monet knew personally. The paint is flat and the atmosphere somber, although contrasts of light and dark animate the surface.

An Ambitious Failure

The most ambitious project of Monet's early career, his *Déjeuner sur l'herbe*, was eventually abandoned, since he could not finish the canvas in time for the Salon of 1866. It was intended both as a response and homage to Manet's painting of the same title, exhibited at the Salon des Refusés in 1863.

While working with his friends Renoir and Bazille in the Forest of Fontainebleau during the summer of 1865, Monet embarked on this controversial and explicitly modern subject matter: a group of contemporary bourgeois men and women seeking recreation at a picnic out-of-doors in the Forest of Fontainebleau. The work gains its modernity in the context of traditional academic Salon painting. It dares to present an everyday subject in a monumental format, which was generally reserved for religious or history paintings. Furthermore, the figures appear to be casually conversing with one another, without offering a single focus or point of reference. Consequently, many viewers were at a loss as to what the painting was actually about. Critics pointed out the slapdash manner with which they felt the painting was executed, not realizing that the rendering of light and atmosphere required a different painting technique than the slick surface of an academically painted Venus. But Monet also looked back to appropriate historic models like the informally structured gatherings of the early 18th century 'fête champêtre,' in particular the world of Antoine Watteau.

The Salon of 1866

When Monet realized that he could not finish the canvas in time for the Salon of 1866 (the Salon was held each year from April until June), he quickly painted another work, *Camille*, again with clear echoes of recent paintings by Manet. Although it represents his future wife, Camille Doncieux, this modern figure is less a life-size portrait of her than a rendering of a characteristic Parisian type. Her pose is in fact very similar to contemporary fashion prints and must have been recognized as such by visitors of the Salon. The second painting that was accepted at the Salon that year was *Pavé de Chailly, Forest of Fontainebleau*, a

Déjeuner sur l'herbe (left fragment)
1865; *oil on canvas*; 97 3/5 x 85 2/5 in. (248 x 217 cm.).
Paris, Musée d'Orsay.
This fragment was originally part of a much larger composition which Monet left unfinished when he could not complete it in time for the Salon of 1866. He began this project during the summer of 1865 in the Forest of Fontainebleau, where he worked with his friend Bazille, who together with his future wife Camille posed for almost all the figures.

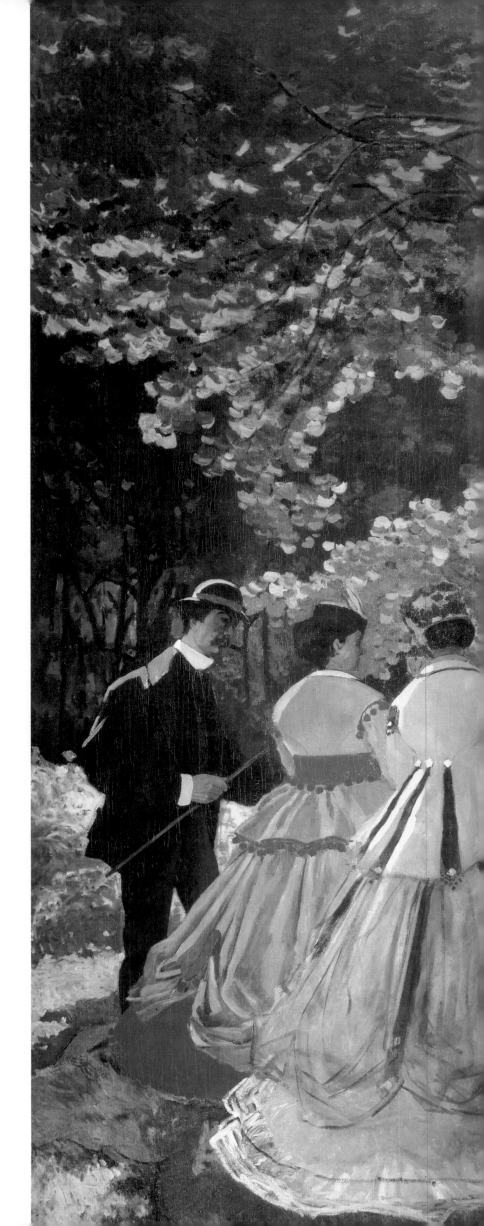

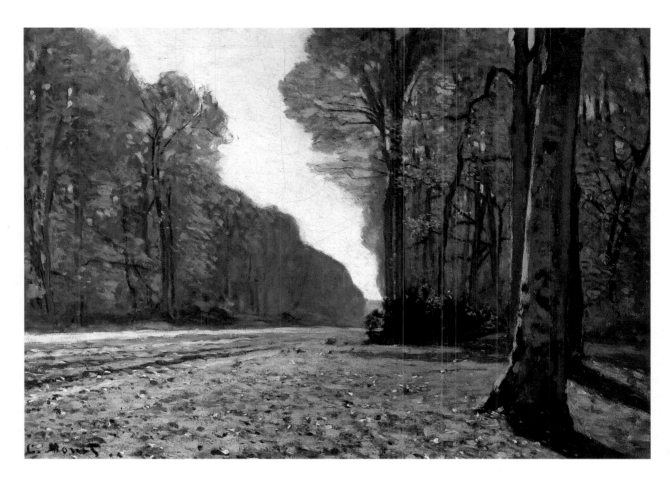

The Pavé de Chailly, Forest of Fontainebleau
1865; oil on canvas; 17 x 23 1/4 in. (43 x 59cm.). Paris, Musée d'Orsay. Beginning at Easter 1863, Monet and Bazille went regularly to Chailly, a village on the edge of the Fontainebleu forest, not far from Barbizon, where they painted the famous woods. Probably executed in the summer of 1865, showing a road leading through the forest and the effects of sunlight, reflects the tradition of the Barbizon school.

luminous work, very much within the tradition of the Barbizon School.

At Le Havre

In a group of paintings done at Le Havre in 1866, Monet not only used strong, unmixed colors but he also applied the paint in short, small strokes of the brush, which dot the canvas in an attempt to reproduce textures as well as radiate light effects. Thus he finally overcame the influence of his teachers and friends and found his own style, characterized by an unsentimental approach to nature, but full of vibrancy and joy. In *Garden at Sainte-Adresse*, the influence of Boudin and Jongkind can still be felt in the depiction of the ships arriving at the Seine river from the ocean. Monet's family lived in Sainte-Adresse, a suburb of Le Havre. The sunlit terrace itself, where members of Monet's family are seemingly casually placed between red nasturtiums and gladioli dabbed in bright red onto the canvas, is all Monet's own invention. The breeze of the ocean can be felt in the waving flags, the smoke coming from the smokestacks of the ships, and the ripples on the surface of the water. Similarly, the *Garden in Bloom at Sainte-Adresse* is full of sparkling and buoyant flowers set against a deep green of the leaves and a clear blue sky. Some petals, fallen to the ground, suggest the flowers' ephemeral nature.

In both scenes, the eye seems to have caught a casual glimpse of the subjects. When analyzing the paintings, though, they turn out to be carefully composed and balanced. In *Garden at Sainte-Adresse* the wall on the right is not completely perpendicular to the gate on the waterfront, thus allowing more space for the display of the flowers. The couple sitting in the chairs, Monet's father and aunt, is echoed by the man and woman standing in the back. Two empty chairs are reserved for them at the left and right off center. Long afternoon shadows give the composition a diagonal twist, counterbalancing the painting's horizontality. In the *Garden in Bloom* Monet has positioned himself in a way so that the darker large tree on the left and the lighter small one on the right serve as anchors for the composition. A poplar tree in the distance behind the house picks up the upward movement of the slender stems of the rose bushes in the foreground. Even the colors of the house,—the beige walls, the green shutters, and the gray roof,— are repeated throughout the scene thus binding the various elements together.

Another scene painted during the same stay at Le-Havre depicts Monet's aunt *Jeanne-Marguerite Lecadre in the Garden*. Again, he used bright unmixed colors, particularly a saturated green for the sunlit grass and an intense blue. The brush gives such undifferentiated areas an assertive flatness comparable to the effects of palette-

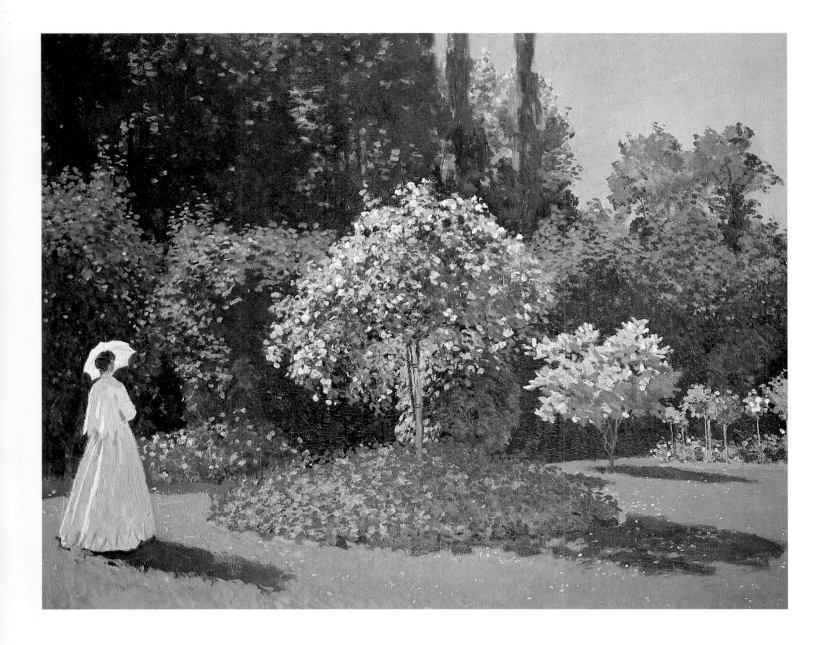

Jeanne-Marguerite Lecadre in the Garden

1866; *oil on canvas*; 31 1/2 x 39 in. (80 x 99 cm.).
St. Petersburg, Hermitage Museum.
Jeanne-Marguerite Lecadre, a relative of the artist, is seen
in her family's garden at Sainte-Adresse in Normandy.
The sky and the grass are treated with an assertive flatness
of the brush, while decisive accents model the figure's skirt
and the various textures of the foliage and flowers.

Garden in Bloom at Sainte-Adresse

detail; 1867; Paris, Musée d'Orsay
The flowers are rendered with small dots of paint, a
technique Monet was to develop further in the following
years. During this period he often adopted pure, unmixed
colors with vibrant effects. The individual flowers sit
on the surface of the painting as a thick impasto.

knife work, while other parts of the painting have been
treated differently. Decisive marks model the figure's
skirt, and various dots of paint define the textures of
foliage and flowers. *The Beach at Sainte-Adresse* picks up
a popular subject, which was Boudin's specialty. But
instead of a complacent, uneventful depiction of vaca-
tioners on the beach, Monet preferred to suggest a casu-
al encounter of fishermen near their boats. Unlike most
of Boudin's views, this painting is of almost square for-
mat thus providing a large space for the sky. Dabs of
color define the surface of the water and the beach with
almost unprecedented simplicity.

Paintings of Urban Life

Although Monet favored landscape painting, he was
nevertheless interested in city views and other scenes of
modern life. This was also necessary in order to be
respected as an avant-garde artist. Academic staleness, it
seemed, could only be overcome through confronting

the reality of a modern urban and industrialized environment. Like Renoir, Monet walked through the streets of Paris looking for motifs for his paintings. The results are *Jardin de l'Infante*, also known as *Garden of the Princess*, and *Quai du Louvre*.

Painted from a balcony of the Louvre, *Jardin de l'Infante* depicts the park from an oblique view. The corner of the flower bed with its small bush is perpendicular to the dome of the Panthéon in the distance. The spatial arrangement is still indebted to Corot, but the broad definition of the sky and the rapid brushstrokes that describe the movement on the streets already reveal Monet's own language. Monet painted *Quai du Louvre* from almost the same spot. Again, the dome of the Panthéon crowns—though less prominently—the cityscape. Several slightly oblique elements divide the space: the embankment of the Louvre, the Seine with the Pont-Neuf, the houses around Place Dauphine, and the Quai des Grands-Augustins on the other side of the river. With the open-sided horizontality of the composition and the figures scattered right across the foreground, Monet adopted conventions common in contemporary topographical printmaking.

Radical Gestures

Monet's understanding of avant-garde painting was not shared by many people, and not necessarily by other artists either. Latouche had bought *Jardin de l'Infante*, but when he displayed it in the window of his paint shop at the corner of rue Laffitte and rue LaFayette the painter Honoré Daumier supposedly demanded that this "horror" be taken away, and even Édouard Manet, whom Monet admired, is said to have made a disdainful remark.

Monet's first radical gesture toward open-air painting was *Women in the Garden*, painted entirely in the open. It was so large Monet had to dig a trench in his garden, into which he could lower the canvas, in order to reach the upper part of the painting. Camille posed for all figures and the artist Gustave Courbet, whom Monet had befriended, came from time to time and watched this curious scene with amusement. At that time, Monet's technique consisted of large, rapid brushstrokes with

Bathers at La Grenouillère
detail; 1869; London, National Gallery
This painting can be considered one of the first truly "impressionistic" paintings, executed with many small strokes of colors. The artist did not distinguish between the figures of the bathers and the water with its reflections on the surface. Both are rendered in the same pictorial manner.

which he applied the colors thickly. He contrasted the sunlit areas of the dresses with the darker shadows of the leaves, thus dividing the canvas clearly into lighted and unlighted areas. The work's overall quality was however a huge step away from the dark official Salon paintings.

The jury for the Salon of 1867 rejected the painting, which Monet had hoped to exhibit. This blow was even worse than previous ones, as the show coincided with a

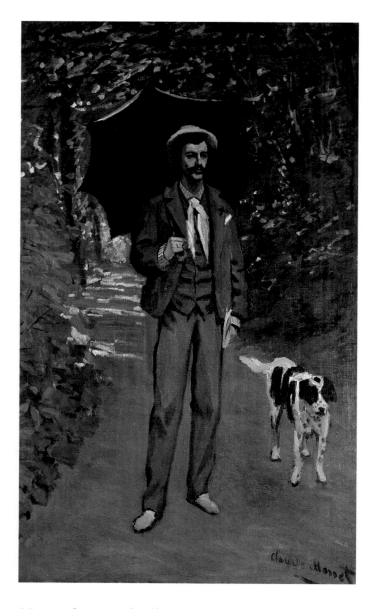

Man with an Umbrella, Portrait of M. V. Jacquemont
1865; *oil on canvas*; 39 x 24 in. (99 x 61 cm.).
Zurich, Switzerland, Kunsthaus.
Next to still-life painting, portraits were the most reliable source of income for an artist. Nevertheless, renderings of people other than members of his family or close friends are rare in Monet's oeuvre. Standing in a garden next to his dog, the casually dressed sitter is holding an umbrella behind his head. Sunshine is breaking through the leaves, modeling the man's features.

new World's Fair in Paris and many visitors would have been able to see it. Eventually, Bazille bought the painting for 2,500 francs when Camille turned out to be pregnant, throwing Monet into a particularly precarious situation. His financial difficulties forced him to leave for Le Havre and spend time with his parents, while Camille in the meantime delivered the child, a boy named Jean.

Difficulties and Triumphs

The year 1868 was a difficult one for Monet. He was without money; he had left his aunt's house in Normandy and there was not even enough money to buy coal for Camille and their baby. In the spring, however, Boudin wrote to him from Le Havre, inviting him, Courbet, and Manet to participate at an International Maritime Exposition. All three artists were awarded silver medals. But what was even more important was the ensuing commission Monet received from Louis-Joachim Gaudibert for a portrait of his wife, which the artist painted at his patrons' château at Etretat, near Le Havre. Some concessions to the official formulas notwithstanding, Monet painted a portrait in which the disparate luxuries of the Second Empire are rendered with great subtlety and harmony.

The Le Havre exhibition ended with the seizure of the exhibited works, which were then cheaply sold off at auction. Some of Monet's landscapes were actually bought by M. Gaudibert for 80 francs apiece, a ridiculous sum of money, compared to the 800 francs the artist had received for *Camille* from an art critic. In a letter to Boudin, Monet complained about the hardship of an artist's life: "My painting doesn't go, and I definitely do not count any more on fame ... I've become utterly lazy, everything annoys me as soon as I make up my mind to work ... At the exhibition on Le Havre, I sold nothing. I possess a silver medal (worth 15 francs), some splendid reviews in local papers, there you are; it's not much to eat."

At the Salon that same year, Monet was represented by one painting only, a seascape. His friends Degas, Renoir, Sisley, and Berthe Morisot also showed only one work each. Although poorly hung and difficult to see, the young artists' works did not pass completely unnoticed by the critics, noticeably Emile Zola. But more difficulties were awaiting Monet after he left Paris for Normandy. From Fécamp, toward the end of June, he wrote to his friend Bazille : "I am writing you a few lines in haste to ask your speedy help. I was certainly born under an unlucky star. I have just been thrown out of the inn, and stark naked at that. I've found shelter for Camille and my poor little Jean for a few days in the country. This evening I'm leaving for Le Havre to see about trying something with my art lover. My family

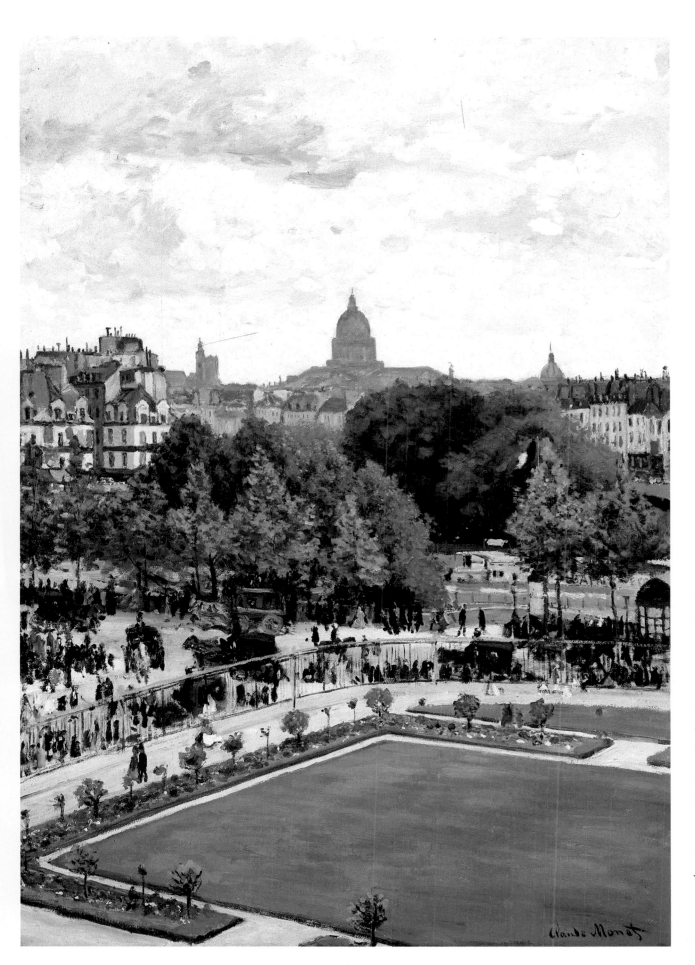

**Garden of
the Princess**
1867; *oil on canvas;*
35 4/5 x 24 2/10 in.
(91 x 62 cm.).
Oberlin, Ohio, Allen
Memorial Art Museum.
*A high viewpoint
and the lack of focus
on a particular scene
are characteristic of
Monet's paintings from
this period. The curv-
ing garden establishes
an off-center plane
floating between view-
er and distance, where,
as in* The Quai du
Louvre, *the dome of
the Panthéon appears.*

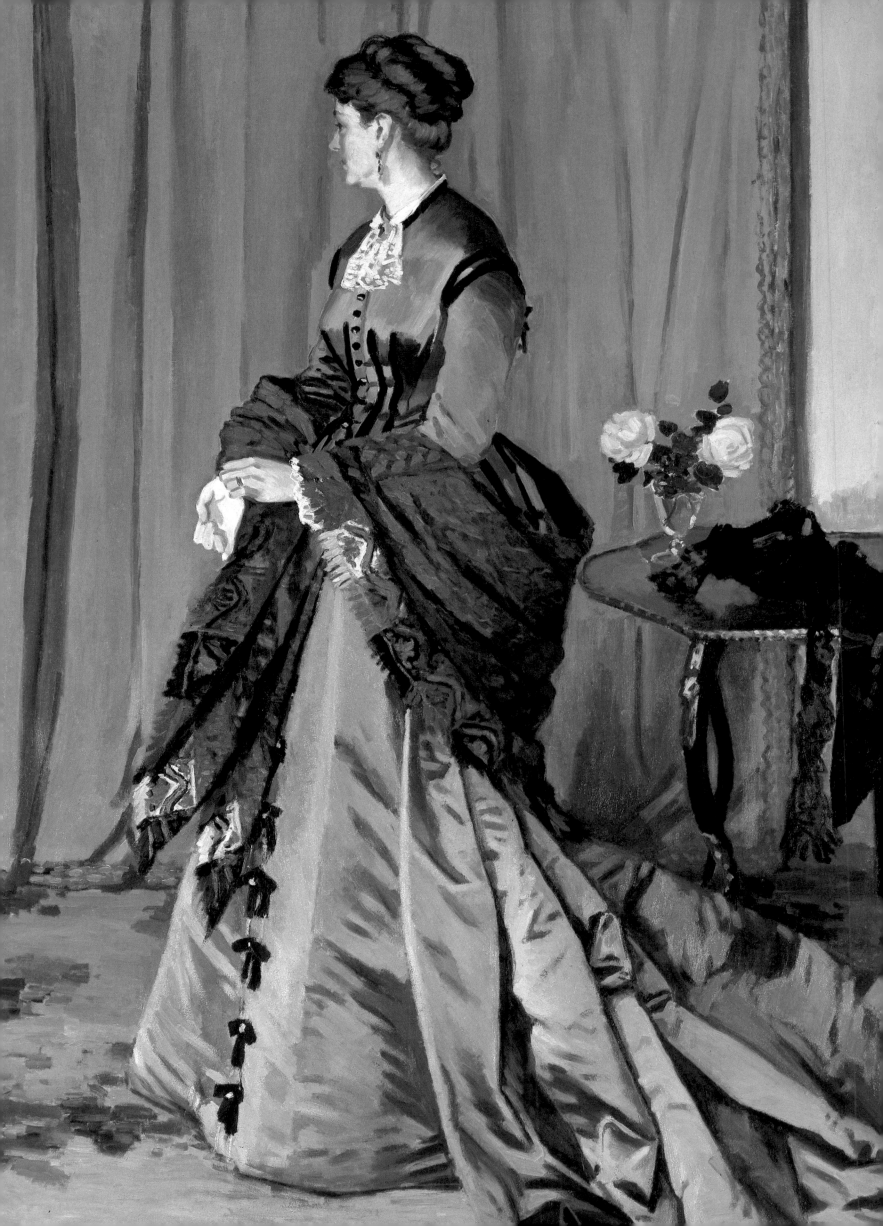

have no intention of doing anything more for me. I don't even know where I'll have a place to sleep tomorrow. Your very harassed friend - Claude Monet. P.S. I was so upset yesterday that I had the stupidity to throw myself into the water. Fortunately, no harm came of it."

Refuge in Normandy

Monet's patron in Le Havre, M. Gaudibert, was luckily more supportive of the artist than his own family was. He provided Monet with an allowance which enabled him to find temporary relief from his strains and new encouragement for his work. Together with Camille and his son, Monet spent the winter at Fécamp in complete tranquility, studying the pebbled beach and the countryside. "I sure don't envy your being in Paris," he wrote to Bazille in September. "Frankly, I believe that one can't do anything in such surroundings. Don't you think that directly in nature and alone one does better? I'm sure of it; besides, I've always been of this mind and what I do under these conditions has always been better. One is too much taken up with what one sees and hears in Paris, however firm one may be; what I am painting here will have the merit of not resembling anyone, at least I think so, because it will be simply the expression of what I shall have felt, I myself, personally. The further I go, the more I regret how little I know, that is what bothers me most."

This letter virtually summarizes many of Monet's later positions, especially his dislike for the city and his indifference toward gossip in the art world and other distractions. He did remain sensitive, however, to both political as well as aesthetic issues and followed closely from his refuges in the country the events in Paris.

In *The Luncheon*, painted at Etretat during the period of Gaudibert's support, it was Monet's own family

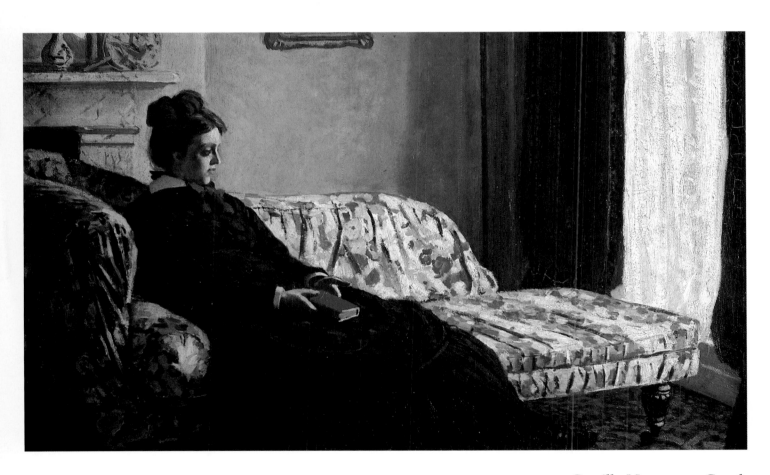

Camille Monet on a Couch
1871; *oil on canvas;* 18 7/8 x 29 1/2 in.(48 x 75 cm.).
Paris, Musée d'Orsay.
Camille Monet is caught during a moment of relaxation on the couch, looking away from a book she is holding on her lap. Areas of light and darkness are carefully balanced. The interior is probably the couple's apartment in Paris.

Portrait of Mme. Louis-Joachim Gaudibert
1868; *oil on canvas;* 85 1/2 x 54 1/2 in. (216 x 138 cm.). Paris, Musée d'Orsay.
Monet executed this portrait of the wife of a wealthy businessman at Etretat during the summer of 1868. Since the artist was in difficult financial circumstances, he was willing to make some concessions to the official formulae of portrait painting. The influence of Manet is visible in the clear arrangement of the figure and the exquisite rendering of the dress.

which provided the subject. This large canvas, rejected at the Salon of 1870, presents a family mealtime with a studied informality. The vacant place on the near side of the table is waiting for the head of the household, the painter himself. The comfort of this bourgeois interior sheds some doubt about Monet's alleged poverty; it even includes a maidservant, who is just about to leave the room.

On the Seine at Bennecourt is a work that precedes–not in chronology but in style and spirit—the crucial pictures which Renoir and Monet painted together at La Grenouillère outside Paris. Overlooking the Seine from an elevated point on the embankment, Camille, in a striped summer dress, is sitting in a contemplative position under a tree. Firmly composed and structured in clear horizontal layers, the work reminds one very much of certain canvases by Frédéric Bazille. Flat patches of color and occasional rapid brushstrokes reveal Monet's shifting interest toward the "impression." The reflections on the water and the broken surface of the objects became characteristic of Impressionism with its pleasurable world of sun, air, water, and nature.

The Birth of Impressionism

It was in October of 1869 that Monet and Renoir began to paint in a manner which is now called Impressionism; Camille Pissarro may, however, have come to this style independently at around the same time. In a letter to Bazille, Monet explained their goals: "I have a dream, a painting, the baths of La Grenouillère, for which I've done a few bad sketches, but it's a dream. Renoir, who has just spent two months there, also wants to do this painting."

Located on the Seine river at Chatou, La Grenouillère (literally 'the Frog Pond') was a favorite bathing and boating site for Parisians. A short train ride from the capital, which cost only 12 sous at the time, the locale offered Parisians relaxation during a day's outing. Here, side by side, Renoir and Monet each painted three pairs of landscapes of almost the same view. They capture a casual moment of daily life, created in an atmosphere of freedom and seeming randomness with vivid colors, small, intense brushstrokes and a pervasive light. People are seen strolling or dining, children swim in the river, others are in their boats, and all of this is bathed in the gleaming light reflected by the surface of the rippled water. The overall effect is that of a spontaneous execution, when in fact both Renoir and Monet had carefully studied their compositions, painstakingly weighing every single one of the tiny details. The surface in Monet's versions is painted without recourse to traditional types of spatial recession. By changes of scale and emphasis, the reflected forms suggest a progression across the stretches of water; diagonals leading to the islet at the center

suggest a shallow recession. Brushwork and composition alike give a sharply articulated sense of 'pattern' across the canvas.

In order to achieve the high keys of their palettes, Monet and Renoir used canvases that were not prepared with the traditional warm brown or red ground, but rather with a white or pastel tone to enhance the luminosity of the scenes. The idea of recording immediate impressions rather than the permanent aspects of a subject was born out of the attempt to reproduce on canvas the actual image as it would (supposedly) appear on the retina of the eye. To that end, both Monet and Renoir used "rainbow" colors and eliminated black shadows and outlines of forms. The depicted objects thus gained lightness and atmosphere. Brush strokes vary from dry to wet, from thin to impasto, and are broken into hundreds of small spots, each of them having its own hue. Complementary colors are used to model the objects, to give them a tangible feeling in a space no longer defined by lines and perspective. An intense richness and airy, fleeting quality are the results of these efforts.

The Artist Marries

In the summer of 1870, Monet and Camille got married and the couple spent their honeymoon at Trouville, on the coast of Normandy. In *Camille Monet at Trouville* and *Hôtel Roches Noires* the artist continued to explore his impressionistic color dot technique. In July the Franco-Prussian War broke out. In order to escape the draft, Monet left his wife and son behind and managed to reach London. His friend Bazille, who volunteered instead, was killed during the early months of the war, depriving Monet as well as Renoir of his moral and financial support.

In London Monet met other refugees, Pissarro and the dealer Paul Durand-Ruel, who became an ardent supporter of Impressionism. Monet painted some scenes of the Thames river, a subject he rediscovered about twenty years later. Before returning to France in the winter of 1871, Monet visited Holland, where he painted views of the canals at Zaandam.

On the Seine at Bennecourt
detail; 1868;
Chicago, The Art Institute.
The figure of Camille and houses reflected in the Seine are rendered with broad brushstrokes, without distinguishing between the elements of nature and the human presence. Both the subject as well as the technique show the influence of Monet's friend and fellow painter Bazille.

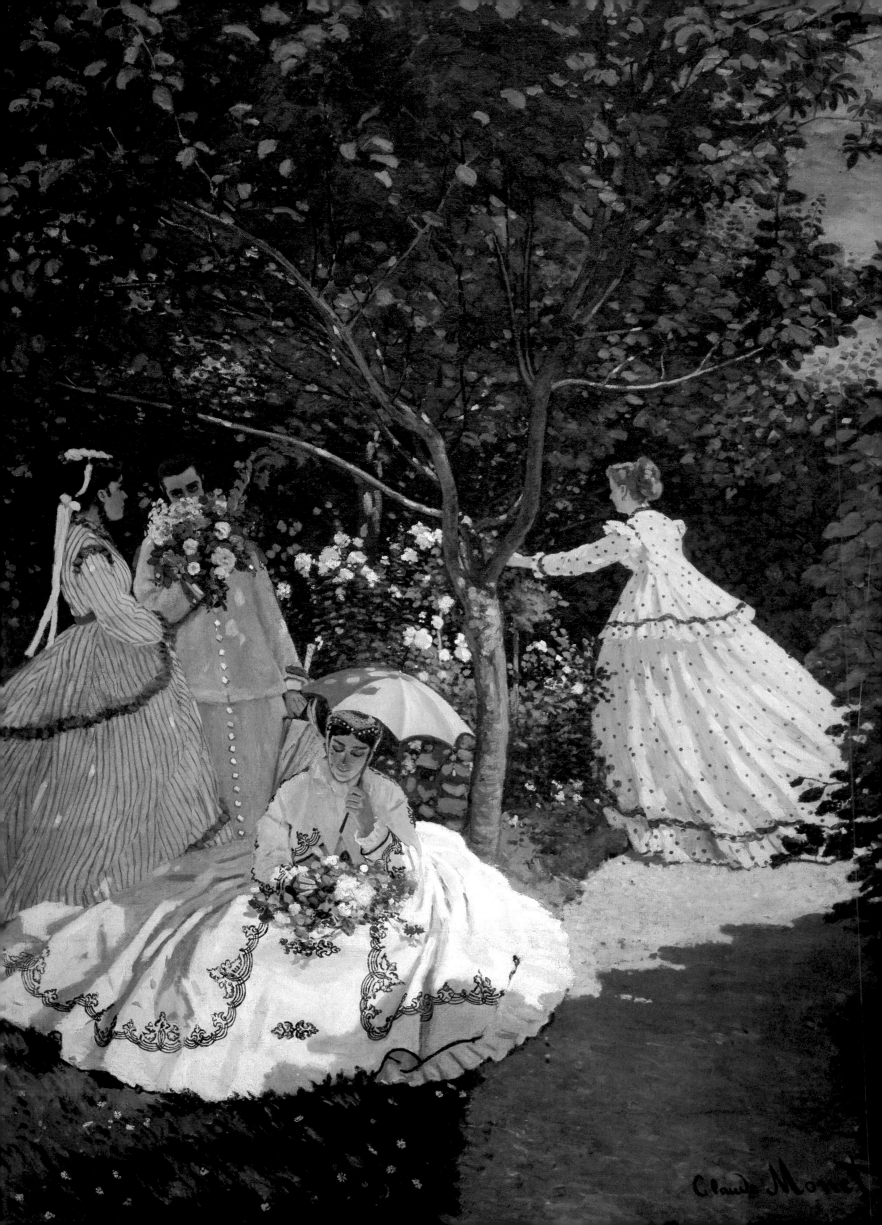

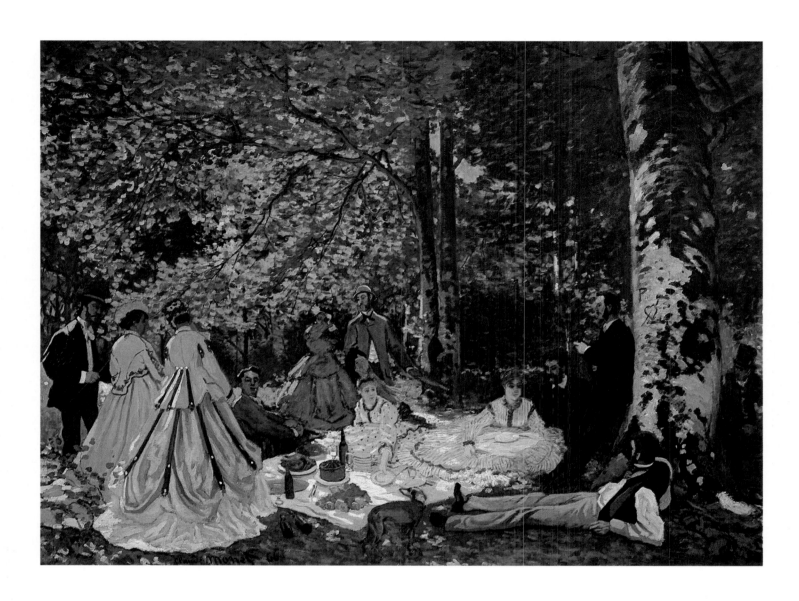

Déjeuner sur l'herbe (final study)
1865–1866; *oil on canvas*; 51 1/8 x 71 1/4 in. (130 x 181 cm.).
Moscow, Pushkin Museum of Fine Arts.
In 1865, Monet started an ambitious project depicting
explicitly modern themes. This was the final study for a painting
in which he sought to give the scale and weight of a history
painting to a scene depicting commonplace bourgeois amusements.
Two years earlier, Édouard Manet's work of the same title
had caused an uproar when presented at the Salon des Refusés.

Women in the Garden
1866; oil on canvas; 100 2/5 x 80 5/8 in. (255 x 205 cm.).
Paris, Musée d'Orsay.
Monet's companion and future wife, Camille
Doncieux, was the model for all four women in
this painting. The white dresses reflect bright
spots of sunlight and contrast with the darker
green tones of the garden. The canvas was
executed outdoors and without any focus on a
particular subject, which was considered revolution-
ary in the light of the traditional Salon painting.

The Quai du Louvre
1867; *oil on canvas*; 25 3/5 x 12 3/5 in. (65 x 93 cm.). The Hague, Netherlands, Gemeentemuseum. *The horizontality of this view of Paris adopts conventions of popular topographical printmaking styles. People are strolling along the banks of the river and in the distance the dome of the Panthéon crowns the cityscape.*

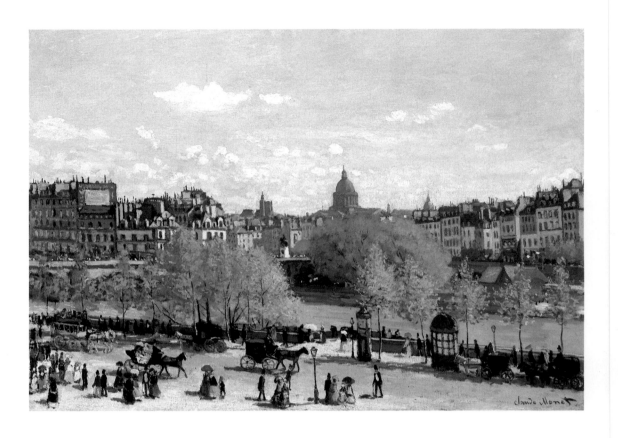

The Luncheon
1868; *oil on canvas*; 90 1/2 x 59 in. (230 x 150 cm.). Frankfurt, Germany, Staedelsches Kunstinstitut. *Monet's own family supplied the subject for a number of canvases. In the very large* Luncheon, *rejected at the Salon of 1870, the family mealtime is presented with a distinct informality, with the vacant place on the right awaiting the arrival of the artist himself. His son Jean was born in August of 1867, but Monet and Camille did not marry until the summer of 1870, shortly after the completion of the painting.*

Camille
1866; *oil on canvas*; 91 x 59 1/2 in. (231 x 151 cm.). Bremen, Germany, Kunsthalle. *Unable to finish his ambitious project of the* Déjeuner sur l'herbe *for the Salon of 1866, Monet submitted instead a portrait of his companion Camille. However, it is not so much the portrait of an individual as a study of a characteristic Parisian type. The clear composition and representational style are clearly indebted to examples by Édouard Manet.*

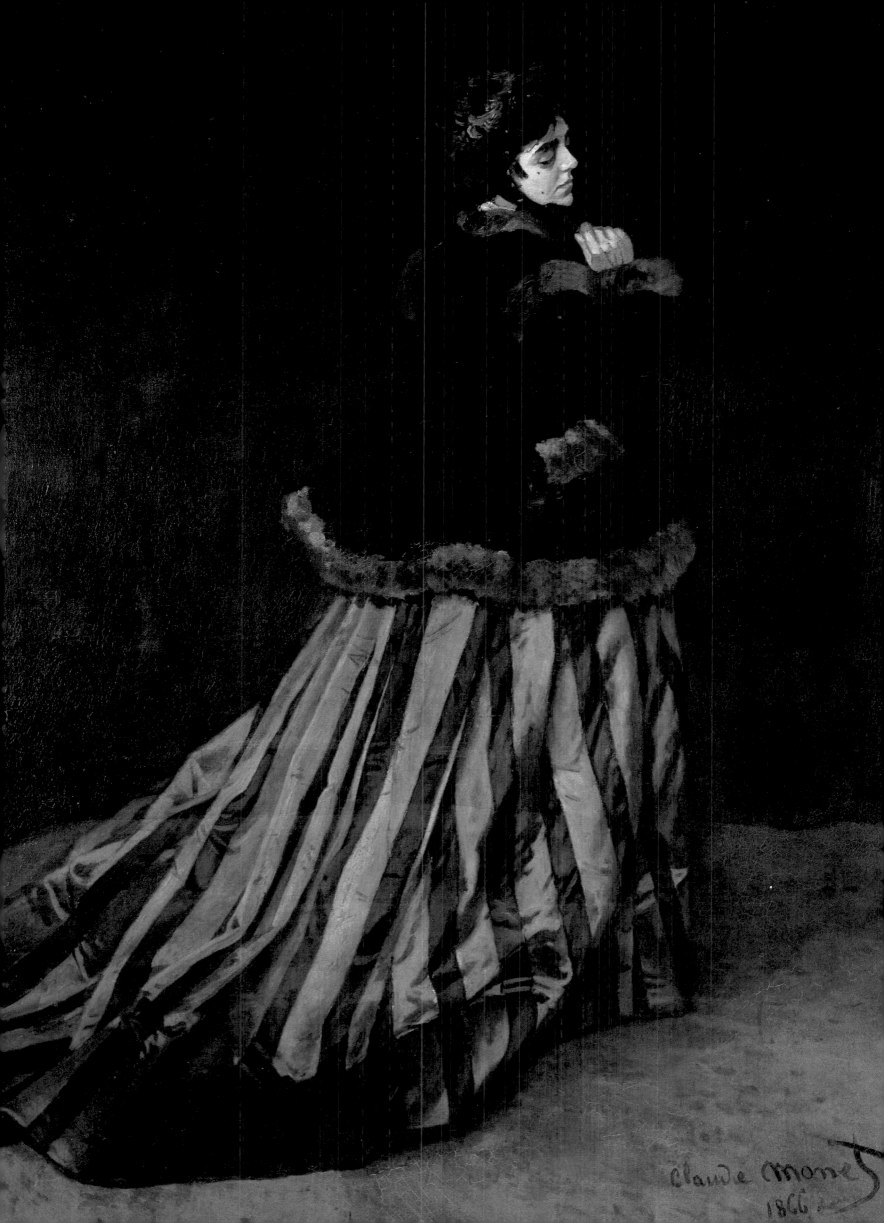

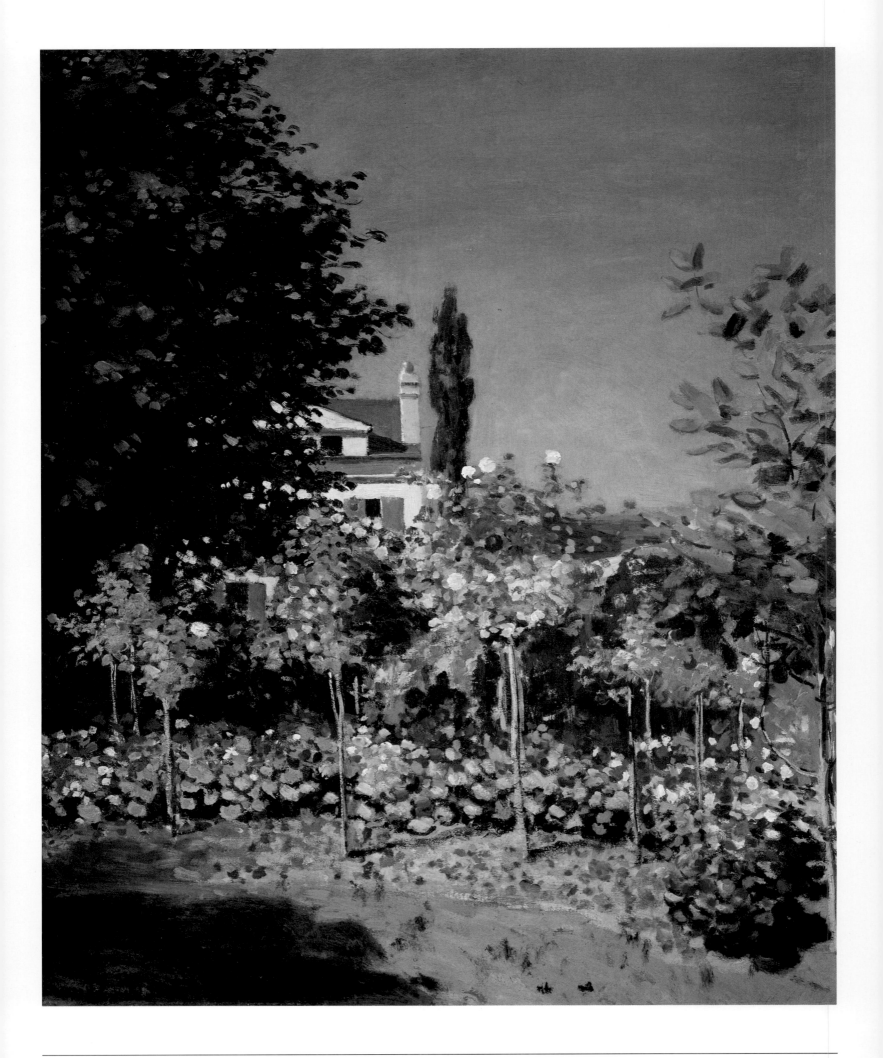

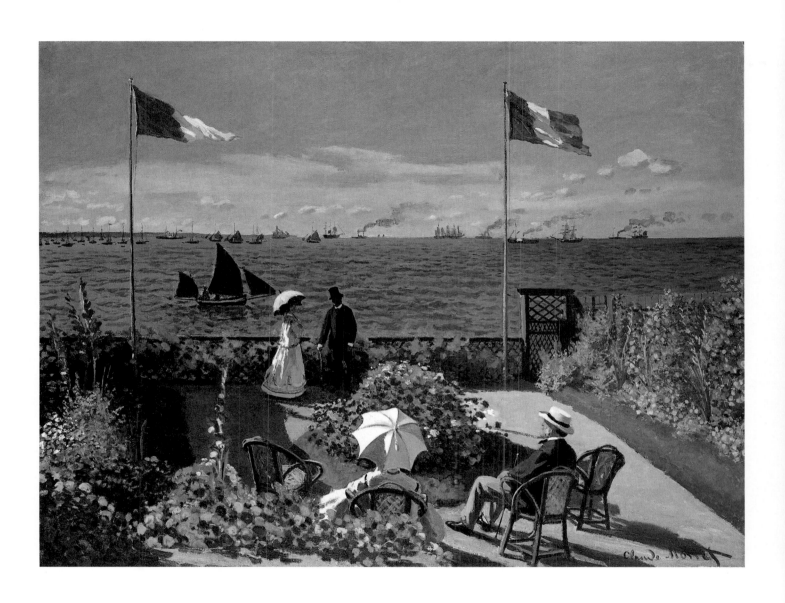

Garden at Sainte-Adresse

1866-1867; *oil on canvas*; 38 5/8 x 51 1/8 in. (98.1 x 129.9 cm.).
New York, Metropolitan Museum of Art.
This painting shows the picturesque terrace of the family's house at Sainte-Adresse, a suburb of Le Havre on the coast of Normandy. The man sitting in the chair is the artist's father. The high viewpoint and the patterns of sparkling light and bright color spots, as well as the atmosphere of the garden and water, are all elements of Monet's later style.

Garden in Bloom at Sainte-Adresse

1867; *oil on canvas*; 25 1/2 x 21 1/4 in. (65 x 54 cm.).
Paris, Musée d'Orsay.
Monet had already captured the fresh and crisp air of his hometown in Terrace at Sainte-Adresse. *But instead of that solemn view, this garden scene with its character of an accidental snapshot could hardly be more casual and modest. Sparkling and buoyant geraniums have been rapidly dabbed onto the canvas as small dots of red, white, and pink.*

The Cart, Snow-Covered Road at Honfleur
1867; *oil on canvas;* 25 5/8 x 36 3/8 in. (65 x 92.5 cm.). Paris, Musée d'Orsay.
Monet had a particular fondness for extreme weather conditions. He depicted winter scenes such as this numerous times. A horse-drawn cart is trying to make its way along a snow-covered road near Honfleur in Normandy. The road recedes toward the horizon with the tree as a focal point. Such a traditional composition was soon to be replaced by atmospheric renderings of space.

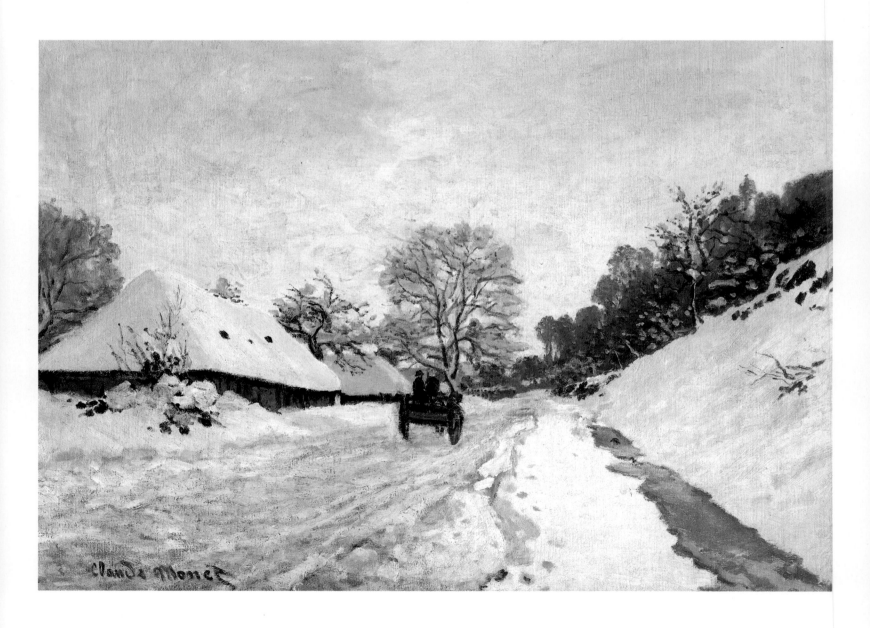

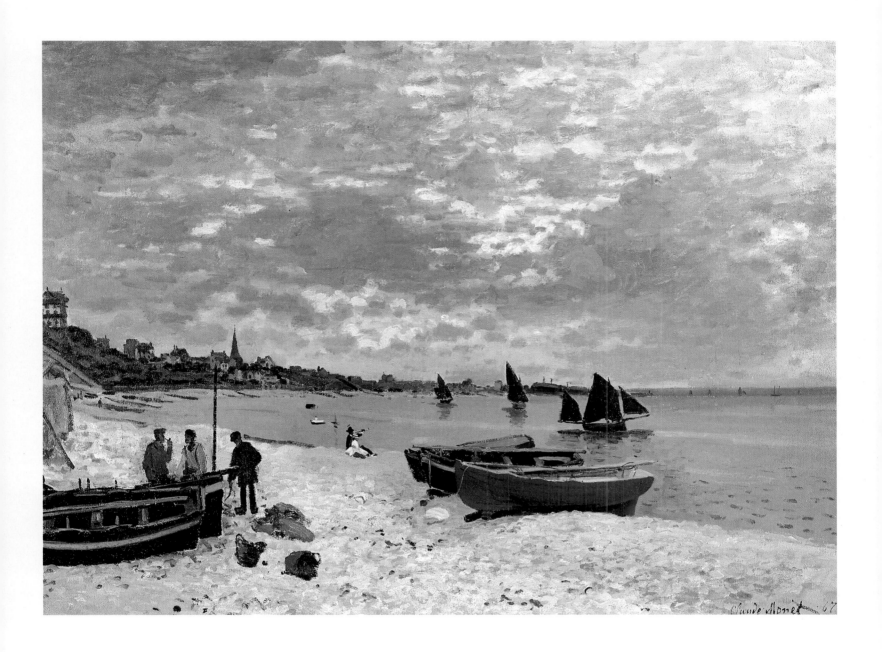

The Beach at Sainte-Adresse
1867; *oil on canvas;* 29 13/16 x 40 5/16 in. (75.8 x 102.5 cm.). Chicago, The Art Institute.
"Monet's landscapes are very beautiful. A seascape with a blue boat on the
beach is a masterpiece." Thus a critic described this work at its showing
at the second Impressionist exhibition in 1876. Sainte-Adresse, on the
coast of Normandy, was the hometown of Monet's parents.

**Ice Floes on the
Seine at Bougival**
1867–1868; *oil on canvas*;
25 5/8 x 31 7/8 in.
(65 x 81 cm.).
Paris, Musée d'Orsay.
*By the time Monet
executed this painting,
his figures had become
typified rather than
personal representations
of human activities,
rendered in a few crisp
strokes of the brush.
Without achieving
any individual weight,
the various elements
of nature form a harmo-
nious unity in the
almost monochromatic
handling of the canvas.*

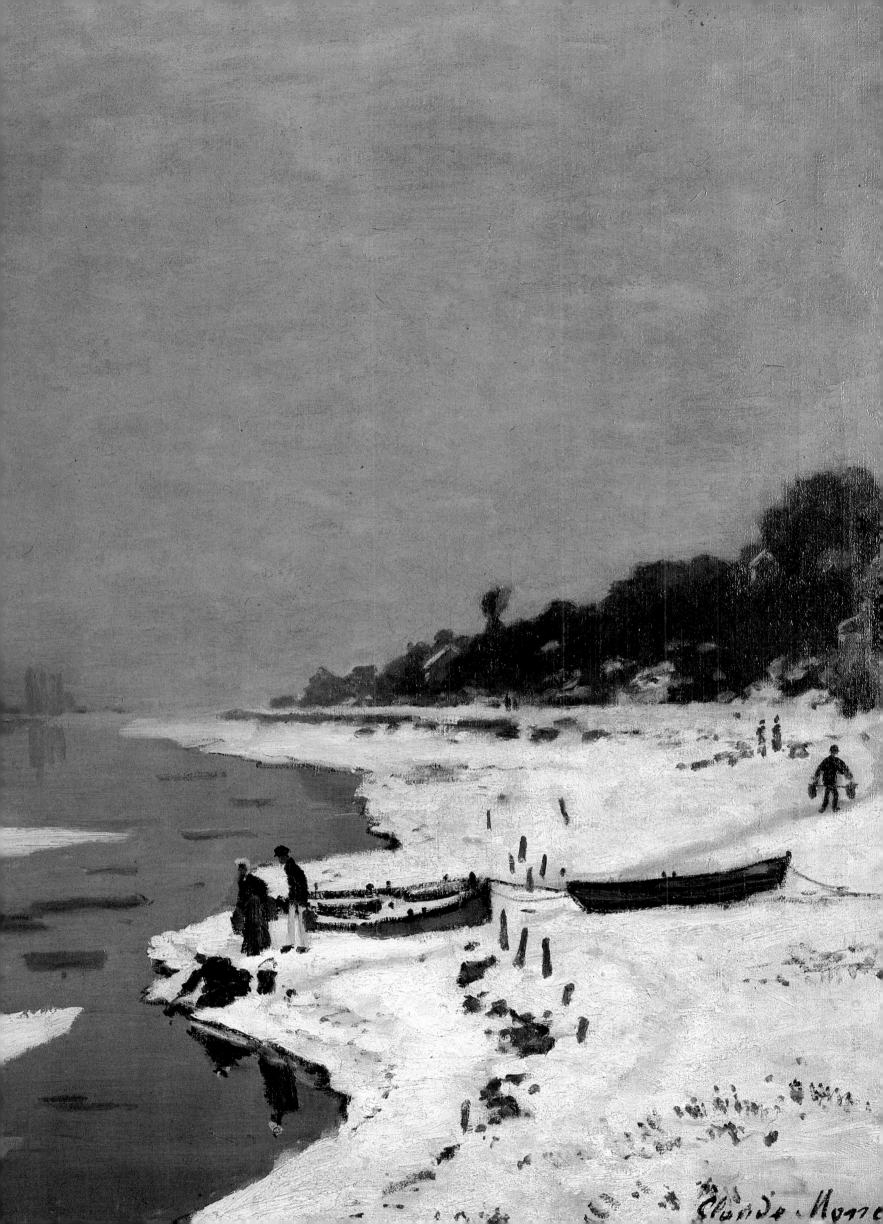

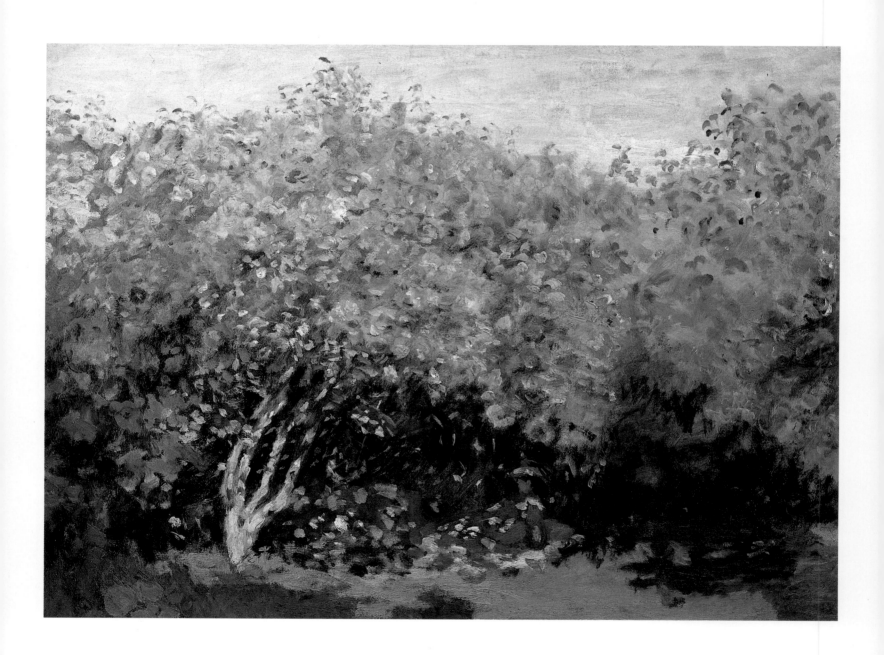

Lilacs in Sunlight
1872; *oil on canvas*; 19 2/3 x 25 5/8 in. (50 x 65 cm.).
Moscow, Pushkin Museum of Fine Arts.
The flickering sunlight is rendered with small brushstrokes, which absorb
the figures underneath the tree and the foliage alike into a single vibrant
play of colored patches. This was the first painting by Monet to arrive in Russia.
It was purchased from Durand Ruel's gallery by the collector Shchukin.

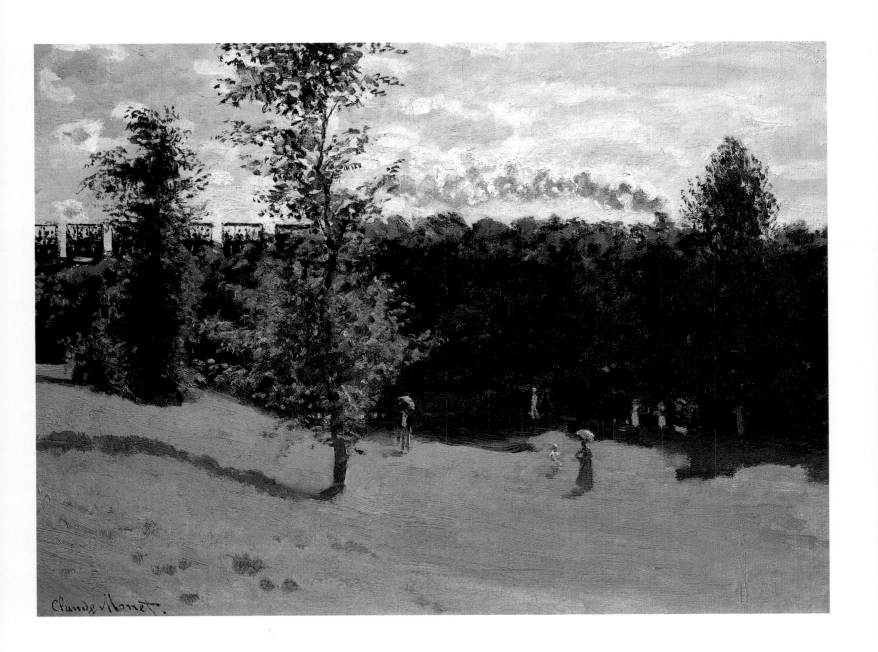

Train in the Country

1870; *oil on canvas;* 19 5/8 x 25 1/2 in. (50 x 65 cm.).

Paris, Musée d'Orsay.

Monet painted trains and train stations repeatedly, fascinated by the contrast of modern technology and nature. He particularly liked the smoke and steam coming from the engines since they created a misty quality of light, which he tried to imitate in many of his works.

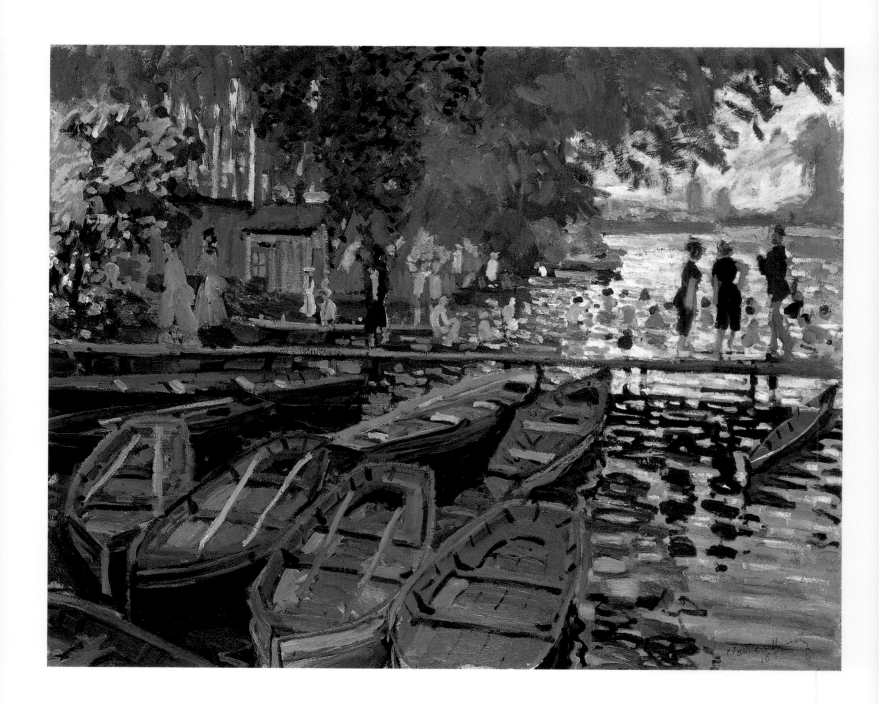

Bathers at La Grenouillère

1869; *oil on canvas*; 28 3/4 x 36 1/4 in. (73 x 92 cm.). London, National Gallery.
Renoir and Monet painted this same scene, side by side. But while the former focused on the representation of the human figures, Monet was more interested in translating the light and atmosphere of this bathing resort. The figures in this painting are therefore treated with quick brushstrokes and completely integrated into the surrounding nature.

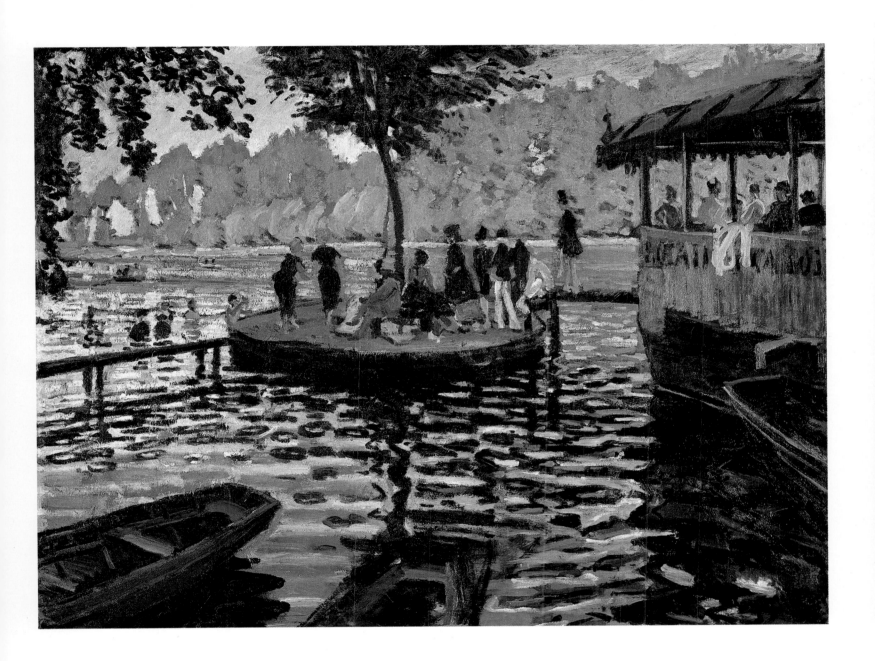

La Grenouillère

1869; *oil on canvas;* 29 3/8 x 39 1/4 in. (74.6 x 99.7 cm.). New York, Metropolitan Museum of Art.
With La Grenouillère, *painted in 1869, Monet introduced a style and a subject which remained
important throughout his life. Together with his friend Renoir, Monet visited this site on the
Seine a few miles outside of Paris, where on weekends Parisians enjoyed bathing and boating.
Single brushstrokes evoke the flickering sunlight and the atmosphere of the locale.*

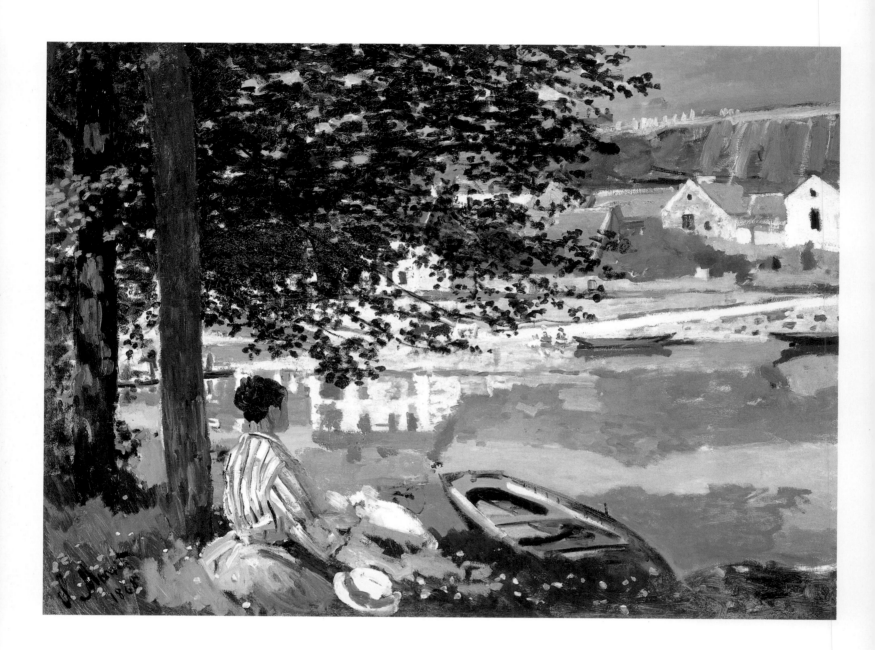

On the Seine at Bennecourt

1868; *oil on canvas*; 31 7/8 x 39 1/3 in. (81 x 100 cm.).
Chicago, The Art Institute.
*Sitting on the riverbank of the Seine at Bennecourt
is Monet's future wife Camille. Her figure is completely
integrated with the colors and textures of her surroundings.
The scene is inundated with light, filtered through the trees
on the left. Pure colors and bold brushstrokes enhance the
immediacy of this calm and idyllic scene, reminiscent of a
similar painting by Monet's friend and fellow painter Bazille.*

Hôtel Roches Noires at Trouville

1870; *oil on canvas*; 31 7/8 x 23 in. (81 x 58.5 cm.). Paris, Musée d'Orsay.
*After his marriage to Camille Doncieux on June 26, 1870, the
couple went to Trouville on the coast of Normandy. The atmos-
phere and light of the beach are rendered with luminous colors
and rapid brushstrokes. The work marks a transition period,
during which Monet overcame the monochromatic legacy of real-
ism and established the rich palette of* en-plein-air *painting.*

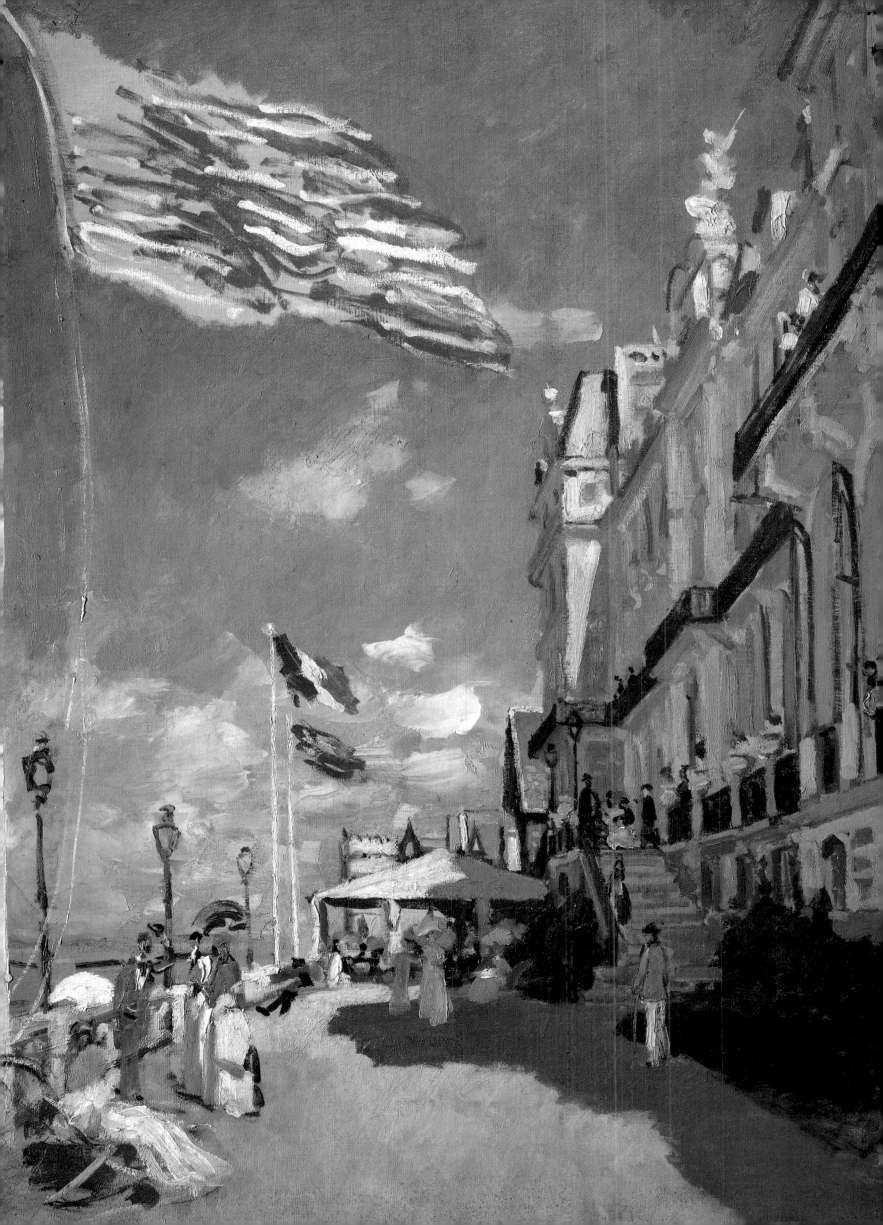

CHAPTER 2

CITY LIFE

*U*pon his return to France after the war, Monet settled at Argenteuil near Paris, which remained his main base until early 1878, interrupted only by occasional short trips to Paris and the Normandy coast. The artist became more sedate during that time and focused on life with his family.

His little son Jean appears to the left in *Luncheon in the Garden at Argenteuil* (1873), playing on the ground near a table covered with a white tablecloth and typical still-life objects such as a coffeepot, glasses, and fruit. In the background two women seem to converse, adding a further touch of intimacy to the scene. The whole painting breathes the peaceful atmosphere of a happy, self-contained world. The worldly picnickers of the *Déjeuner sur l'herbe* are left far behind.

Additional scenes of the artist's house and garden as well as other motifs in Argenteuil will be discussed in the following chapter. It might be sufficient here to point out that Monet became more and more absorbed in this new environment, which set the pace for his artistic development of the following decade.

Camille Monet in Japanese Costume

1876; oil on canvas; 91 x 56 in. (231 x 142 cm.).
Boston, Massachusetts, Museum of Fine Arts.
The model for this unusual portrait was once more Camille Monet, dressed in a sumptuous Japanese kimono adorned with the image of a samurai warrior. Monet, like many of his fellow artists, admired Japanese woodblock prints and studied the compositional methods of such works. The present painting, however, merely follows the fascination with the exotic, and the artist himself later called it "simply whimsical."

Rue Montorgeuil, Paris:
Festival of June 30, 1878
detail; 1878; Paris, Musée d'Orsay.
Monet was a patriotic Frenchman, deeply concerned about politics and France's position in the greater European context. Painting these flags, which had served as a decoration for a national holiday, was more than just a pictorial experience for the artist.

Portraits of Camille

Until Camille's untimely death in 1879, Monet painted his wife on numerous occasions. *Red Hat, Madame Monet* is a peculiar portrait, since it depicts Camille outdoors, seen through a window. The frame of the door with its white curtains also serves to frame her figure. *Madame Monet Embroidering*, is a more traditional rendering, reminiscent of Vermeer's famous *Lacemaker* in the Louvre, a work that Monet undoubtedly was familiar with, although he might not have intended any specific reference. As in other interiors, he included elements of nature such as the plants in the large blue vases, which appear also in other paintings, including *Interior of an Apartment*. These vases

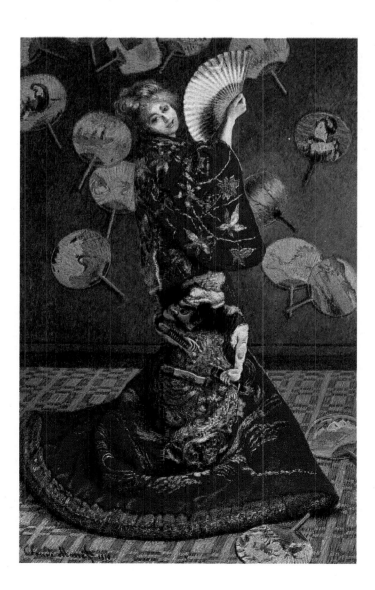

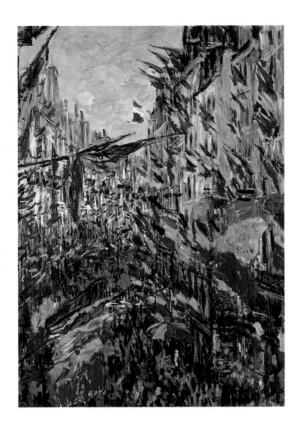

Rue Saint-Denis, June 30, 1878

1878; *oil on canvas;* 29 7/8 x 20 3/8 in. (76 x 52 cm.).

Rouen, France, Musée des Beaux-Arts.

Here, Monet depicted another view of the celebration of the World's Fair in Paris. Evoking the sensation rather than the vision of the festivities, the artist expresses the confusion of the event through the movement of the flags and a flickering light. The fair helped France to regain its emotional balance after its humiliating defeat during the Franco–Prussian War of 1870–1871.

were very dear to the artist and he took them with him every time he moved to a new place.

The splendid but unusual portrait *Camille Monet in Japanese Costume* was later called by the artist a caprice. In its explicit concentration on Japanese artifacts, it reflects Monet's deep admiration for the Japanese paintings and prints which he collected. The decoration of his home in Giverny testifies to his fondness for them. The exquisite red kimono with fish, butterflies, and birds woven into its fabric, the display of numerous fans on a wall of light blue, and the strange contrast that Camille's blond head forms with the exotic accessories made this work a great success when exhibited in 1876. It sold immediately for 2,000 francs. Monet might indeed have calculated this victory, but he never tried anything similar again, a sign that he did not consider this type of work congenial to his interests.

Parisian Influences

Although his life in Argenteuil seemed an isolated one, in actual fact it was not. His painting *Railway Bridge at Argenteuil* illustrates his situation in an almost emblematic form. Paris was only a short train ride away. Monet went there quite frequently to see potential patrons, but above all to keep abreast of the development of the works of his friends.

At the Café Guerbois and later at the Café de la Nouvelle Athènes he saw regularly the painters Manet, Cézanne, Caillebotte, and Degas as well as writers and critics, among them Émile Zola, who had become the mouthpiece of his friends in the press. It seems that Monet's almost brutal refusal to compromise in his youth had begun to wear off with the years, and he thus became an unobtrusive guest during the meetings of his friends.

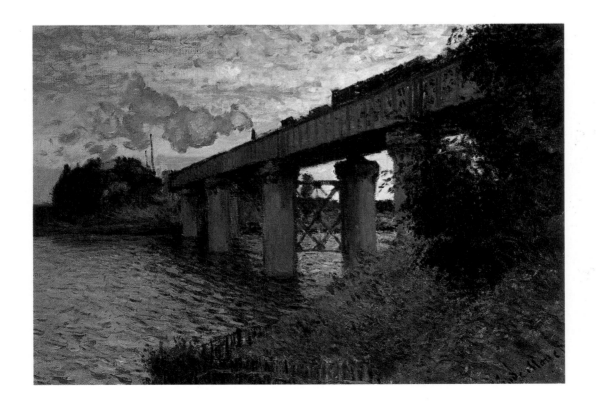

The Railway Bridge at Argenteuil

1874; *oil on canvas;* 21 2/3 x 28 1/3 in. (55 x 72 cm.). Paris, Musée d'Orsay. *Between 1871 and 1878 Monet lived in Argenteuil, which provided him with numerous favorite motifs, such as the railway bridge. He depicted trains, then still a relatively modern means of transportation, on various occasions. In fact, he frequently traveled by train on his search for new pictorial subjects.*

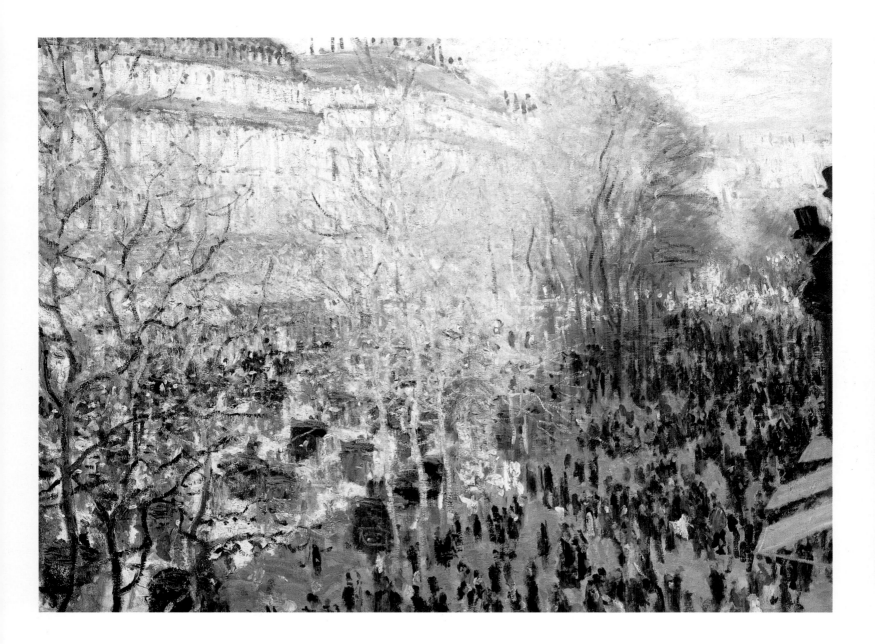

Carnival on the Boulevard des Capucines

1873; *oil on canvas*; 23 5/8 x 31 1/2 in. (60 x 80 cm.). Moscow, Pushkin Museum of Fine Arts. *The annual carnival parade was one of the most popular festivals of the year in Paris. People dressed in costumes and colorful decorated carts filled the boulevards of the city. On the right, cut off by the edge of the canvas, two gentlemen in top hats are watching the event from a balcony The figures buzzing about the street are captured with quickly painted dots of color.*

He certainly needed their companionship, and the assurance that ridicule and rejection could be endured as long as he could carry on with determination.

In 1873 Monet took up the idea he and Bazille had cherished some years earlier—that of opening a group exhibition at their own expense. The time seemed to be ripe. The despised Salon jury system had not lost its power through the introduction of "liberal" ventures such as the *Salon des Refusés*, the Salon of the rejected artists. The critic Paul Alexis wrote in an article, doubtlessly influenced by his painter friends, that "like any other corporation, the artistic corporation has much to gain by organizing its own syndicate" and by presenting independent shows. These ideas had been discussed previously at the Café Guerbois and were welcomed by Monet.

A Modern Salon

The group's intention to present their works to a larger audience became, finally, reality. From April 15 until May 15, 1874, just before the opening of the official Salon, the first exhibition of the Society of Painters, Draftsmen, Sculptors, and Engravers was held in the vacant studio of the photographer Nadar on the boulevard des Capucines, right in the heart of Paris. Twenty-nine artists took part, including Monet, Cézanne, Renoir, Pissarro, Morisot, and Monet's friend of

The Tuileries, Esquisse
1876 (dated 1875); *oil on canvas;*
19 2/3 x 29 1/8 in. (50 x 74 cm.).
Paris, Musée d'Orsay.
This sketch (esquisse) *of the*
Tuileries Gardens behind the
Louvre in Paris is a finished
work, but left in a sketchy
state. The surface is animated
throughout, with soft pink
in the sunny areas and deep
green in the shadows. To his
dealer Durand-Duel, Monet
once declared that "sometimes
I sell certain 'esquisses' a
little more cheaply, but
only to artists or friends."

his years in Le Havre, Boudin. The most conspicuous absentee was Édouard Manet.

The group exhibited a total of 165 works, of which five paintings and seven pastels were by Monet. Renoir's brother Edmond wrote the catalogue essay. Monet later explained that he had submitted for the exhibition a painting of Le Havre done from his window showing the sun appearing in damp vapors with some ship's masts in the foreground: "I was asked to give a title for the catalogue; I couldn't very well have called it a view of Le Havre. So I said: 'Put "Impression."'" If one has to take this account at face value it might be debated. However, the truth is that the painting was catalogued as *Impression–Sunrise*.

The show was originally well attended, although the majority of the public came mainly to laugh. Critics were often very harsh in their rejection of the exhibition or they ignored it altogether. On April 25, though, an article signed by Louis Leroy appeared in the *Charivari* under the title "Exhibition of the Impressionists." A fictitious dialogue between the critic and a painter friend by the name of Joseph Vincent summed up the attitude and reaction of the majority of the visitors. In it the author ridiculed and grossly distorted the intentions of the artists and their works. About Monet's contribution we read: "I glanced at Bertin's pupil [i.e. Joseph Vincent]; his countenance was turning a deep red. A catastrophe seemed to me imminent, and it was reserved for M. Monet to contribute the last straw.

" 'Ah, there he is, there he is!' he cried, in front of

No. 98. 'I recognize him, papa Vincent's favorite! What does that canvas depict? Look at the catalogue.'

" 'Impression, Sunrise.'

" 'Impression—I was certain of it. I was just telling myself that, since I was impressed, there had to be some impression in it ... and what freedom, what ease of workmanship! Wallpaper in its embryonic state is more finished than that seascape.' "

The painting in question was of course Monet's work. It thus gave the movement its name Impressionism and its practitioners were henceforth called Impressionists.

Altogether 3,500 people came to visit the exhibition. Compared to the 400,000 persons who went to see the Salon, this was a meager attendance. Many who came were motivated by curiosity rather than by serious interest in the works themselves. The group's financial report at the show's end recorded a modest loss, but for many participating artists it was more than they could bear.

The Red Hat, Mme. Monet
1873; *oil on canvas;* 39 3/8 x 31 1/2 in. (100 x 80 cm.).
Cleveland, Ohio, Museum of Art.
Camille Monet is seen standing outside a window
on the terrace of the house at Argenteuil. This
seemingly casual view is most carefully composed;
the figure is framed by the parted curtains.

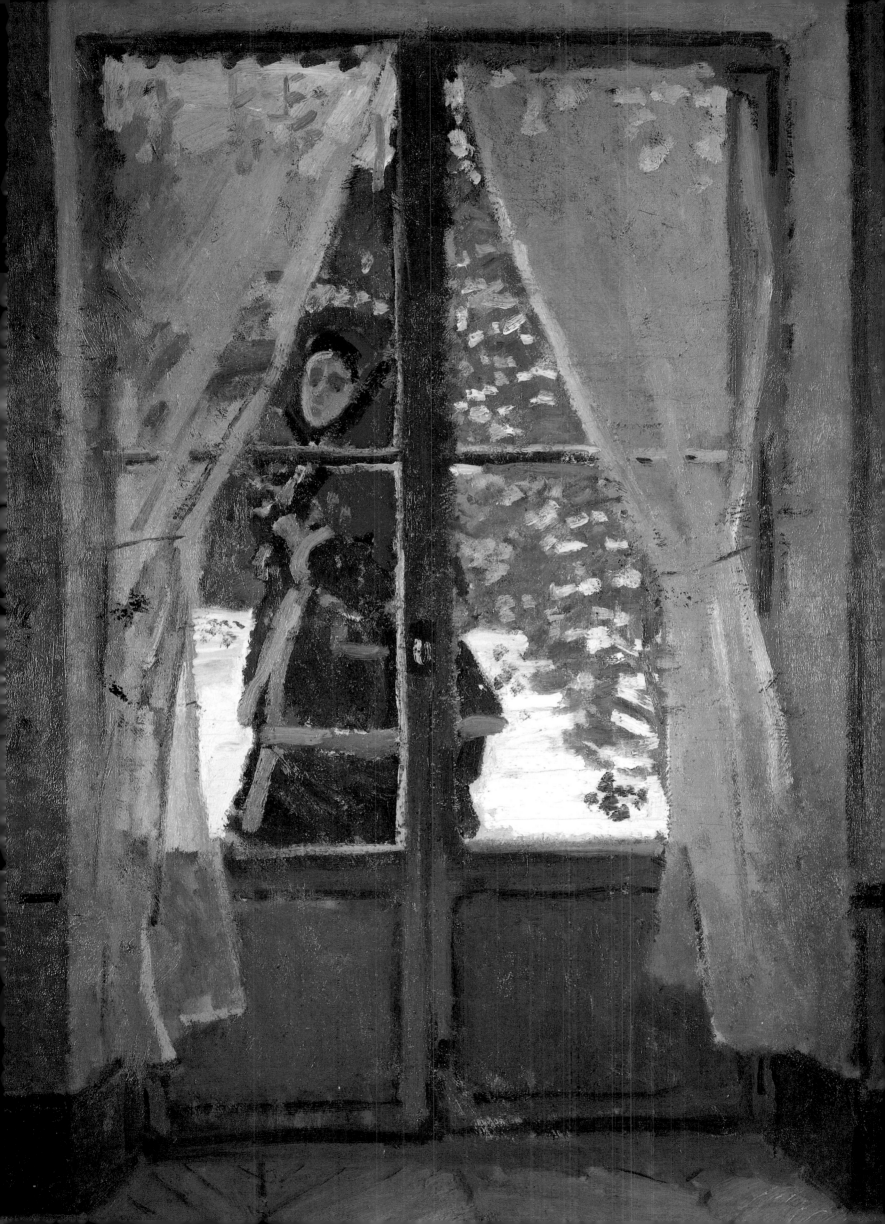

Although hardly a disaster, the exhibition had failed to initiate a dialogue with a public that was apparently totally unprepared for the new work. Only a few devoted collectors had bought some of the paintings exhibited.

Monet's Cityscapes

Although Monet's interest was focused on landscape painting, he did treat modern urban subjects, for example the annual parade in the *Carnival on the boulevard des Capucines*, one of the most popular festivals of the year in Paris. Crowds of costumed people populate the boulevard, some riding in colorful decorated carts. On the right, looking down onto the street from the balcony of a building, are two gentlemen in top hats. Their figures are cut off by the picture frame, thus providing the viewer with the sensation of immediate presence. The figures on the sidewalk, dotted with many rapid strokes, contrast with the light yellow-beige of the leafless trees shimmering in the February sun. The work was shown at the first Impressionist exhibition in 1874.

A distinctly modern subject is his work *Unloading Coal*, a depiction of working people unique in the artist's oeuvre. But his focus is less on the actual people performing their labor than on the effects of the light on an overcast day in the city. The atmosphere is rendered in soft and constantly varying nuances of color, notably yellows, yellow-greens, and blue-greens. A strong tonal dominance derives from the bridge, the barges, the figures and the gangplanks, where the workers are lined up like members of a ballet following the choreography.

The principal elements of the composition—bridge, figures, and gangplanks—are rendered with clearly defined shapes, unified by the same bluish-gray color, while the surface of the whole is treated with delicate touches of paint. The subject matter notwithstanding, the painting is treated more like a landscape than a scene of people at their hard work.

Similar observations can be made of a subject matter that fascinated Monet over many years: trains. He himself was most certainly a dedicated user of this relatively new means of transportation and he must have spent a good deal of time at stations while waiting for his trains. *The Locomotive* is an homage to the colossal engine, spitting smoke into the air during a halt at a country station. Its length is paralleled by the fence on the right and the row of leafless trees. The paint has been applied almost flat on the canvas with slight undulations. The two lights at the front of the locomotive are like the two glowing eyes of a cat in the dark.

Monet was particularly fond of the winter season and enjoyed its uniform conditions of light. Again, as in *Unloading Coal*, the modern world appears harmoniously integrated into its surroundings. The rules and rigor which dominate Monet's landscape paintings apply equally to his contemporary subject matters.

Gare Saint-Lazare

Later in 1876 Monet moved his small family to Paris for a time, taking both an apartment and a studio. What may have prompted Monet to settle again in Paris was

The Locomotive

1875; oil on canvas; 23 1/4 x 30 3/4 in. (59 x 78 cm.).
Paris, Musée Marmottan.
This is another example of Monet's fascination with locomotives and trains. The smoke from the engine is absorbed by the gray clouds of the dark winter sky. Only the two yellow lights on the front of the locomotive give some warmth. The fence and the row of leafless trees parallel the full length of the train into the distance.

Gare Saint-Lazare

detail; 1877; Paris, Musée d'Orsay.
This is a detail of the most elaborate canvas of the Gare Saint-Lazare series. Monet was fascinated by the effects created by the steam vented from the locomotives within the vast spaces of the train station. Repeated additions of paint to the surface resulted in a coarse, crusted texture.

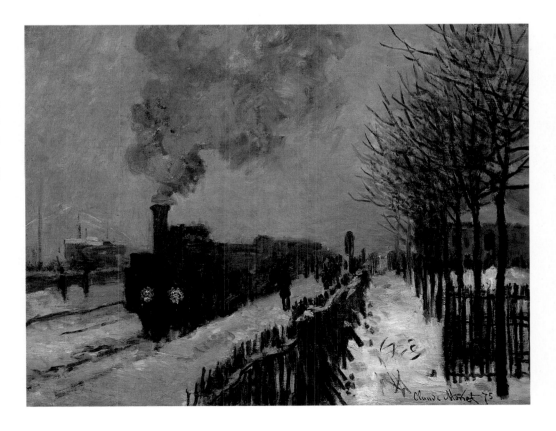

**Luncheon in
the Garden
(The Artist's Garden
at Argenteuil)**
detail; 1873;
Paris, Musée d'Orsay.
*The artist included
this still-life in a larger
composition of his garden
at Argenteuil. Carefully
painted light effects
describe the various
objects, from the tray
to the coffeepot and
glasses. The sun is
filtered through the
tree above. The period at
Argenteuil was a particu-
larly happy one for the
artist and his family.*

his attraction to the railroad station of Saint-Lazare. Setting up his easel in different corners of the station (with the permission of its director), Monet began to study this huge steel and glass structure, where trains, people on the platforms, and the opaque vapors from the engines created unusual and exciting subjects. Moving around the station, Monet explored the motif from different angles, seizing the specific character of the place and its atmosphere.

His efforts resulted in a group of canvases which is sometimes seen as a precursor to his series paintings done in the 1890s. It should be noted, however, that the Gare Saint-Lazare paintings are not variations of the very same motif.

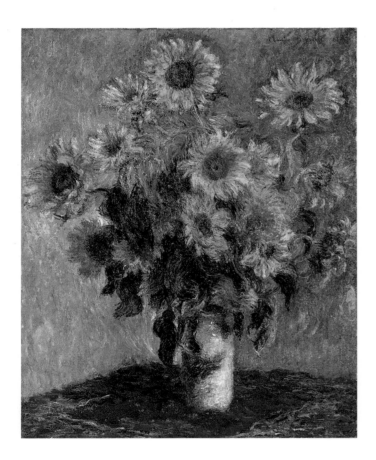

Bouquet of Sunflowers
1881; *oil on canvas;* 39 3/4 x 32 in. (101 x 81.3 cm.).
New York, Metropolitan Museum of Art.
More realistic than his poetic landscapes, Monet's still-lifes often have an expressive and decorative effect. The bright yellow petals of the sunflowers are set against a neutral background of the wall, while the table is covered with a complementary red and green tablecloth. The angle of the corner adds a sense of depth to the scene.

Gare Saint-Lazare, the Normandy Train was exhibited at the Impressionist show in 1877 and was described by Georges Rivière in the pamphlet *L'Impressioniste* of 6 April 1877, which accompanied the exhibition:

"This year Monet is giving us a number of canvases showing locomotives, either by themselves or coupled to a line of cars in the Saint-Lazare station. These paintings are amazingly varied, despite the monotony and aridity of the subject. In them more than anywhere else can be seen that skill in arrangement, that organization of the canvas, that is one of the main qualities of Monet's work. In one of the bigger paintings the train has just arrived, and the locomotive is about to leave again. Like a spirited, impatient beast stimulated rather than fatigued by the long journey it has just finished, it shakes its smoky mane that billows against the glass roof of the vast hall. Men swarm around the monster like pygmies at the feet of a giant. On the other side, locomotives not in use wait, sleeping. And, in the background, the gray sky blanketing the tall pale houses closes the horizon. We hear the shouts of the workers, the sharp whistles of the engines blasting their cry of alarm, the incessant noise of scrap-iron, and the formidable panting of the steam.

"We see the broad sweep and tumultuous movement in this train station where the ground shakes with every turn of the iron wheels. The pavements are damp with soot and the air is charged with the bitter odor of burning coal. Looking at this magnificent painting, we are gripped by the same emotion as before nature, and it is perhaps even more intense, because the painting gives us the emotion of the artist as well."

The 1877 exhibit included eight views of the Gare Saint-Lazare and must have made a strong impression in their cumulative effect. But despite the fact that these works had been hailed as a typically modern subject, which no other artist before Monet had treated, one can not ignore the fact that Monet's approach is devoid of any social engagement. The railroad station was a pretext for rendering light and atmosphere rather than a subject in itself. Monet explored the pictorial aspects of the machinery superbly but did not comment on the essence of its physical being and its relationship to man. In other words, it is the scene's aesthetic quality which fascinated the painter, not its material existence.

In the Gare Saint-Lazare paintings, Monet painted the principal puffs of smoke directly onto the priming of the canvas in order to increase the luminosity of the forms. This proves how carefully calculated even the most transient effects were, as Monet could have done this only with a precise idea of the paintings' concept already in mind. Curiously, in his later London series many areas of smoke were added as an afterthought over the darker paint underneath.

In the loosely finished *Pont de l'Europe*, the engine on the left and parts of the smoke are animated by bold curls of paint, but it is hard to differentiate the figures from the forms around them. The highly finished *Gare Saint-Lazare"* summarizes Monet's efforts. It was again Georges Rivière who perfectly described the painting in the same edition of *L'Impressioniste*, which accompanied the 1877 exhibit:

"[This painting] shows the arrival of a train in full sunlight. It is a joyous, lively canvas. People hurriedly get down from the cars, smoke puffs off into the background and rises upward, and the sunlight, passing though the windows, gilds the gravel on the tracks as well as the trains. In some paintings, the irresistible, fast trains enveloped in light rings of smoke are engulfed in the platforms. In others, huge locomotives, immobile and widely scattered, await their moment of departure. In all of them, the same power animates these objects that Monet alone could render."

Two canvases of the Tuileries Gardens were featured at the same show. Their presence together was exceptional in so far as one of them was subtitled *esquisse* (sketch), although the latter was not directly related to the former. Occasionally, Monet considered some of his less completed works to be good enough to be given away to his artist friends or even for sale to collectors who could appreciate their loosely painted character. In the case of *View over the Tuileries Gardens, Esquisse*, it was in fact Gustave Caillebotte who purchased the work at the show.

Political Upheaval

The national celebration of the World's Fair in 1878 prompted at least two paintings. *Rue Montorgeuil, Paris: Festival of June 30, 1878* and *Rue Saint-Denis, June 30, 1878* are two patriotic statements about France and an affirmation about its regaining powers.

After the defeat in the Franco-Prussian War in 1870-1871 France had undergone an identity crisis. People were wondering about the country's future and its role in Europe; it had lost its political leadership to the much smaller Prussian state under Bismarck, who had even dared to proclaim the new German Reich in the Hall of Mirrors at Versailles, symbol of a triumphant French history. France's history, wealth, and culture needed to be reestablished, or so at least all good French patriots thought.

The country underwent several political crises during the last two decades of the century, of which the heinous Dreyfus affair, which virtually tore the country apart, was the most conspicuous. Monet defended Dreyfus and supported Zola's campaign for his liberation, while his friend Renoir was in the other camp. Surprisingly,

Unloading Coal

1875; oil on canvas; 21 2/3 x 26 in. (55 x 66 cm.). Private Collection. Workers are unloading coal from barges on the Seine river near a bridge at Clichy, between Argenteuil and Paris. The lines of the gangplanks combine with the figures to create an animated pattern in this somber atmosphere. This decidedly modern painting is perhaps Monet's most uncompromising depiction of an industrial subject. It was shown together with his paintings of the Gare Saint-Lazare at the third Impressionist group show in 1877.

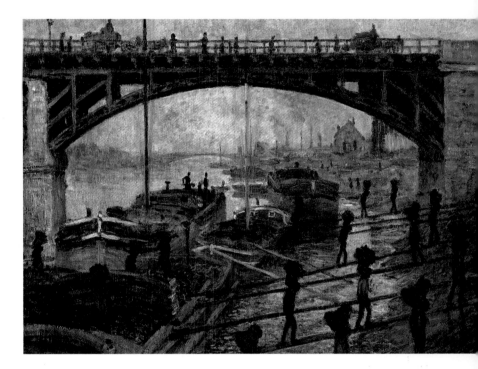

though, these differences did not seem to have any major consequences, as both artists continued to see each other and admire the other's work.

Still-Life Paintings and Portraits

During the late 1870s Monet's financial situation was a reflection of the country's difficult economic situation. In order to better his meager income, he began to paint more still-lifes, which could be sold more easily and at higher prices than his landscapes. Between 1878 and 1882 he executed by far the largest group of still-lifes of his career. *Vase with Chrysanthemums*, *Apples and Grapes*, and *Vase with Sunflowers* were all painted during those years. Although these works were not essential to Monet's artistic development, they served him well as an occupation for days when the weather prevented him from working out-of-doors.

Occasionally, Monet continued to paint small portraits of family or friends. In 1882 Monet went twice to Pourville near Dieppe in Normandy where he painted the portrait of Paul, the local pastry chef, whose roughly hewn face is framed by the white jacket and the hat of his professional

outfit *(The Cook)*. Monet seemed to have rated this portrait highly enough to include it in his important one-man show in 1883 at the Durand-Ruel gallery alongside his landscapes. The curious *The Cakes (Les Galettes)* is also an homage to this friend, who most likely satisfied Monet's refined taste for good food.

In 1886 the painter embarked on a new path, which ultimately remained an unresolved period of experimentation: the problem of "figures treated like landscape," as the artist himself described it. Few of these paintings were signed and dated at the time of their execution, thus suggesting that he did not consider them to be fully resolved.

Woman with Parasol Turned toward the Left and *Woman with Parasol Turned toward the Right* are both based on an earlier work showing Camille and his son Jean on a bank. The canvases served apparently as studies for his research, which he described once to a critic: "I'm working as never before, at some new experiments, figures in the open air as I understand them, treated like landscapes. It's an old dream, that constantly plagues me and which I want to realize once and for all; but it's difficult!" Above all, he was taking up the challenge posed by Seurat's *Afternoon at la Grande Jatte*.

By 1890 Monet's attention returned to landscapes, which had always been his main source of inspiration.

The Cakes (Les Galettes)
1882; *oil on canvas;* 25 58 x 32 in.
(65 x 81 cm.). Private Collection.
This rare still-life of cakes, painted during Monet's stay at Pourville, is an homage to the man who made them.

Woman Seated on a Bench
1874; *oil on canvas;* 29 x 22 in. (73.7 x 55.9 cm.). London, Tate Gallery.
The scene has been handled in an exceptionally free style and might reflect the influence of Édouard Manet, with whom Monet was painting during the summer of 1874 in Argenteuil. By all accounts, the woman is not the artist's wife Camille but an unknown model.

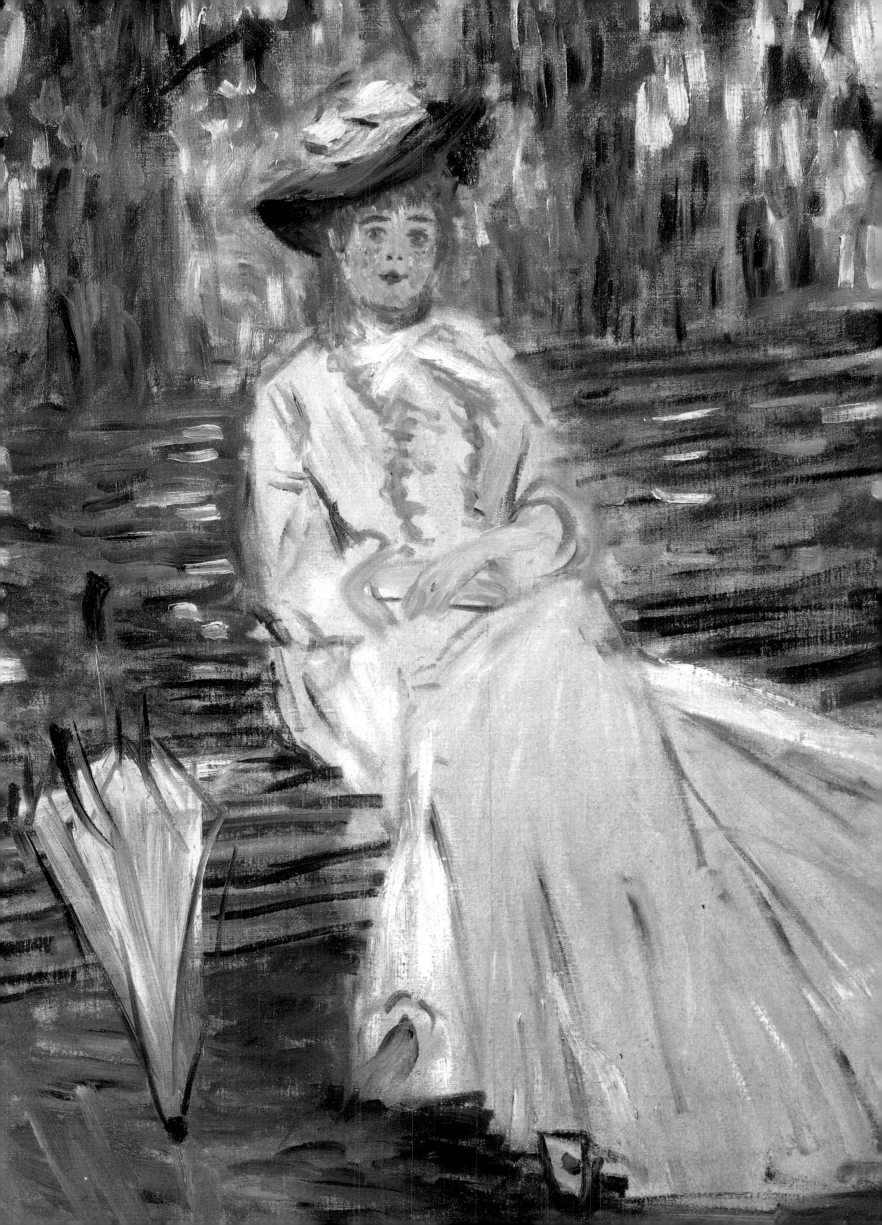

The Thames below Westminster

1871; *oil on canvas*; 18 1/2 x 28 3/4 in. (47 x 73 cm.). London, National Gallery.
During the Franco-Prussian War of 1870–1871, Monet took refuge in London in order to
avoid the military draft. There he painted views of the city, in particular the scenic vistas
across the Thames with the Houses of Parliament in the distance. Very light gray priming,
which shows through the thin layers of paint, has preserved the luminosity of the sky.

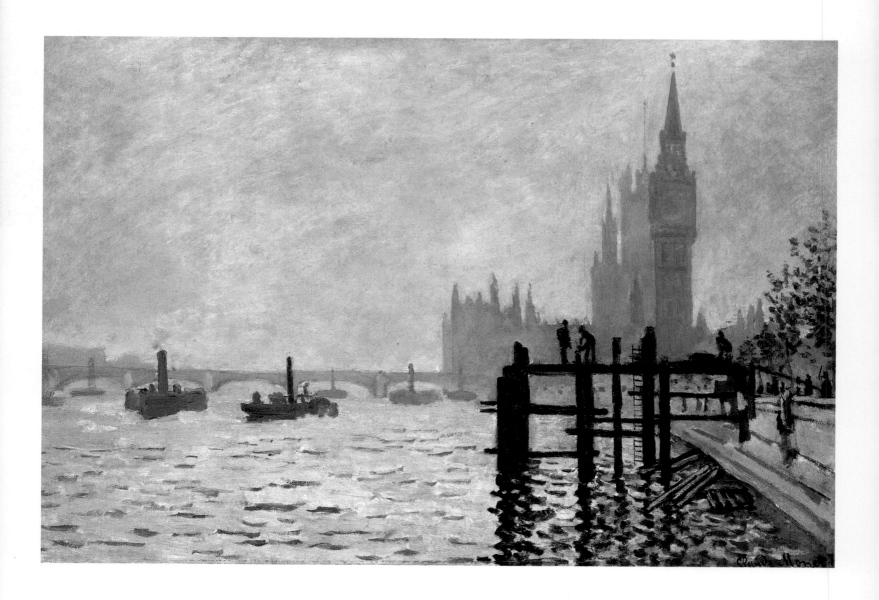

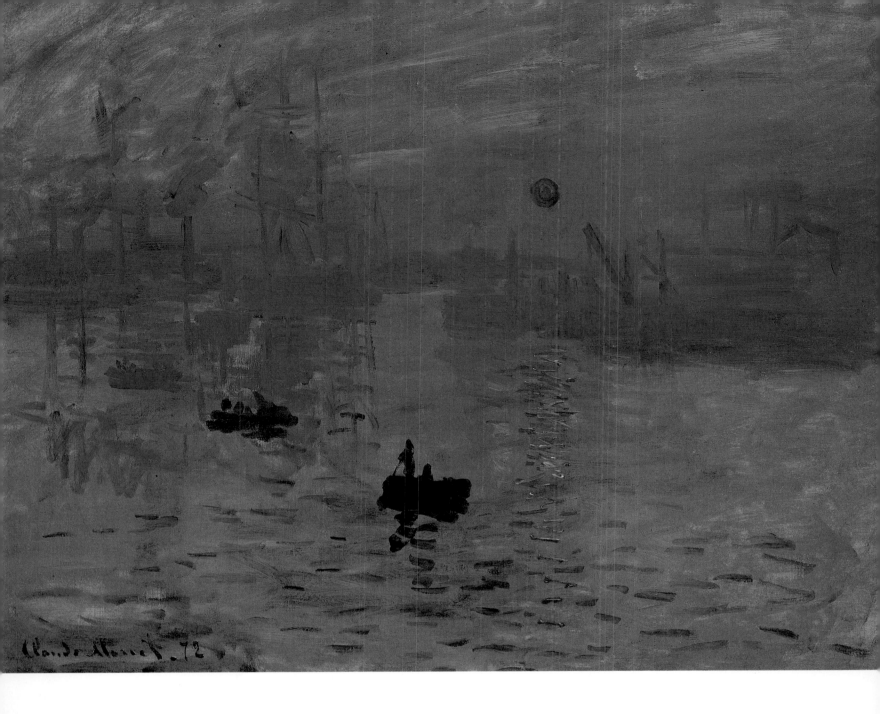

Impression—Sunrise

1872; *oil on canvas;* 18 7/8 x 24 3/4 in. (48 x 63 cm.). Paris, Musée Marmottan.

When this painting was shown in 1874, at the first independent exhibition of the future Impressionists, Monet's title for it lent the new movement its name, after a critic ironically labeled the artists "Impressionists" while discussing this picture. An early morning hour in the haze of the Le Havre harbor was the inspiration for this poetic scene.

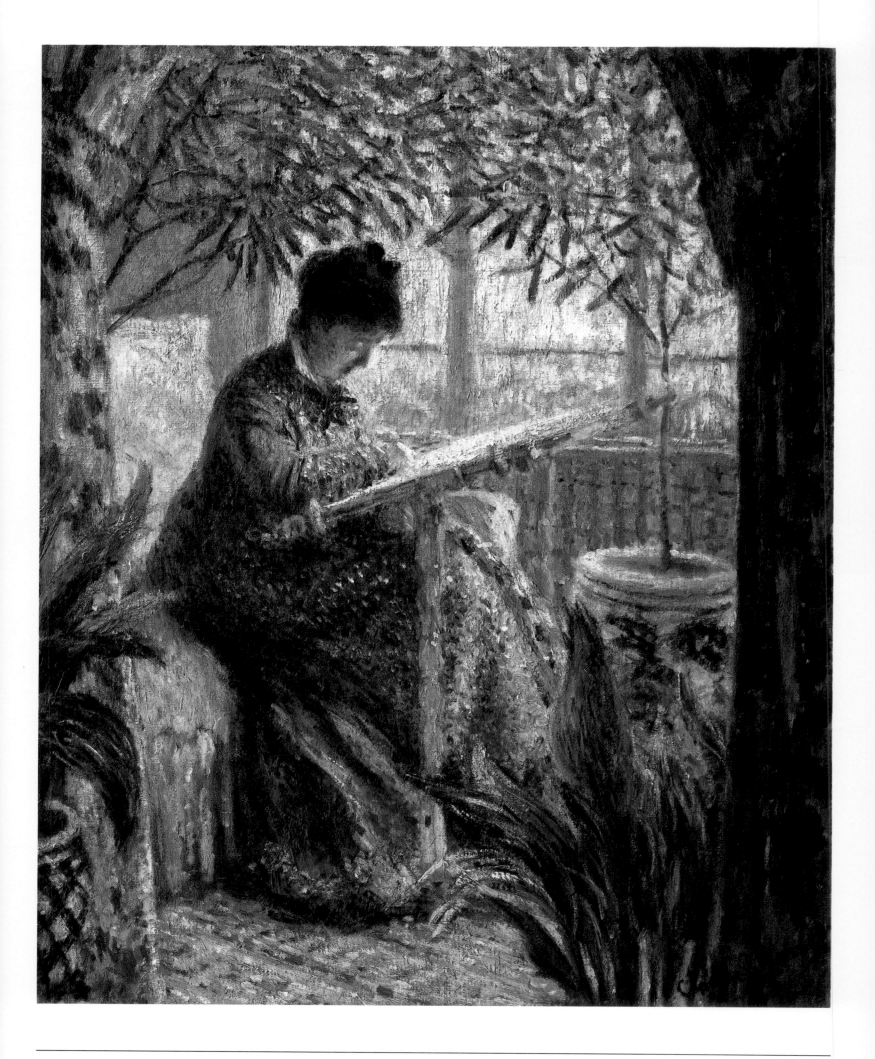

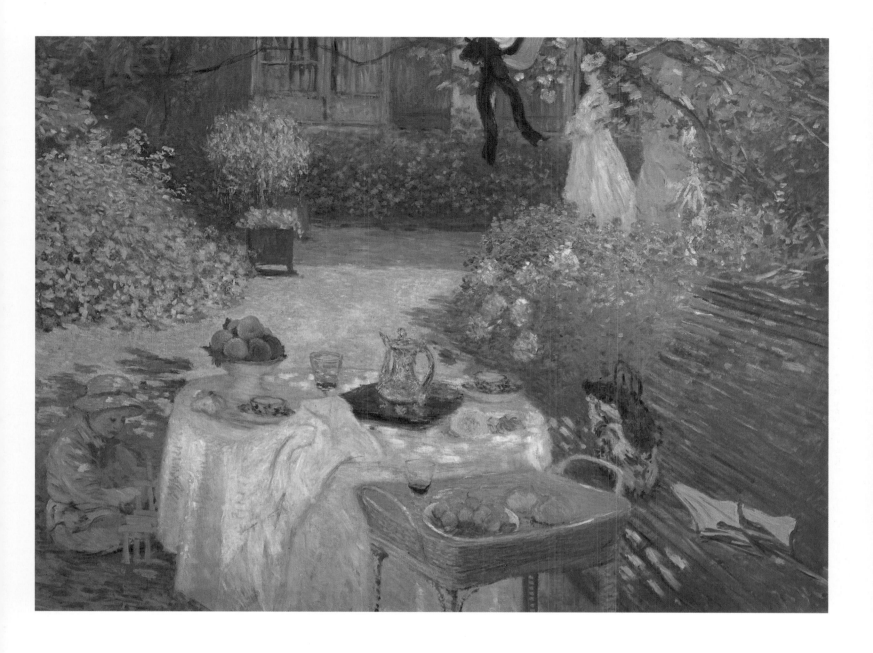

Luncheon in the Garden (Monet's Garden at Argenteuil)
1873; *oil on canvas;* 63 x 79 1/8 in. (160 x 201 cm.). Paris, Musée d'Orsay.
This combination of a still-life painting and an outdoor scene reflects
the artist's sense of intimacy with his own house. Next to the table,
Monet's son, Jean, plays with some toys. One of the two women in the
background is most likely his wife Camille. However, the main focus
of the work is the rendering of the atmosphere of a garden in bloom.

Madame Monet Embroidering
1875; *oil on canvas;* 25 5/8 x 21 5/8 in. (65 x 55 cm.).
Merion, Pennsylvania, The Barnes Foundation.
Camille Monet is sitting near a window, bent over
a table with her embroidery. She is surrounded by
plants in large terra-cotta vases, which appear also
in other paintings. The subject might have appealed
to Monet because of its analogy to painting, but
certainly also because of its homey atmosphere.

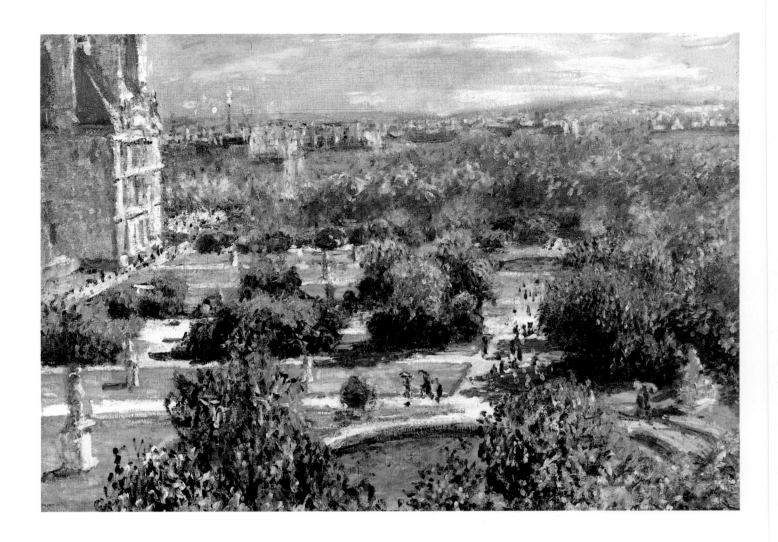

View over the Tuileries Gardens
1876; *oil on canvas;* 20 7/8 x 28 1/4 in. (53 x 72 cm.). Paris, Musée Marmottan.
The view is taken from a window overlooking the park of the
Tuileries adjacent to the Louvre in Paris. The angle is carefully chosen;
the left margin is framed by the Pavillon de Flore at the end of the
south wing of the Louvre, while the ruins of the Tuileries Palace,
burned under the Commune in 1871, are excluded.

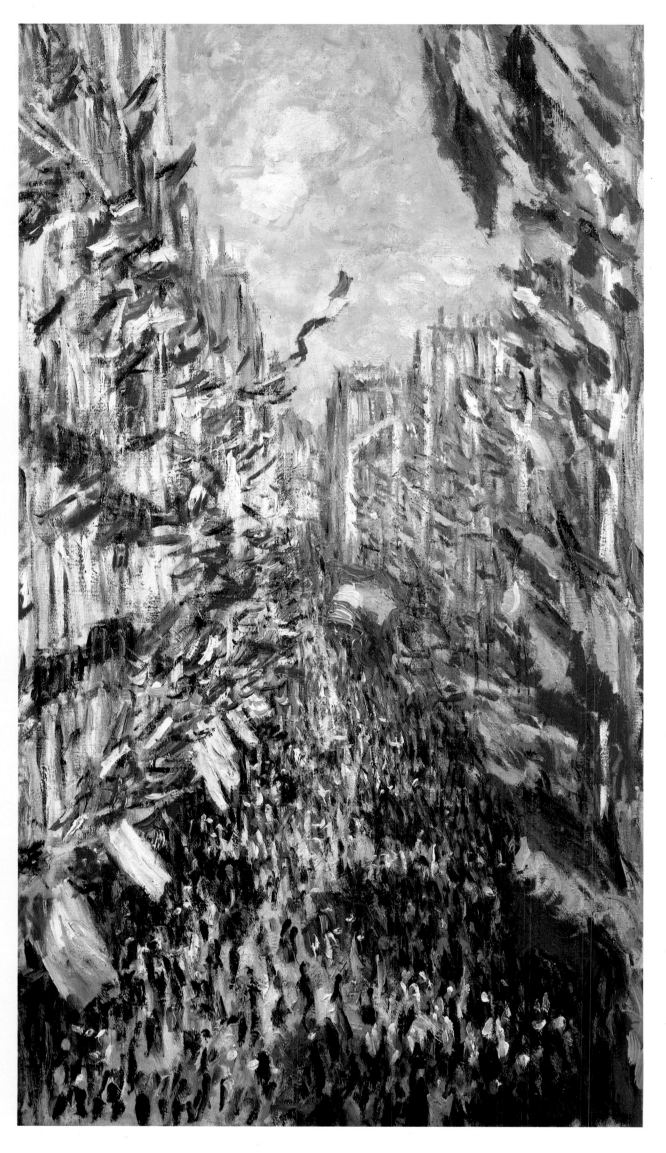

Rue Montorgeuil, Paris: Festival of June 30, 1878

1878; oil on canvas; 31 7/8 x 20 in. (81 x 50.5 cm.). Paris, Musée d'Orsay.

Until 1878, Monet's subject retained an explicitly contemporary flavor. He painted this street scene in Paris during a national holiday which celebrated the success of the World's Fair held that year, fusing houses and flags into a series of verticals and horizontals. Rapid strokes of black, gray, and white represent individual figures on the street, which become almost indistinguishable in the flurry of light effects.

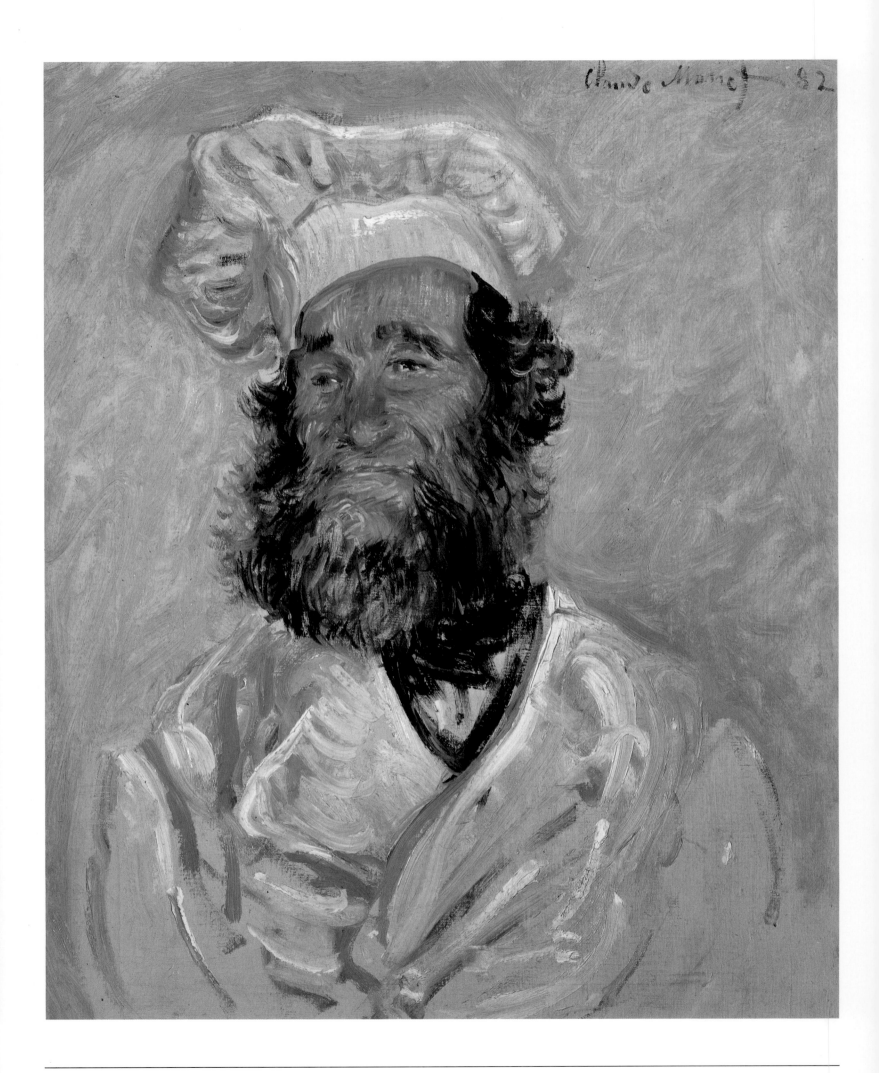

Still-Life with Pumpkin

1876; *oil on canvas;* 21 7/8 x 28 3/4 in.
(53 x 73 cm.). Lisbon, Portugal,
Calouste Gulbenkian Museum.
This splendid still-life is characterized
by its lack of perspective and its focus
on a two-dimensional space. The plate,
leaning against the wall and decorated
with a pattern of foliage, responds
to the surface of the pumpkin, cut
into slices for immediate consumption.
Peaches and grapes offer a different
experience of surface texture.

Vase with Chrysanthemums

1878; *oil on canvas;* 21 1/2 x 25 5/8 in.
(54.5 x 65 cm.). Paris, Musée d'Orsay.
Still-lifes played only a minor role in
Monet's painting. Between 1876 and
1880, however, he returned repeatedly
to this subject, since they sold more
easily and for higher prices than his
landscapes. Loosely arranged in a
terra-cotta vase, the white chrysanthe-
mums contrast with the colorful
flower bouquets of the wallpaper.

The Cook

1882; *oil on canvas;* 25 1/8 x 20 in.
(64 x 51 cm.). Vienna, Austria,
Kunsthistorisches Museum.
During his stay at Pourville on the
coast of Normandy, Monet painted
this portrait of the pastry chef Paul,
a man with an expressive face. The
artist himself apparently considered
it a successful work and loaned it
for his exhibition at the gallery of
Durand-Ruel in March 1883.

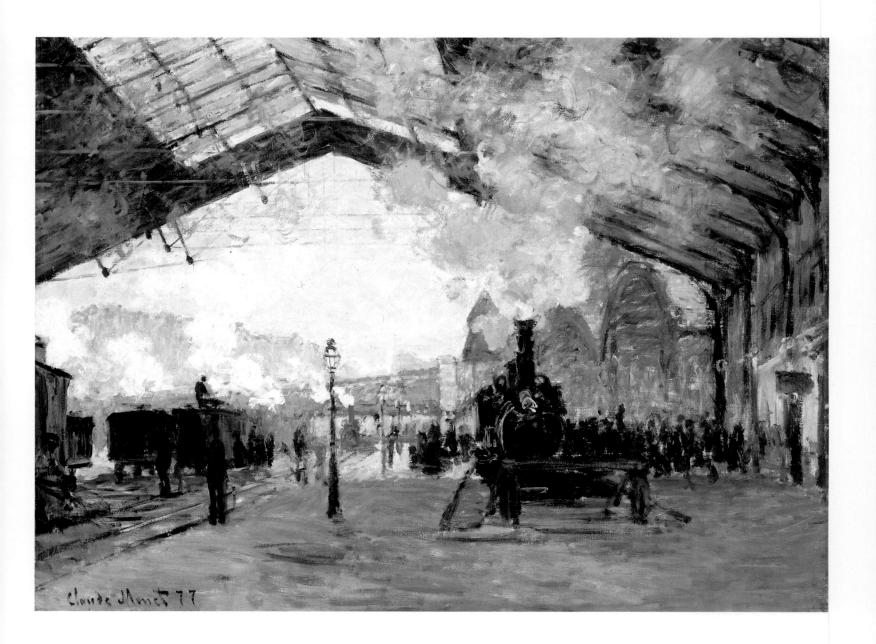

Arrival of the Normandy Train, Saint-Lazare Station
1877; oil on canvas; 23 1/2 x 31 1/2 in. (59.6 x 80.2 cm.). Chicago, The Art Institute.
The train has just arrived in the station of the Gare Saint-Lazare and fills the
space with smoke and steam while figures swarm on the platform. This work
was first owned by Monet's friend and patron Ernest Hoschedé and was
shown at the third Impressionist exhibition in 1877.

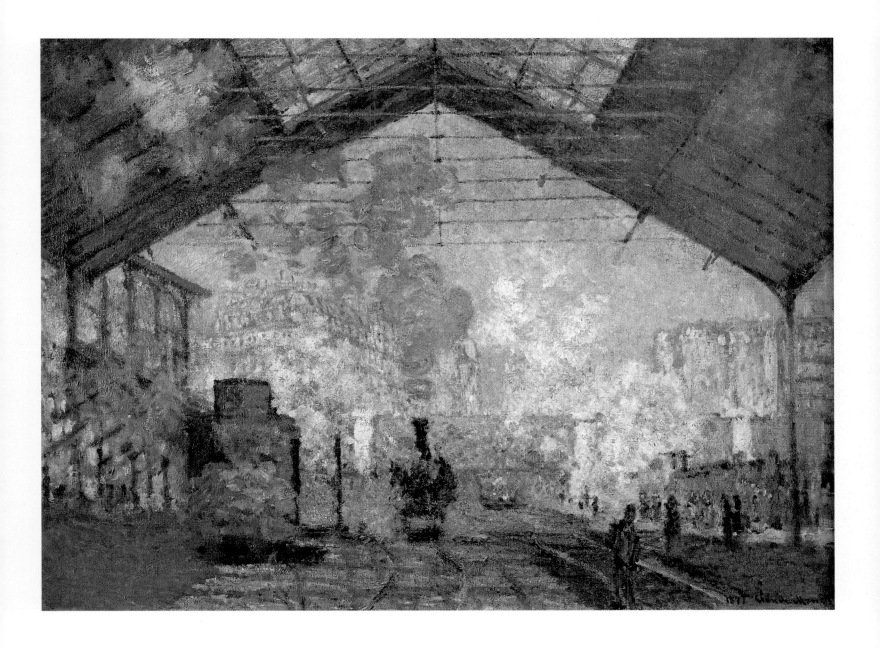

Gare Saint-Lazare
1877; *oil on canvas*; 29 3/4 x 41 in. (75.5 x 104 cm.). Paris, Musée d'Orsay.
The paintings of the Gare Saint-Lazare were Monet's last major group to
include contemporary life of the city. He would rise early in the morning to
study the atmosphere of the train station, filled with the steam of the
arriving engines. This is the most elaborate version of the entire series.

**The Pont de l'Europe,
Gare Saint-Lazare**
1877; *oil on canvas; 25 1/4 x
31 7/8 in. (64 x 80 cm.).*
Paris, Musée Marmottan.
*This is a view from just
outside the Gare Saint-
Lazare where the tracks
are spanned by the Pont
de l'Europe. Steam from
the engines is filling the
early morning air of the
city, waking up under an
overcast sky. Grays, blues,
and black are the dominant
colors. A red signal lamp
and the bricks of the chimneys
are the only bright colors.*

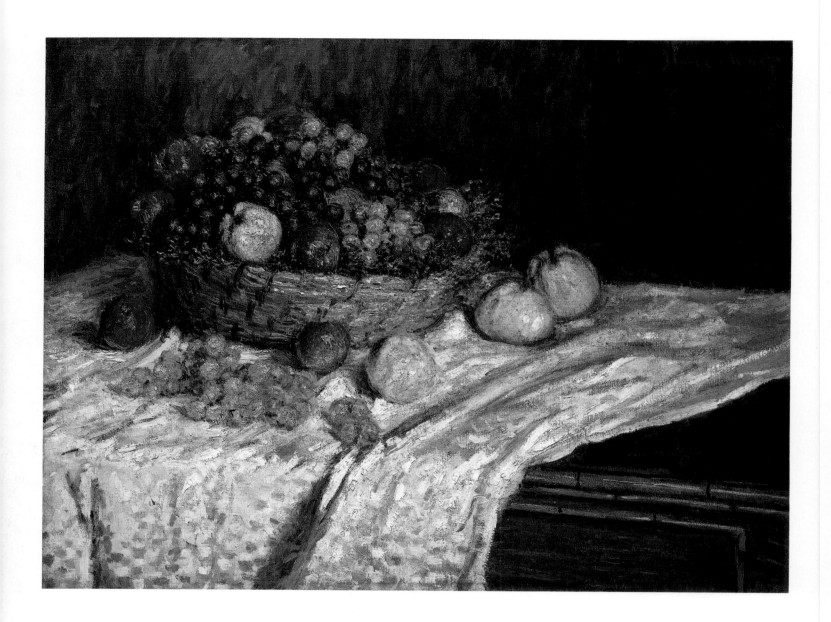

Apples and Grapes

1879–1880; *oil on canvas*; 26 5/8 x 35 1/4 in. (67.6 x 89.5 cm.).
New York, Metropolitan Museum of Art.
At the end of the 1870s, after Camille's death, Monet
was in dire financial straits. In order to raise money for
himself and for the family of Alice Hoschedé, he painted
a number of comparatively sober still-lifes, which could
be more easily sold than his landscapes. Although
elaborately executed, these works are full of life and charm.

Camille Monet on her Deathbed

1879; *oil on canvas*; 35 1/2 x 26 3/4 in. (90 x 68 cm.).
Paris, Musée d'Orsay.
Camille Monet died after a short illness on September
5, 1879. To his friend Georges Clemenceau, Monet
later confided that he had painted his wife on her
deathbed while watching the colors of death slowly
alter her appearance. To his distress, he had responded
more to the pictorial challenge than to his own
emotions. The almost symbolist spirituality is a striking
divergence from Monet's usually sun-drenched world

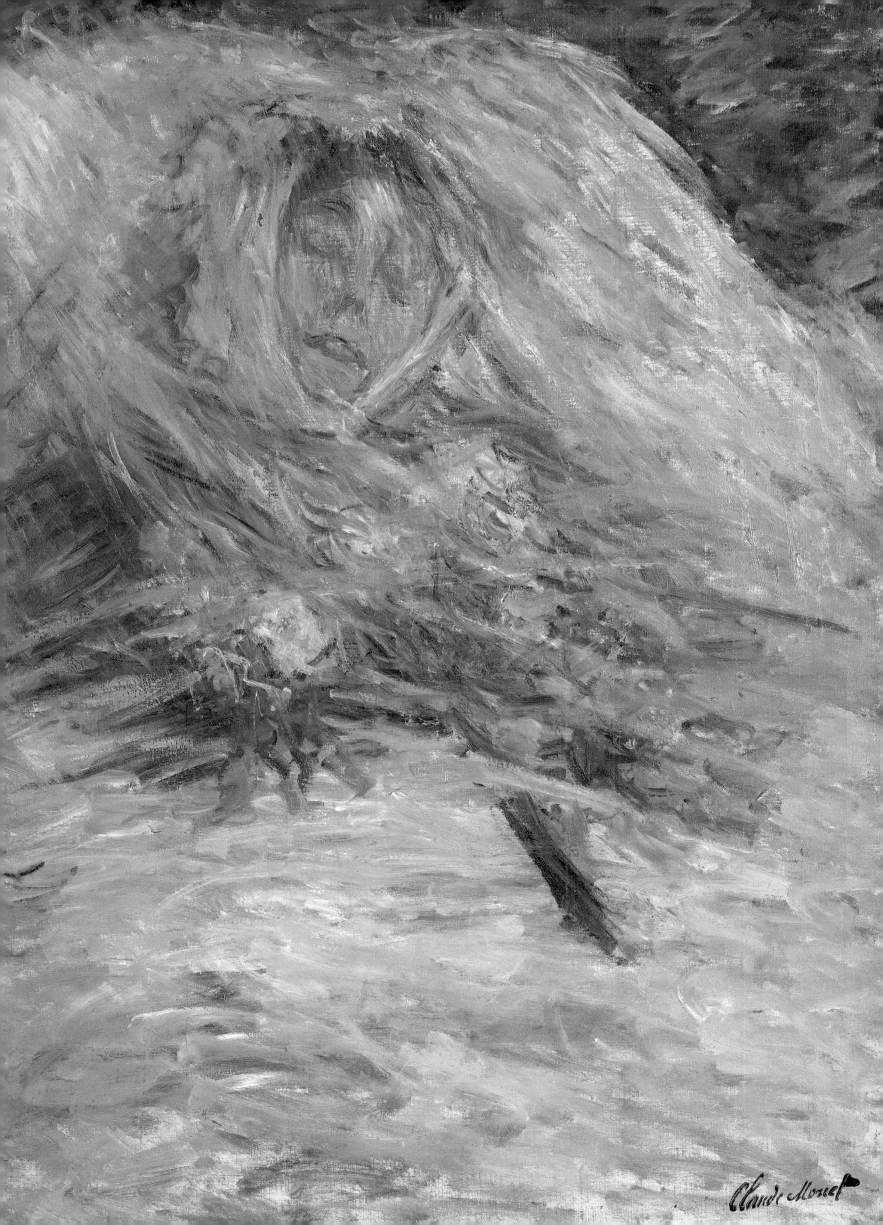

Woman with Parasol Turned toward the Left

1886; *oil on canvas;*
51 1/2 x 34 5/8 in.
(131 x 88 cm.).
Paris, Musée d'Orsay.
Observed from a low angle, the woman is taking a walk, probably on the coast of Normandy. She is protecting herself from the bright sunlight with a parasol, while a light breeze is blowing, as indicated by her veil and the movement of the grass. In a variant, the same woman is turned toward the right.

Woman with Parasol Turned toward the Right

1886; *oil on canvas*; 51 l/2 x 34 5/8 in. (131 x 88 cm.). Paris, Musée d'Orsay. *During the late 1880s, Monet again allowed more figures into his paintings, perhaps under the influence of his friend Renoir. Monet, however, treated his figures the same way as their surroundings, integrating them into the landscape. This painting as well as its pendant, "Woman with Parasol Turned toward the Left," was inspired by an earlier rendering of Camille and Jean on a riverbank.*

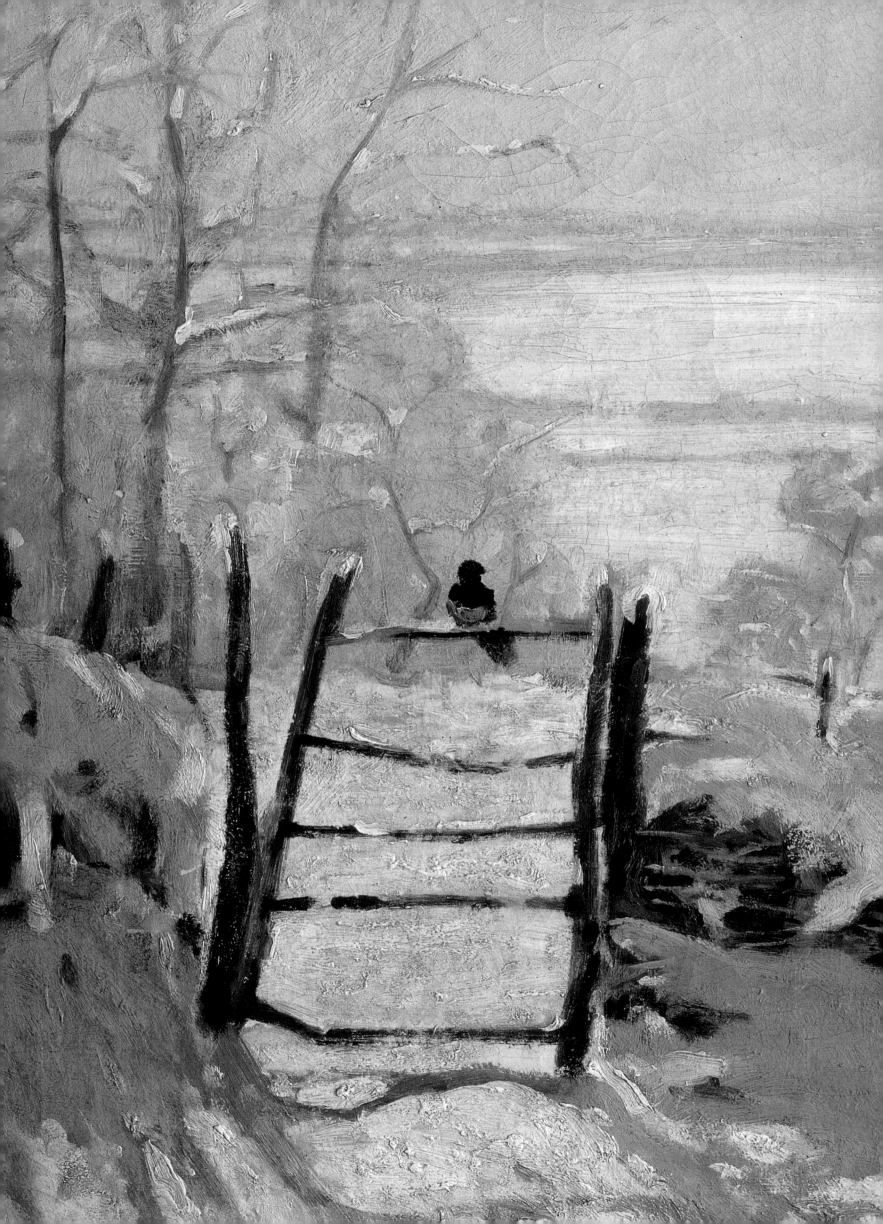

CHAPTER 3

NATURE

Monet was in his element when surrounded by nature. In his youth, he would climb for hours on the rocks along the coast near Le Havre, and after Boudin and Jongkind had introduced him to landscape painting, he immersed himself in the genre, which remained his lifelong passion.

It was rarely the specific topographical location as such that interested him. He in fact detested artists who, like some of those he encountered at Bordighera on the Mediterranean coast, suggested to him "beautiful" spots, attractive to tourists and visitors, for his paintings. Monet preferred to explore nature rather than landscapes, and the atmospheric conditions of sun, rain, fog, and wind are the most vital subjects of his works. He liked virtually any season, but had a preference for the cold winter months, one of his most brilliant renderings being *The Magpie*, painted at Argenteuil.

Man and Nature

In his work before 1880, nature was still very much characterized by the presence of man, as in *The Terrace at*

Sainte-Adresse or even later in his paintings from Etretat and Argenteuil. Émile Zola remarked about Monet's early country scenes: "Nature seems to lose some of its interest for him when it does not bear the imprint of our customs." This modern aspect was also pointed out by Boudin, who wrote to his dealer of his own fashionable Trouville beach scenes. "The peasants have their favored painters . . . but the bourgeois who walk on the jetty toward the sunset, don't they have the right to be fixed on canvas, to be brought out into the light?" This was exactly Monet's position during the 1860s and 1870s, but during the following decade his attention focused on the unspoiled, raw side of nature.

On the Water at Argenteuil

When Monet moved to Argenteuil in 1871, he found a place in a state of transition: an agricultural village with invading factories which was also home to bourgeois Parisian society's favorite recreational harbor. In some of his paintings from that period, he deliberately stressed this diversity. *The Dock at Argenteuil* of c. 1872 shows

The Dock at Argenteuil

1872; *oil on canvas, 23 5/8 x 31 1/4 in. (60 x 80.5 cm.).Paris, Musée d'Orsay. Between 1871 and 1878, Monet lived mostly in Argenteuil, about fifty miles west of Paris on the Seine river. There he found an abundance of motifs for his paintings, such as this view of the river basin framed by an avenue of trees, under which Parisians liked to stroll on their Sunday excursions to the country.*

The Magpie

detail; 1872;. Paris, Musée d'Orsay. *Monet had a preference for the cold winter months. Indeed, many of his landscapes are winter scenes or were painted in the pale light and the haze characteristic of the season. Here he caught the effect of snow during a bright, sunny winter day with delicate brushstrokes of different hues of white.*

weekenders strolling along the promenade watching others arriving or departing in their small boats.

But for the most part Monet focused on a single aspect of the place: the harbor and docks with boats calmly floating on the water or his lavish garden. *Boats and Bridge at Argenteuil* and *Boats on the Seine at Argenteuil* are idyllic settings untainted by industrialization. To that end Monet even deliberately omitted factory chimneys. He also began to subordinate separate items to the overall effect of the scene, to the play of textures and colors which gave the pictures their coherence. As a result, any kind of contemporary or social observation is played down. A famous example of this type is the *Field of Poppies* which shows Camille walking with Jean through a field of high grass and red poppies strewn like tapestry across the surface. Except for the two figure groups, which most likely represent the same people, there is no other intrusion into this peaceful natural setting.

In 1873, after a lucrative sale had provided him with some extra money, Monet had a studio-boat constructed, which was even large enough for him to sleep in there. It was probably inspired by the example of Charles François Daubigny, who had launched his floating atelier in 1857 in order to paint riverscapes along the Seine and the Oise. Monet, who was an early riser, liked to observe "the effects of light from one twilight to the next" and often spent the mornings outdoors painting. In *The Boat*

Studio he depicted himself working in the grayish-blue light of the dusk.

Monet, Manet, and Renoir

The summer after the first Impressionist exhibition (1874), Monet, Renoir, and Manet all painted together at Argenteuil. Monet again had trouble with his landlord; through Manet, he found a new house there. Renoir was once more at Monet's side, painting the same motifs as he did five years earlier at La Grenouillère, while Manet spent several weeks at Gennevilliers on the bank of the Seine river opposite Argenteuil.

It was only that summer, when he watched Monet paint, that Manet finally believed in out-of-doors painting. His palette became brighter and he adopted smaller brushstrokes, and both he and Renoir painted Camille and Jean in Monet's garden. During the summer of 1874 Manet painted Monet and Camille on the studio-boat. Later, Monet made trips with his boat, once taking his family all the way down the Seine to Rouen.

In Monet's own paintings at Argenteuil, the colors became brighter, as one can see in *Resting Under the Lilacs*, but clearly even more so in *Monet's House at Argenteuil*, where highly colored flower masses are organized around the open foreground of the path. The effect is based on the full range of pure high colors; shadows are only slightly indicated by a softly nuanced blue. The two figures, Camille and Jean, are treated in an unconventional parental relationship that allows for physical as well as emotional independence.

A similar explosion of colors was achieved with *Gladioli*. The figure of Camille is treated with the same restless web of color patches as the petals of the flowers. The mobile handling of the brush leaves no point of repose in the subject, a technique that served to unify the scene and to emphasize the play of light across the canvas. Monet's touch is differentiated, in order to suggest the varied natural textures, but the overall effect is pulsating and seemingly weightless like the butterflies fluttering among the flowers.

A Move to Vétheuil

In August of 1878 the Monet family moved together with the family of his patron Ernest Hoschedé, who was bankrupt, to Vétheuil, about fifty miles from Paris. This move to a nearly untouched rural area changed Monet's vision of nature, and from that time on he avoided most references to contemporary elements in his landscapes.

One year earlier, when Hoschedé's business was still successful, he had commissioned from Monet paintings to decorate his château at Montgeron. One of these panels was *The Turkeys: Château Rottembourg, Montgeron*. The artist contrasted the white feathers of

Resting Under the Lilacs

1872; oil on canvas; 19 3/4 x 25 1/2 in. (50 x 65 cm.). Paris, Musée d'Orsay. Three people, two women and a man wearing a black hat, are sitting on the grass under a lilac tree in bloom. The work illustrates the Impressionist technique of making sunlit colors appear paler. The lilac petals are rendered with large, vigorous brushstrokes of thin paint.

the birds, which were kept on the mansion's grounds, with the intense green of the meadows. It is an image of a strangely self-contained world among these animals.

The relationship between the Monet and Hoschedé households was unusually intense. The initial reasons for their move to Vétheuil were largely of a practical nature as the joint families needed to find a cheap and secluded home. The village—an archetype of rural France—provided the painter with a fresh abundance of motifs. During his two-year stay, he explored the villages and riverbanks around their home from all points of view and in all seasons. *The Banks of the Seine near Vétheuil* appears to have been painted in spring or early summer, while *Sunset on the Seine at Lavacourt*, a view of a nearby hamlet, is a winter scene. This last canvas, which Monet considered "too much to my personal taste" to be accepted by the Salon jury, shows a strong similarity to his earlier *Impression—Sunrise*.

Monet rarely had to move further than a couple of hundred yards from home to find his subjects. The village, framed by hills, is dominated to this day by its church, a motif which Monet naturally exploited in *Church in Vétheuil under Snow*. On other occasions he

Field of Poppies

detail; 1873; Paris, Musée d'Orsay.
The red color dots of the poppy flowers are strewn over the canvas like the decoration of a tapestry The surface has been treated with even strokes of paint, thus heightening this effect. Poppies were one of Monet's favorite subjects during his years at Giverny.

painted his family in their own garden (*The Artist's Garden at Vétheuil*).

To Théodore Duret, a journalist and politician, he wrote in 1880 that he was becoming "more and more peasant-like," although it should be noted that Monet's paintings from that period are completely devoid of any reference to farming and peasant experience. His remark was a constructed image of the rural countryside as a retreat from the bustling life of the city. But the notion that the weather and the seasons dictate the rhythms of life was to become the focus of his art for the rest of his career.

Changes and Renewal

The winter following Camille's death, which occurred in September 1879, was extremely harsh and froze the

Seine river completely. But toward the end of that year a sudden thaw created spectacular scenes of ice blocks floating on the water. This effect lasted only a few days during which Monet, looking down from the bank onto the river, made as many sketches as possible. A whole group of canvases of this subject followed, executed in the studio. Monet modestly announced his paintings to the collector de Bellio in a letter of January 1880: "We have had a dreadful thaw here, and naturally I have tried to make something of it." In *Landscape with Melting Snow* the ice blocks float serenely in the soft light of the afternoon sun.

Financial independence and the freedom of his relationship with Alice Hoschedé, whose husband had begun to live a bachelor's life in Paris, allowed Monet to travel across the country from north to south during the 1880s. It was usually on his travels that he found his most dramatic subjects, particularly on the coast of Normandy and Brittany. Away from home, his canvases clearly became more experimental and allowed him to extend the range of his painting. Late in his life he described this situation to his biographer Thiébault-Sisson: "I felt the need, in order to widen my field of observation and to refresh my vision in front of new sights, to take myself away for a while from the area where I was living, and to make some trips lasting several weeks in Normandy,

Brittany, and elsewhere. It was the opportunity for relaxation and renewal. I left with no preconceived itinerary, no schedule mapped out in advance. Wherever I found nature inviting, I stopped."

The places Monet chose for his trips were dramatically varied, ranging from the harsh coast of Normandy or Brittany to the lush, sun-drenched shores of Antibes and Bordighera on the Mediterranean. Geological formations, weather conditions, lighting effects, and temperature ranges were all elements that Monet tried to understand and translate into his work. The results are also strikingly different in mood and appeal.

These travels were occasionally burdened with artistic problems, especially when Monet was not used to a place and its atmosphere. Since he did not have the leisure as he did at home, he had to work quickly and efficiently in order to justify his trips. The process of selecting motifs was also reduced to a short period, as he did not plan in the first instance to spend more than a few weeks in any one place.

However, Monet was familiar with at least some of the locations he visited. Since 1881, he returned each year to the coast, often to sites where he had painted in his youth with Boudin and Jongkind. These include among others his hometown Le Havre and Etretat, where he went in 1883, 1885, and 1886.

The Rocks of Belle-Isle

1886; oil on canvas; 25 1/2 x 32 in. (65 x 81.5 cm.).Paris, Musée d'Orsay. Between September and November 1886, Monet stayed on the rocky island of Belle-Isle, painting, among other scenes, the "pyramides" at least six times. This painting bears striking similarities to a woodblock print by the Japanese artist Hiroshige. Monet was indeed an avid collector of Japanese prints, which helped him to see the pictorial possibilities of natural forms.

Gladioli

detail; 1876; Detroit, Institute of Arts. *The figure of Camille is completely integrated into the surrounding garden flowers. The treatment of the surface does not distinguish between them, achieving an effect of unity and harmony. Only from a distance do the shapes become more distinct.*

Etretat

Etretat, with its impressive rock formations, had been visited by a great number of artistic precursors. Delacroix did watercolors there earlier in the century, and Courbet, whose example was influential on Monet's own conception, had painted almost the same views. Monet, who had seen these works at the Courbet retrospective at the Ecole des Beaux-Arts in 1882, must have felt the challenge to equal or perhaps even outdo the artist he admired so much. Before starting his own paintings there he declared: "I reckon on doing a big canvas of the cliff of Etretat, although it's terribly audacious of me to do that after Courbet who did it so well, but I'll try to do it differently."

Unlike the many tourists who visited the fashionable resort during the summer months, Monet preferred the winter seasons, when heavy storms battered the beach and the fishermen were among themselves. In two works, *Boats on the Beach at Etretat*, painted during two different visits, Monet depicted the fishermen's activities. On other occasions he painted the stormy sea and the celebrated view of *The Manneporte, Etretat*. The writer Guy de Maupassant, himself visiting the resort town, watched Monet in 1885: "I often followed Claude Monet in his search of impressions. He was no longer a painter, in truth, but a hunter. He proceeded, followed by children who carried his canvases, five or six canvases representing the same subject at different times of day and with different effects. He took them up and put them aside in turn, according to the changes in the sky. Before his subject, the painter lay in wait for the sun and shadows, capturing in a few brushstrokes the ray that fell or the cloud that passed . . . I have seen him thus seize a glittering shower of light on the white cliff and fix it in a flood of yellow tones which, strangely, rendered the surprising and fugitive effect of that dazzling brilliance. On another occasion he took a downpour beating on the sea in his hands and dashed it on the canvas—and indeed it was the rain that he had thus painted."

Maupassant's vivid description of Monet's working methods is corroborated by observations made by other people and by a letter the artist wrote to Alice Hoschedé. In November 1885, while working on a view of the Manneporte cliff, he experienced a serious accident. He had consulted the wrong day's tide table before going down to the beach, and was swept away by a wave. He lost his canvas, easel, and his bag. With his palette plastered to his face, he managed to crawl back to the beach.

Later, Monet indulged in telling this story as the expression of his excitement about his art, literally conquered in his battle with nature. It also shows that Monet put himself to great discomfort when he wanted to obtain certain perspectives or visual effects. Some of the sites he painted at Pourville, near Dieppe, in 1882 are only accessible at low tide.

Sunset at Lavacourt
1880; *oil on canvas*;
39 3/8 x 59 7/8 in. (100 x 152 cm.).
Paris, Musée du Petit-Palais.
The critic Joris-Karl Huysmans, after seeing this painting at the seventh Impressionist exhibition in 1882, wrote: "How true the foam on the waves when struck by a ray of sunlight; how his [Monet's] rivers flow, dappled by the swarming colors of everything they reflect; how, in his paintings, the cold little breath of the water rises in the foliage to the tips of the grass."

Pourville and Dieppe

In *The Cliff Walk, Pourville* two tiny figures near the edge of the cliff maximize the impression of a vertiginous plunge down to the water. Wind gusts are blowing over the grass and the surface of the sea is rippled by numerous waves. The abrupt juxtaposition of the solid cliffs and the void of the open sea heighten the sense of immediacy. In *The Coastguard's Cottage at Pourville* the texture of the vegetation is crisp, the colors directly observed. The overall color scheme consists of greens and blues which, however, are set against reds, pinks, and oranges without simplifying their contrasting opposition. Pink dots have been added to the bushes in order to set off the difference between lit and shadowed foliage. The result is a lively and refreshing view.

Cliffs at Dieppe is a painting of almost monochromatic qualities. The pebbled beach is expressed through a delicate interplay of pinks and blues. Except for two or three dots on the left, indicating sailing boats, the scene is void of human presence.

The Ice-Floes

1880; *oil on canvas*, 28 1/2 x 39 1/8 in. (72.3 z 99.3 cm.).
Lille, France, Musée des Beaux-Arts.
Belonging to a series depicting a spectacular natural event, the view shows the Île de Musard on the Seine with the hamlet of Lavacourt on the opposite side. It was probably finished in the studio some time after the ice had melted. Monet's intention to render the various aspects of light and atmosphere of a given place prefigures his series paintings of the grainstacks and poplars of the 1890s.

Belle-Isle

In September of 1888, shortly after the eighth and last Impressionist exhibition closed with a triumphant success for Seurat, Monet travelled to Belle-Isle, a rocky island off the southwest coast of Brittany. Unaccommodating weather conditions forced him to extend his stay until the end of November, much longer than he initially expected. Monet felt that he had to prove his worth as the leading avant-garde artist, who wanted to claim the proper

place for himself and the movement of Impressionism as such. Seen in this light, his paintings from Belle-Isle appear therefore as a tour-de-force and demonstration pieces of his capabilities as an artist.

The narrowed focus of the subject matter—Monet did a total of some thirty-eight paintings—was due in part to the restrictions of the tiny island. However, if Monet had intended to diversify the subjects, he would have done so. Thirty-five of these paintings include no reference to humankind. There are no people, no houses, no boats. *The Needle Rocks at Belle-Isle* is one of six versions that are near replicas. Other paintings explore a relatively limited number of motifs, for which Monet adopted a restricted range of compositional options, as is illustrated by *The Rocks of Belle-Isle*. These self-imposed limitations forced the artist to scrutinize the phenomena of nature carefully: the movement of the sea and the interplay of light and shadow on

the water and the craggy rocks.

The group of paintings completed at Belle-Isle are forebears to Monet's series paintings of Haystacks and Water Lilies of the following decade. He was confident enough to show them in a group at two exhibitions, one held at Durand-Ruel's gallery in the spring of 1887, right after the artist's return from the island, the other two years later. Critics recognized immediately the importance and impact of these pictures and called Monet the "most significant landscape painter of our times."

Bordighera and Antibes

In 1884, he traveled to Bordighera on the Italian riviera and in 1888 to Antibes, where he became obsessed with "this brilliance, this magical light" in the Mediterranean. "After terrifying Belle-Isle, this will be something tender, there's nothing here but blue, pink, and gold," Monet said

Bordighera
1884; *oil on canvas*; 25 5/8 x 31 7/8 in. (65 x 81 cm.). Chicago, The Art Institute.
Visiting the Mediterranean coast early in 1884, Monet painted several views of the resort town of Bordighera. He was intrigued by the "rather exotic aspects" and "this brilliance, this magical light," captured in the high-keyed colors and the animated pine trees set against the bright blue of the sea.

about Antibes. However, he seemed to have felt less comfortable in the light of the south; at Bordighera he had trouble at first finding suitable viewpoints. "I am really the man for isolated trees and wide-open spaces," he exclaimed. Indeed in many of the seascapes of the 1880s, trees play a pronounced role as in *Bordighera, Stone Pine at Antibes* or the freely handled *Cap d'Antibes, Mistral*, which was presumably largely completed while the wind blew. Certainly, Monet had a preference for challenging weather conditions.

Stone Pine at Antibes is one of the first hints in Monet's oeuvre of a new approach to the picture surface. Slowly shifting away from the dramatic effects he searched for during the 1880s, his preoccupation with the atmospheric 'envelope' (appearance) leads directly to the series paintings of the 1890s, where he introduced constantly varying colored nuances.

A Question of Finish

Monet began a canvas by applying a first layer of paint which varied according to the textures he was trying to suggest. Other layers followed to work out the approximate arrangement of patterns of light and shade. Based on this preliminary work, a number of paintings could be finished in the studio, although Monet insisted publicly that he did not even have a studio and that his paintings were always executed out-of-doors. He was, however, wary not to spoil the initial effects laid down on the canvas, afraid to mar the "purity of accent" of his paintings. Even in continuing bright weather the wind might vary, "which makes a great difference to the state of the atmosphere, and especially the sea." The south of France offered certainly more stable weather conditions than the north, but one might truly say that Monet's works from the south always retain the touch of an outsider.

Boats in Winter Quarters

1885; *oil on canvas*; 25 3/4 x 31 7/8 in. (65.5 x 81 cm.). Chicago, The Art Institute.
This canvas does not show the famous cliffs at Etretat, which were painted at various times
by the artist, but rather the beach with its fishermen and their boats, covered with make-shift roofs.
Since his first extended stay in Etretat in 1868, Monet returned repeatedly to this location.

Later in the 1880s he still spoke of his attempts to finish paintings on the spot, although this happened only very rarely by then, since he had already developed the habit of looking at the results of his outdoor work at home, far removed from the motifs. At Bordighera he described some paintings once as finished, only to modify his previous statement: "When I decide, not that a canvas is finished, but that I will not touch it any more, I jam it in a case so as not to see it again until I'm at Giverny."

This struggle to reconcile spontaneity with finish is a reflection of Monet's changing ideas about this issue. During the 1870s when he was frequently in need of money, he would sell off sketches or less finished works, but later he set his standards higher. In 1884, he lamented that "the further I go, the harder I find it to bring an 'étude' (study) to a successful conclusion." However, his thoughts about the finish of a work were not clear-cut. To his dealer Durand-Ruel he explained: "You know that for a long time now it has been my ambition to give you only finished canvases with which I am completely satisfied. You yourself, in one of your last letters, urged me to work them up, to finish them as highly as possible, telling me that lack of finish was the principal reason for their lack of success . . . As for finish, or rather polish, for that is what the public wants, I shall never agree to it." This last remark was obviously aimed at a certain public taste that preferred to see his paintings as slick as those done by academic painters. But Monet certainly knew where he wanted to draw the line. In 1884, the year of his visit to Bordighera, Monet noted that he (as well as Renoir) had become very conscious about the quality of his paintings: "We are definitely becoming very demanding, and yet people always reproach us for making no effort." Monet's financial independence in later years allowed him to live up to this statement.

Monet's House at Argenteuil
detail; 1873; Chicago, The Art Institute
Standing in the door of their house in Argenteuil is Camille. Her figure has been painted sketchily and does not reveal any distinct features. Indeed, the treatment of the surface is the same the artist used for the rendering of the flowers around her. Monet was not interested in a precise rendering of objects but in the effects of light upon them.

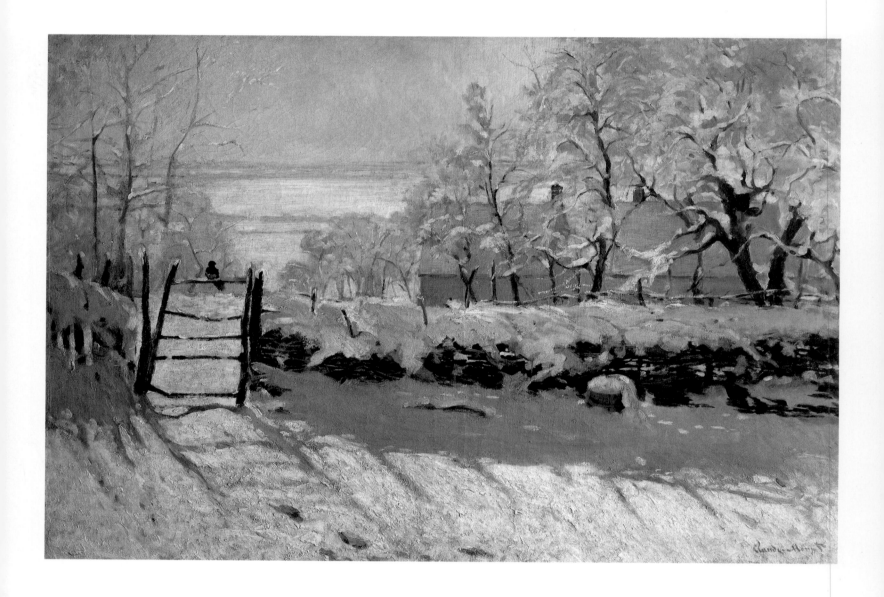

The Magpie
1872; *oil on canvas*; 34 5/8 x 51 1/4 (89 x 130 cm.). Paris, Musée d'Orsay.
The lifeless cold of this scene of snow and ice is animated by the
presence of a magpie resting on a garden gate and the golden
glow of the late afternoon sun. Shadows cast by the wall
create a lively rhythm in this symphony in white.

Field of Poppies

1873; *oil on canvas*; 19 3/4 x 25 1/2 in. (50 x 65 cm.). Paris, Musée d'Orsay. *Exhibited at the first Impressionist show in 1874, this work has become one of Monet's most famous paintings. It shows his wife Camille holding a blue parasol, and his son Jean walking through a field of high grass and red poppies at Argenteuil. A second figure group on the hilltop represents probably the same people, only caught at an earlier moment. In both instances, the figures are completely integrated into the landscape.*

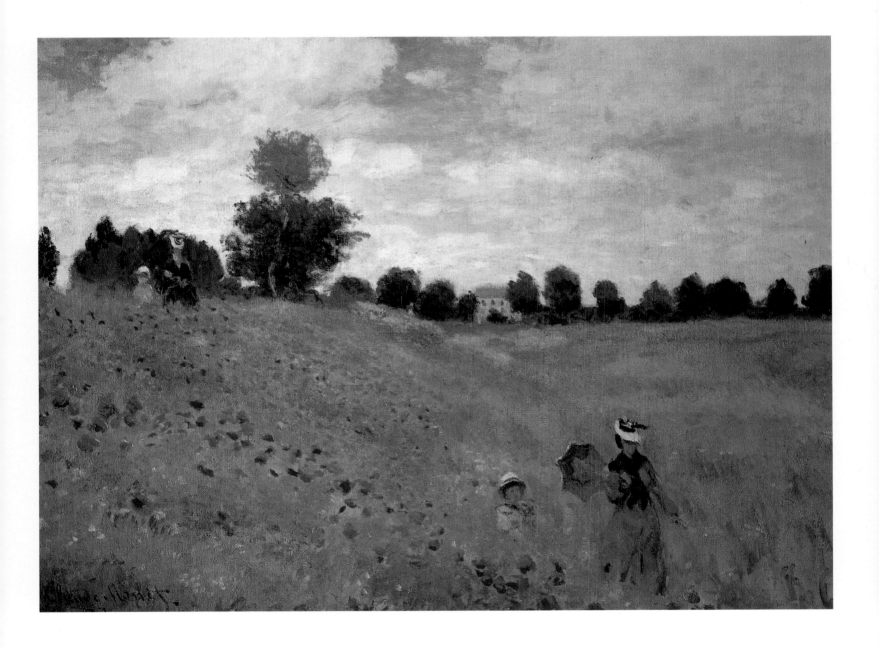

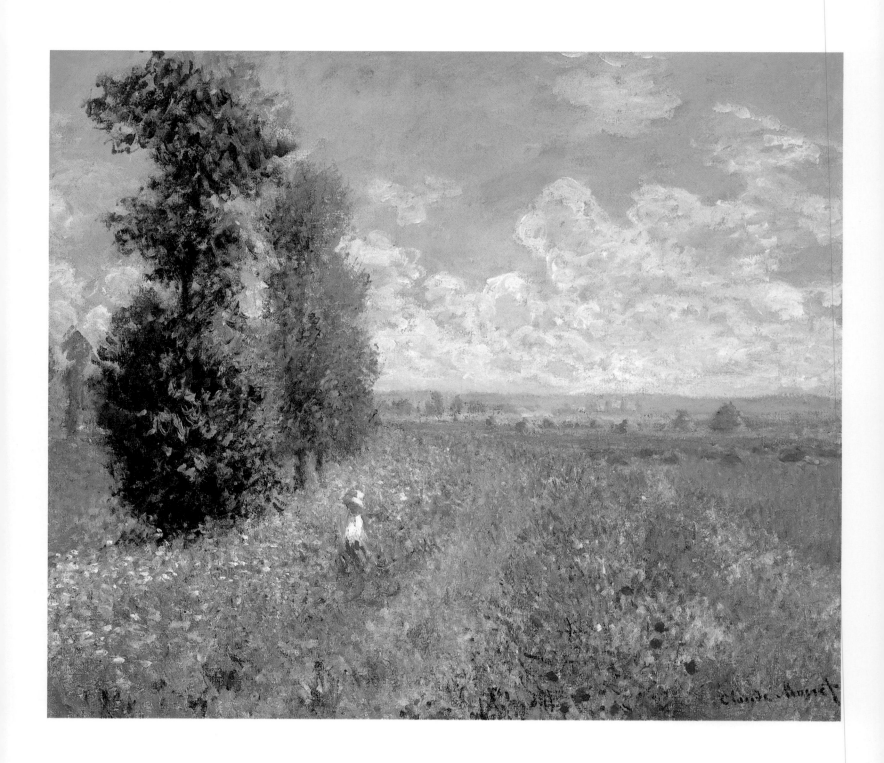

Meadow with Poplars

1875; *oil on canvas*; 21 3/8 x 25 3/4 in. (54.5 x 65.5 cm.). Boston, Museum of Fine Arts.
*Having lost interest in his earlier tendency to juxtapose nature with scenes of
modern life, including houses and factories, here Monet added only a small figure
to give this work a touch of contemporaneity. Spatial depth is expressed through
a series of color fields, ending with the blue tones in the far distance.*

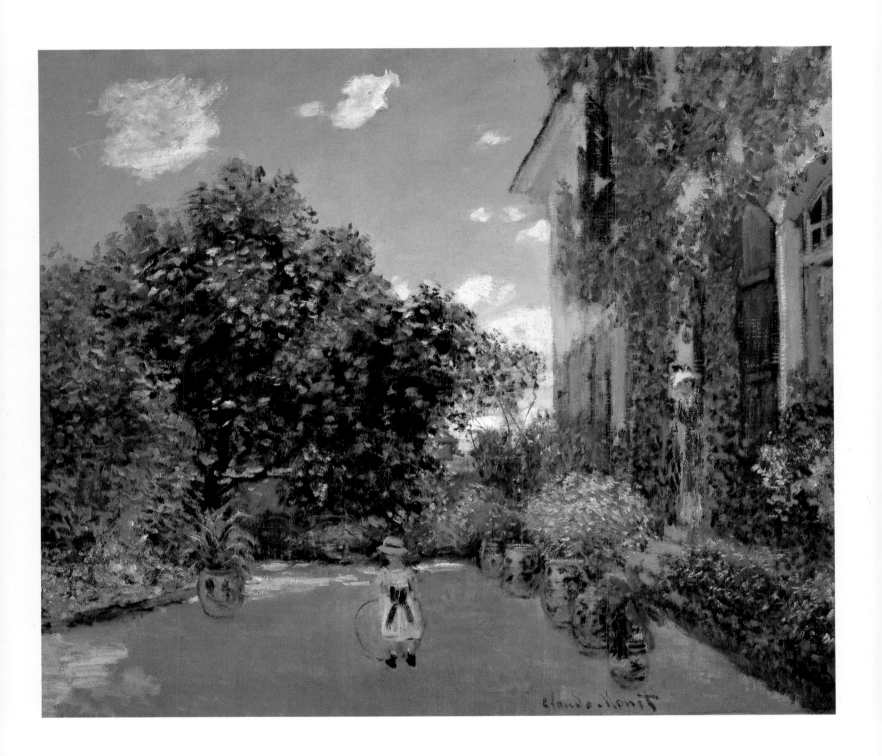

Monet's House at Argenteuil

1873; *oil on canvas;* 23 5/8 x 29 1/8 in. (60.5 x 74 cm.). Chicago, The Art Institute.
The artist's son Jean is seen standing in the garden holding a hoop, while Camille
stands in the doorway. The blue flowerpots, for which Monet had a special fondness,
appear in a number of paintings, for example Interior of an Apartment. *Monet*
moved to Argenteuil, a suburb to the west of Paris, in the winter of 1871.

Boats and Bridge at Argenteuil

1874; *oil on canvas*; 23 5/8 x 31 1/2 in. (60 x 80 cm.). Paris, Musée d'Orsay.
*This scene of the Seine at Argenteuil was carefully selected from many
possible views. The boats, the water, the bridge, and the houses and
trees in the background are all suggested by small dots of color.
The balance and harmony emanating from the scene were
characterized by one critic as an "aerial geometric structure."*

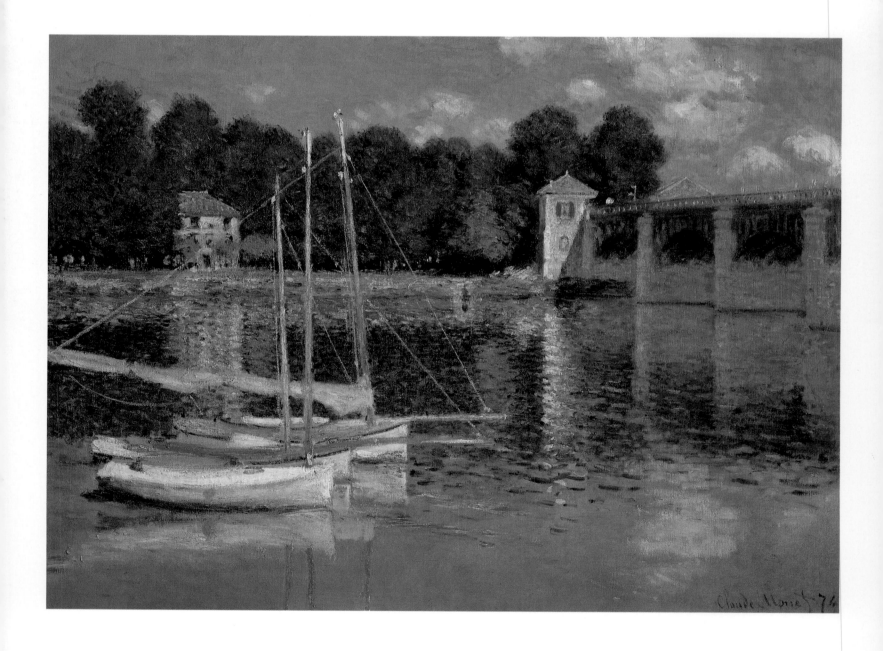

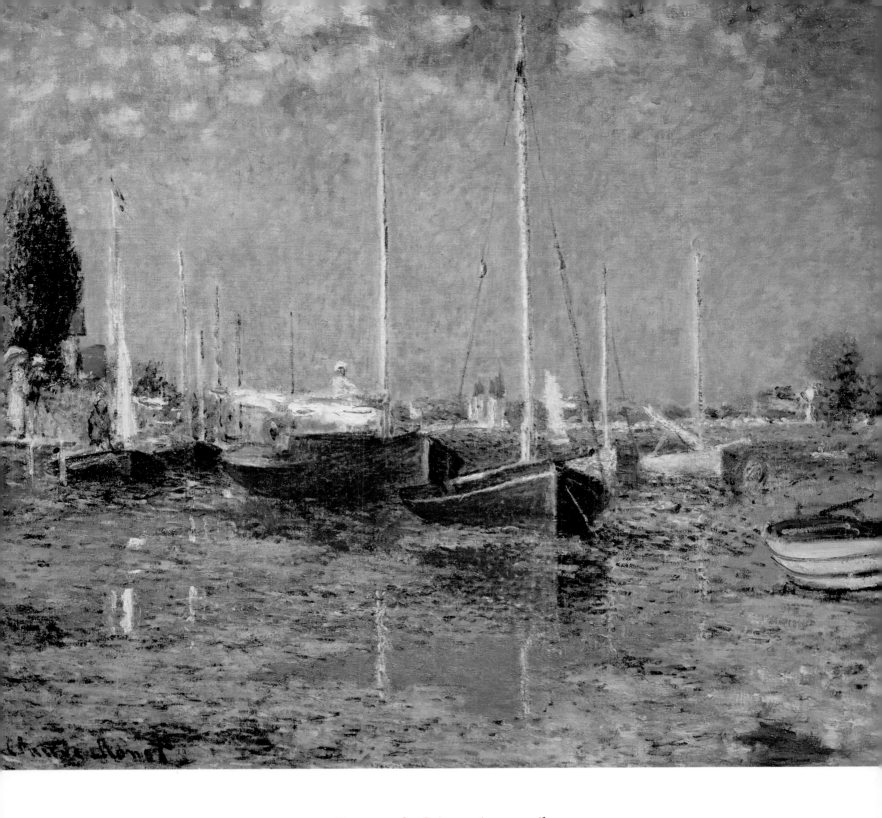

Boats on the Seine at Argenteuil

1875; *oil on canvas*; 22 x 25 3/8 in. (56 x 65 cm.). Paris, Musée de l'Orangerie.
*The pure bright orange of the boats and the azure of the sky are
indicators of the fascination the artist must have experienced on an
early summer morning near his house in Argenteuil. The diagonal
movement of the sailboats cutting across the picture plane ends with a
couple standing underneath a poplar tree on the other side of the water.*

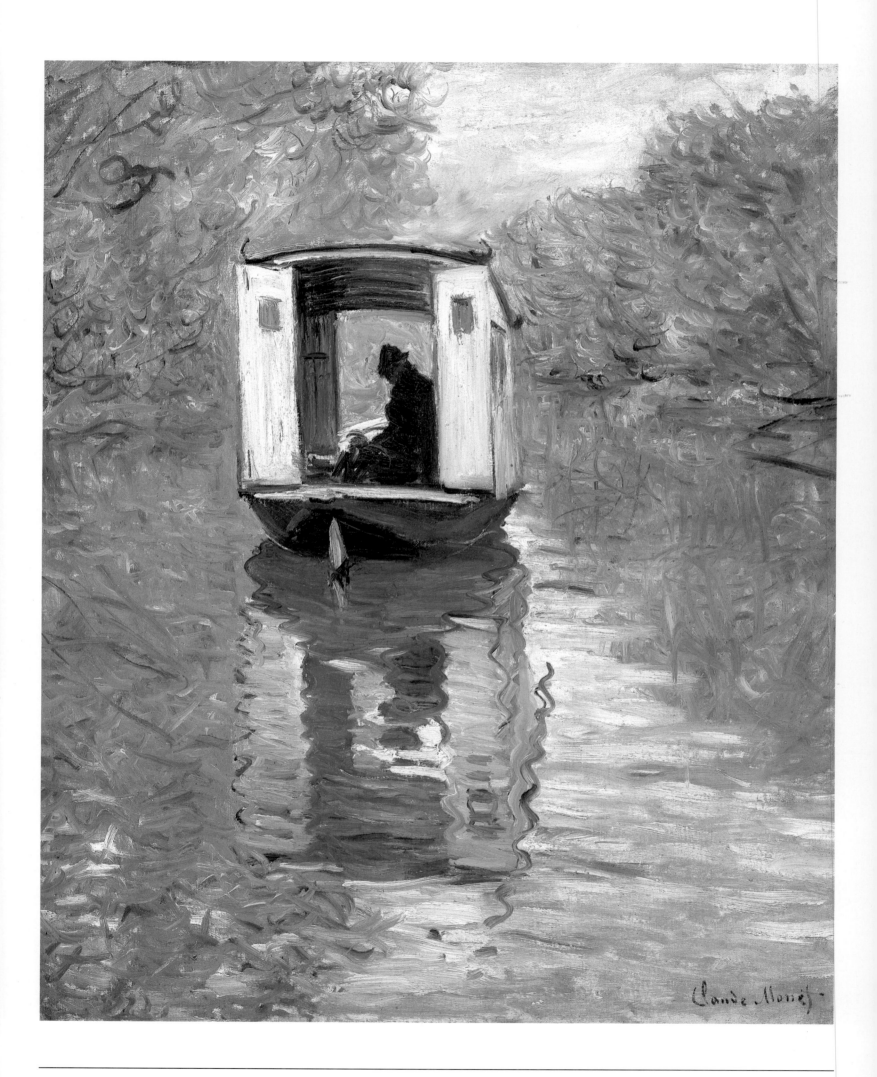

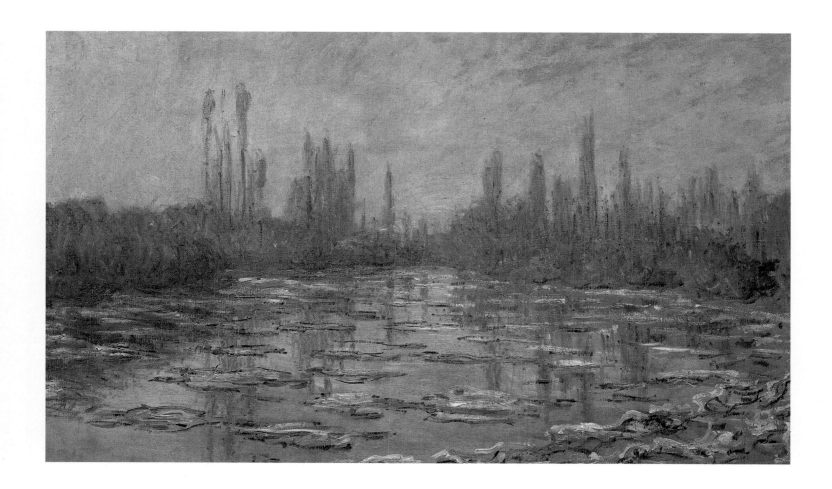

Landscape with Melting Snow
1880; *oil on canvas;* 23 5/8 x 39 3/8 in. (60 x 100 cm.). Paris, Musée d'Orsay.
The winter of 1879–1880 was a particularly harsh one. But toward the end of
the year a sudden thaw created spectacular scenes of ice blocks floating
down the river near Argenteuil. Monet made a number of sketches on the
site, which he later translated into a series of paintings. Here, at a bend of
the river, the ice seems to be calmly drifting on the surface of the water.

The Boat Studio
1876; *oil on canvas;* 28 3/8 x 23 1/2 in. (72 x 59.8 cm.). Merion, Pennsylvania, The Barnes Foundation.
After having sold several paintings, Monet was able to afford to have a small boat-
studio built, from where he could paint the Seine directly from the water. Usually, he
got up very early in the morning to observe the rapidly changing effects of the rising day.

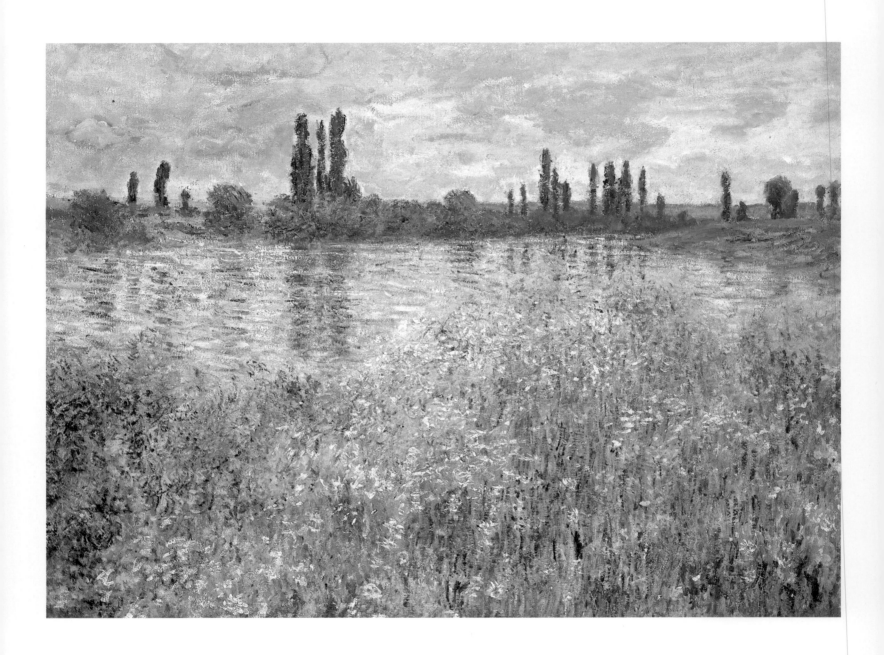

Banks of the Seine, Vétheuil
1880; *oil on canvas*; 28 3/4 x 39 3/8 in. (73 x 100 cm.).
Washington, D.C., National Gallery of Art.
*This highly finished and elaborate painting consists of a dense
sequence of horizontal and vertical brushstrokes, each group
clearly defining the trees, the ripples on the water, the flowers,
and the plant stems. The varied textures of the surface of the painting
are played off against each other in a distinct rhythm of elements.*

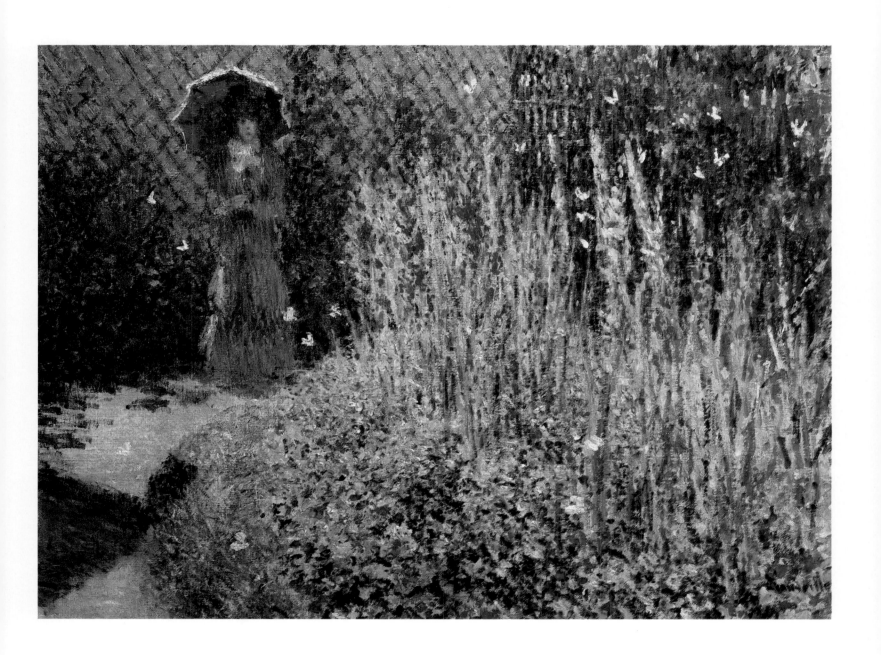

Gladioli
1876; oil on canvas; 21 5/8 x 31 7/8 3/8 in. (55 x 82 cm.). Detroit, Institute of Arts.
Holding a sunshade against her shoulder, Camille stands in the garden at
Argenteuil, gazing at the abundantly blooming gladioli. Her figure is treated with
the same animated and busy texture as that of the mass of flowers, made up of
numerous small brush marks. The overall effect is pulsating and incorporeal.

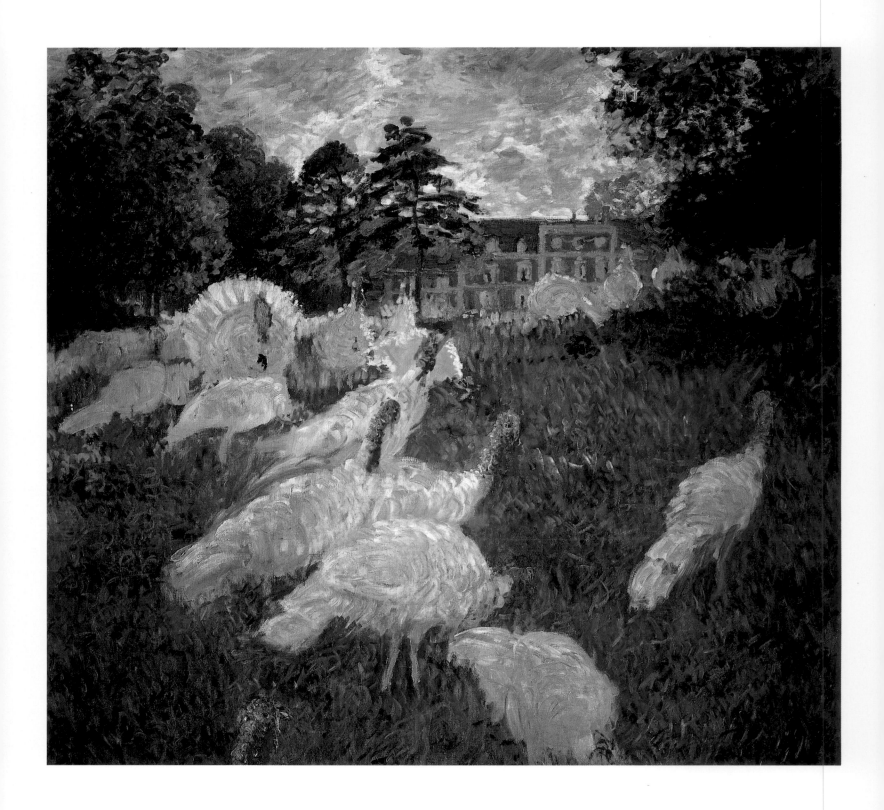

The Turkeys: Château Rottembourg, Montgeron
1877; oil on canvas; 67 3/8 x 67 3/8 in. (174.5 x 172. cm.). Paris, Musée d'Orsay.
The castle in the background belonged to Monet's patron and friend, the
businessman Ernest Hoschedé, whom he had met in 1876. The painting was
twice exhibited in an unfinished state and some critics believe that it was never
finished. Be that as it may, this image of young, white turkeys contrasting
with the fresh green grass is an extraordinary though unusual subject.

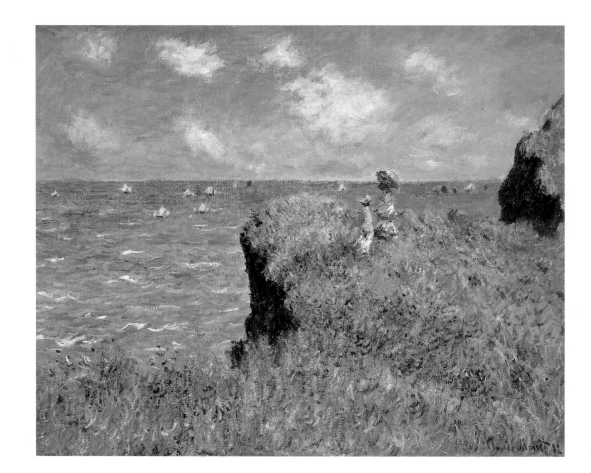

Cliff Walk at Pourville

1882; *oil on canvas;*
25 5/8 x 31 7/8 in. (65 x 81 cm.).
Chicago, The Art Institute.
This painting depicts two fashion-
ably dressed holiday makers
looking down from a cliff. As
in many paintings of the 1880s,
however, they play a subordinate
role. Set on a tipped-up plane,
they are placed well away from
the viewer and relate more to
the surrounding vegetation and
the sailing boats on the water.

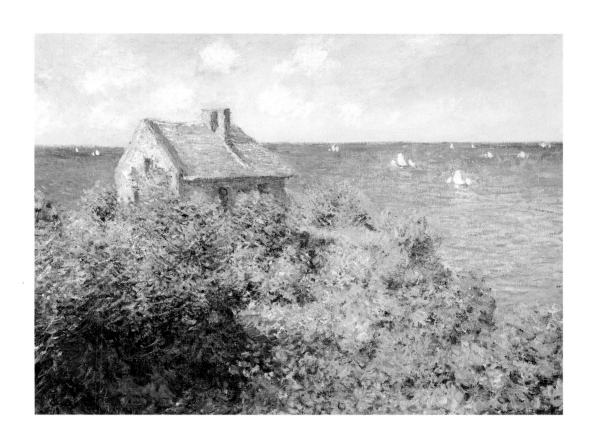

Fisherman's Cottage on
the Cliffs at Varengeville

1882; *oil on canvas;*
23 3/4 x 32 in. (60.5 x 81.5 cm.).
Boston, Museum of Fine Arts.
Monet painted the coastguard's
cottage at Pourville, which over-
looks the ocean on a breathtaking
cliff, many times. Touches of pink
across the central bushes allowed
the artist to create a lively contrast
between the greens of the foliage
and that of the ocean, thus
enhancing the strong color scheme.

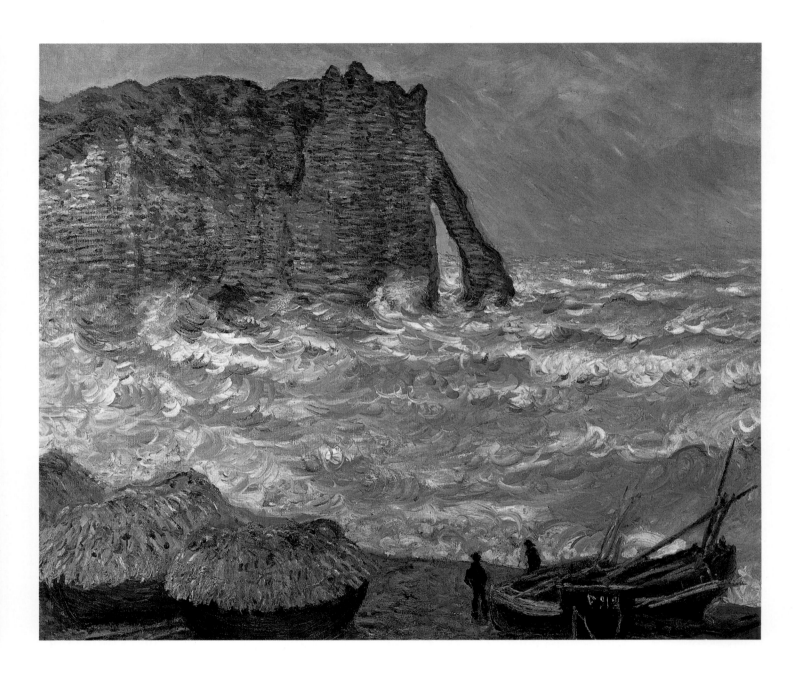

Storm at Etretat

1883; *oil on canvas*; 31 1/2 x 39 3/8 in. (80 x 100 cm.).
Lyon, France, Musée des Beaux-Arts.
*Monet painted a similar view of the cliffs and the
Porte d'Aval at Etretat more than ten years before this
one. Here, however, he chose a higher viewpoint and
raised the level of the horizon, achieving a sense of imme-
diacy and emotional quality. The waves battering against
the rocks are rendered with large, thick brushstrokes.*

The Manneporte, Etretat

1886; *oil on canvas*; 32 x 25 3/4 in. (81.5 x 65.5 cm.).
New York, Metropolitan Museum of Art.
*Monet painted this particular angle of the famous Manneporte
rock at Etretat at least six times during several trips in the
1880s, but apparently never thought of grouping these works
together as he did with other subjects. Here the dominant verticality
of the arch is emphasized by the format of the painting. Both rock
and water are united by the homogeneous texture of the surface.*

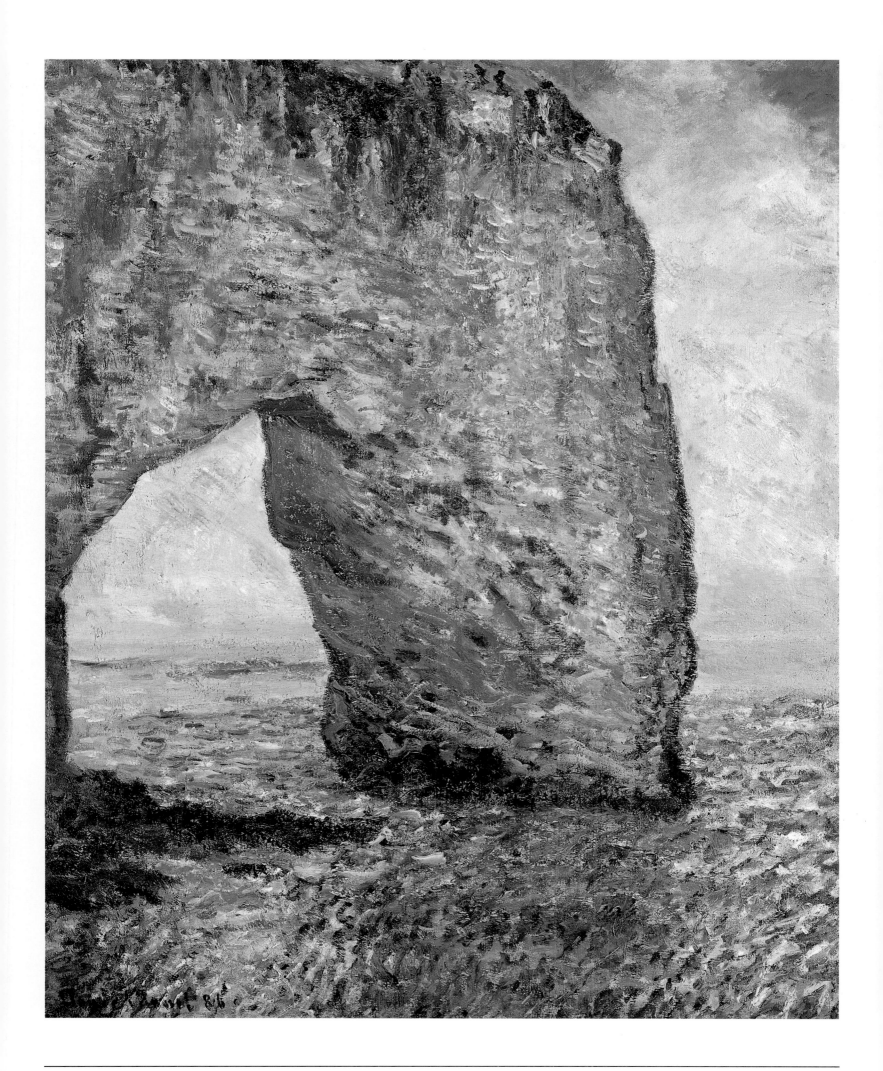

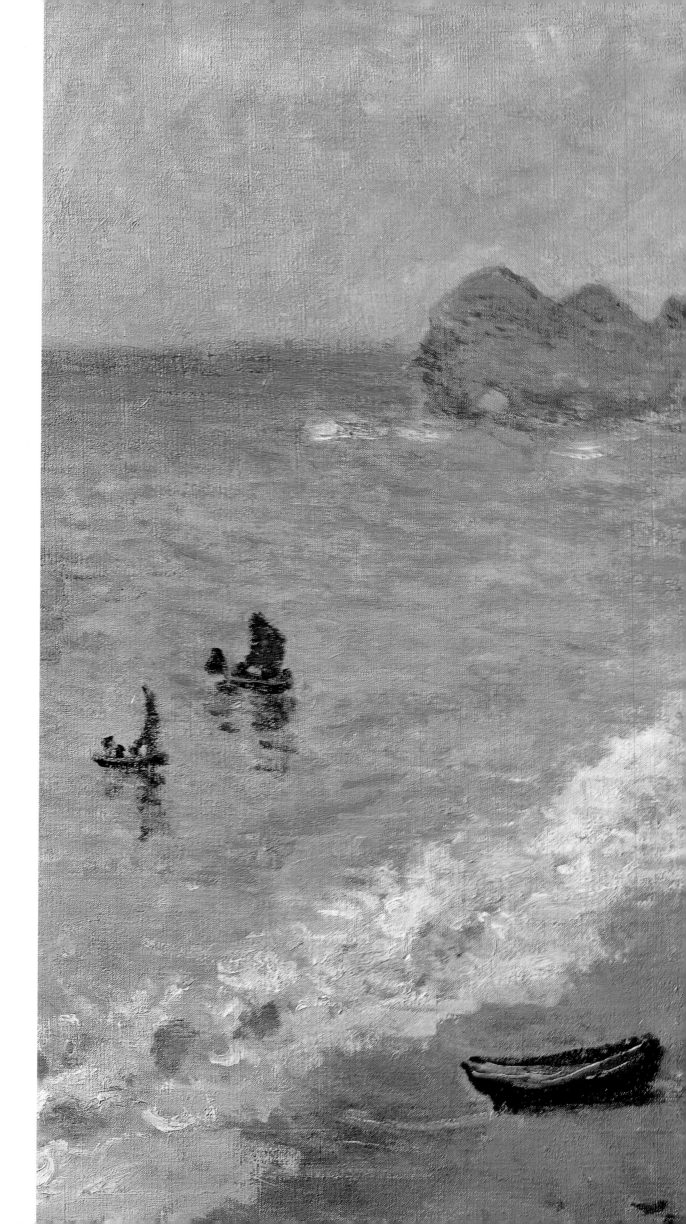

Boats on the Beach at Etretat
1883; *oil on canvas;* 26 x 31 7/8 in. (66 x 81 cm.). Paris, Musée d'Orsay. *The writer Guy de Maupassant once saw the artist on the beach at Etretat, followed by children carrying several canvases, each depicting the same scene but painted at a different hour of the day with a different light effect. The cliffs of Etretat are considered to be the most beautiful in France and have attracted many artists, including Delacroix and Matisse.*

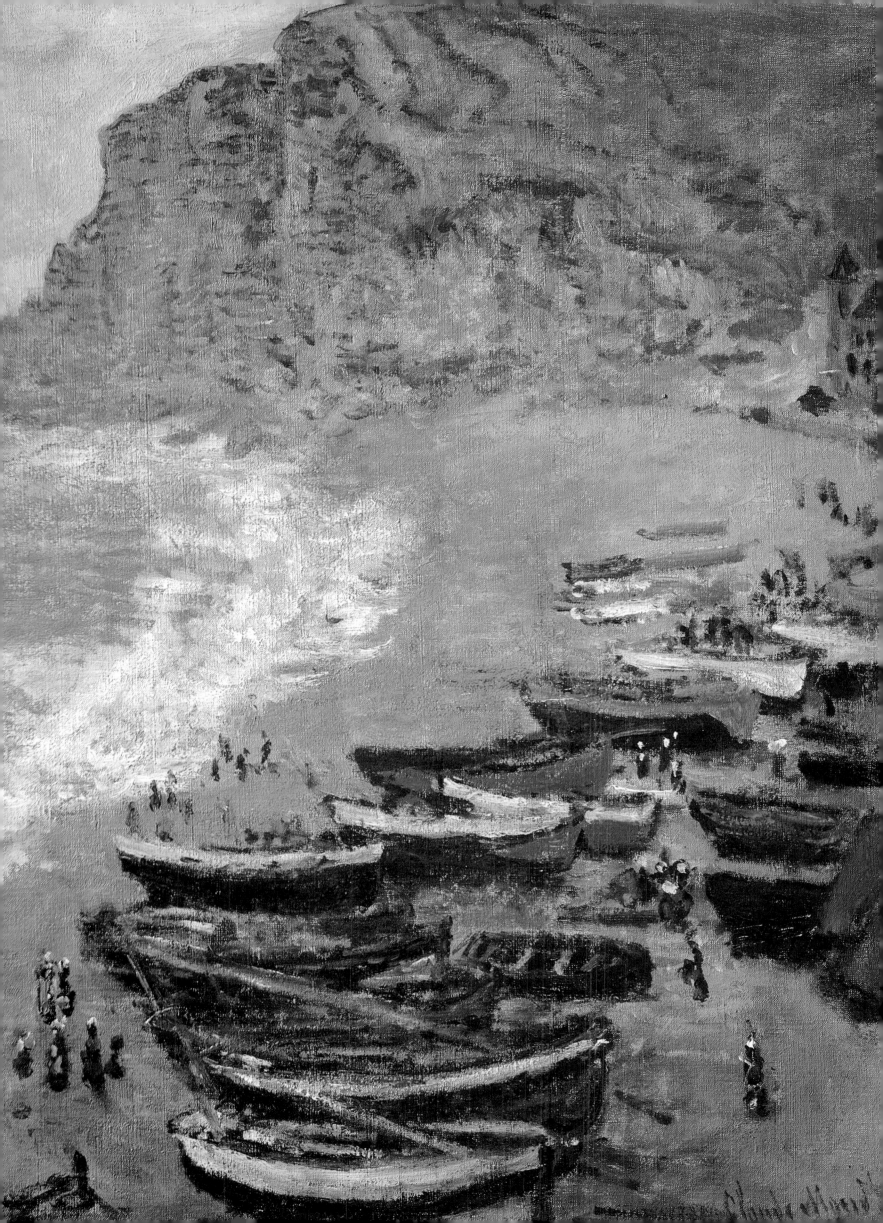

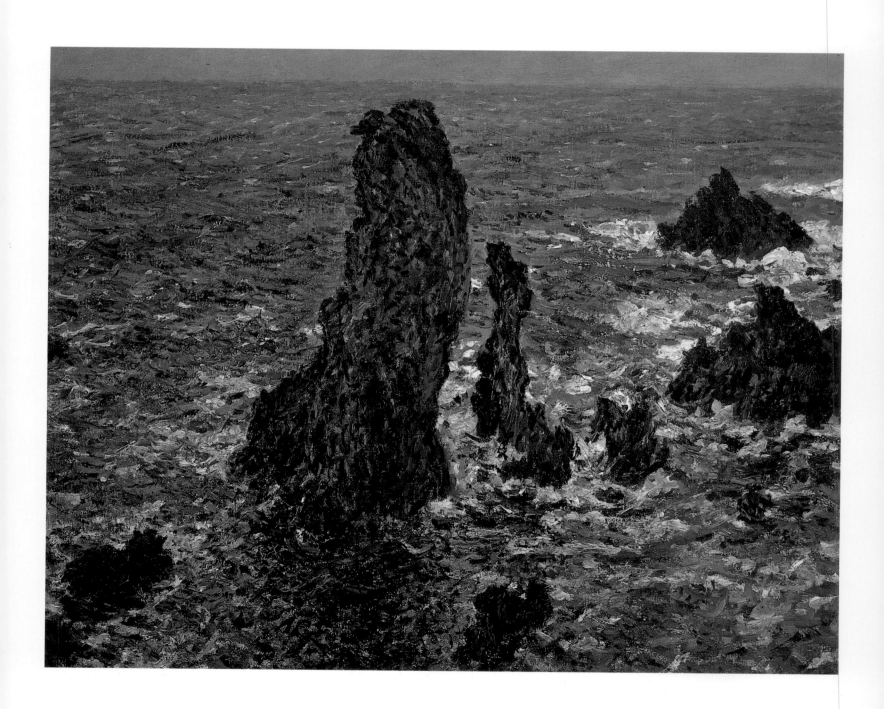

The Needle Rocks at Belle-Isle

1886; *oil on canvas;* 25 5/8 x 31 7/8 in. (65 x 81 cm.). Moscow, Pushkin Museum of Fine Arts.
While painting the Needle Rocks (also known as the "Pyramides" at Port-Coton) on Belle-Isle, an island off the southwest coast of Brittany, Monet felt melancholic sensations apparently generated by the mood of the site, since—as he later described—"this place cannot produce cheerful feelings, because it is sinister." This atmosphere is reflected in the dark brown and blue tones of the rocks and the water.

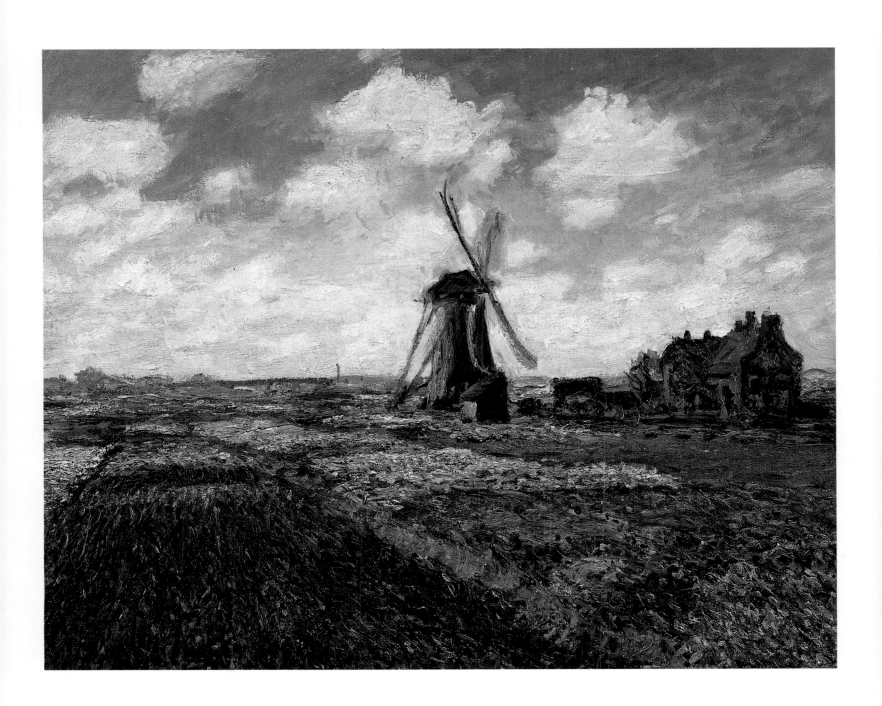

Tulip Fields
1886; *oil on canvas*; 26 x 32 1/4 in. (66 cm 82 cm.). Paris, Musée d'Orsay.
*During a brief visit to Holland in May 1886, Monet painted this homage to the
typical Dutch landscape and its flowers. The windmill and the farmhouses add a
folkloric note to this symphony in red. The low horizon and the lines leading into
the distance reflect Monet's experience with Dutch Old Master painting.*

The Bark at Giverny

1887; *oil on canvas*; 38 1/2 x 51 1/2 in. (98 x 131 cm.). Paris, Musée d'Orsay.
*Alice Hoschedé and two of her daughters are seen fishing from a boat in
the calm backwater of the Seine river at Giverny. The surface of the
water is perfectly smooth, reflecting the three women in their boat. The
main subject is the lush, green landscape rather than a group portrait.*

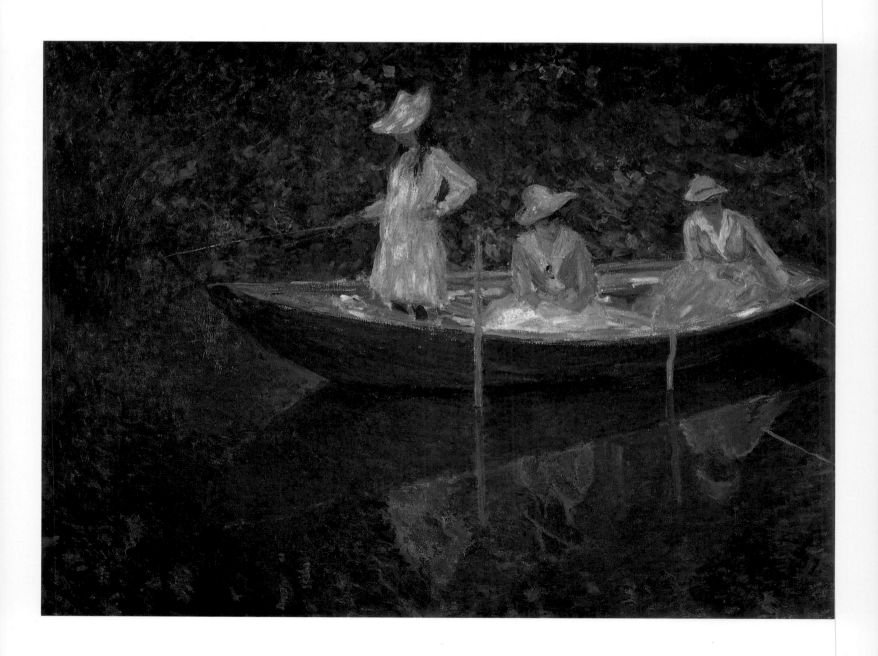

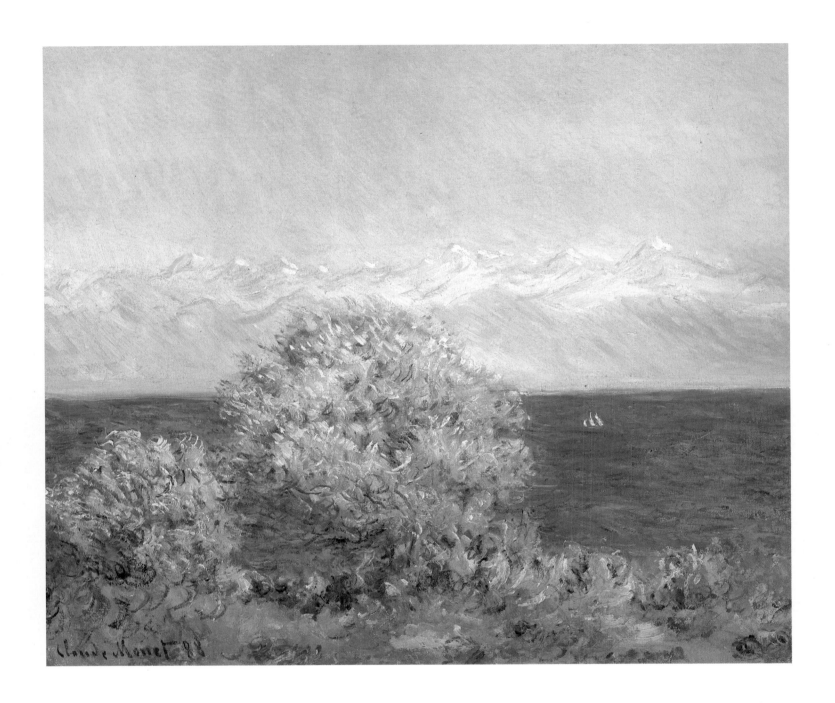

Cap d'Antibes, Mistral

1888; *oil on canvas*; 25 5/8 x 31 7/8 in. (65 x 81 cm.). Boston, Museum of Fine Arts.
The effects of the mistral are expressed in vigorous brushstrokes of paint,
most visibly in the trees. Nonetheless, the painting is a fully finished
canvas with clearly defined forms and spatial relationships. A small
boat is fighting a lonely battle against the churning waves.

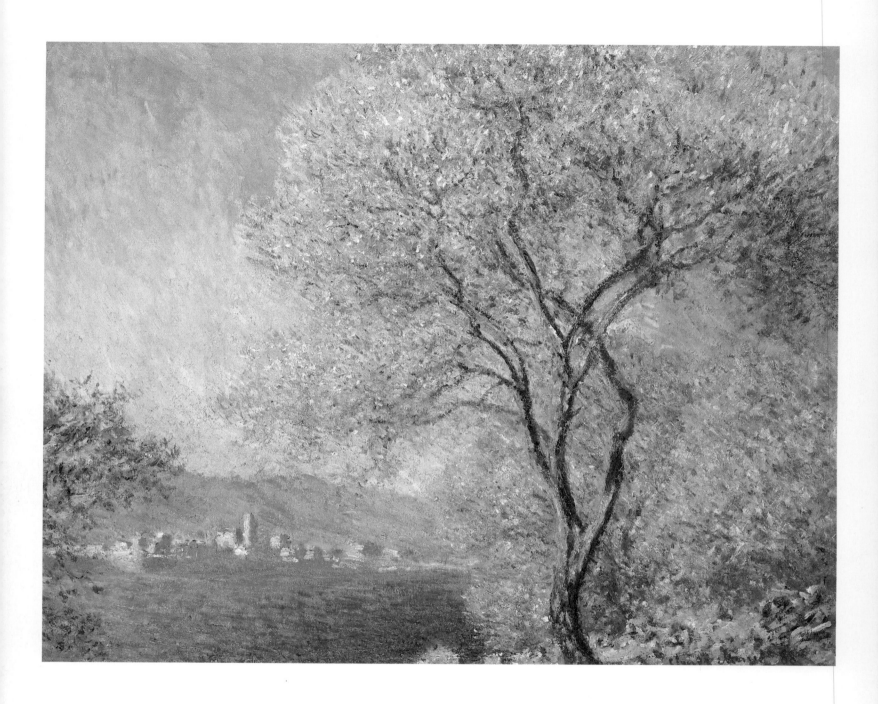

Antibes seen from the Salis

1888; *oil on canvas; 28 3/4 x 36 1/4 in. (73 x 92 cm.).*
Toledo, Ohio, Museum of Art.
Between January and April of 1888 Monet painted in
Antibes and other locations along the Mediterranean coast.
The works were exhibited during the summer of the same
year in Paris. The city of Antibes, seen across the sea with the
mountains rising behind it, is rendered with a few patches of the
bright light of the south, which contrasts with the purple shadows.

Meadows at Giverny

1888; *oil on canvas; 36 1/4 x 31 1/2 in. (92 x 80 cm.).*
St. Petersburg, Hermitage.
The present work might have been executed in
May or June of that year, when Monet had
returned from his trip to Antibes. A meadow of
varied green and yellow brushstrokes stretches far into
the distance, where several trees, set against an opaline
sky, serve as a reference point for the wandering eye.

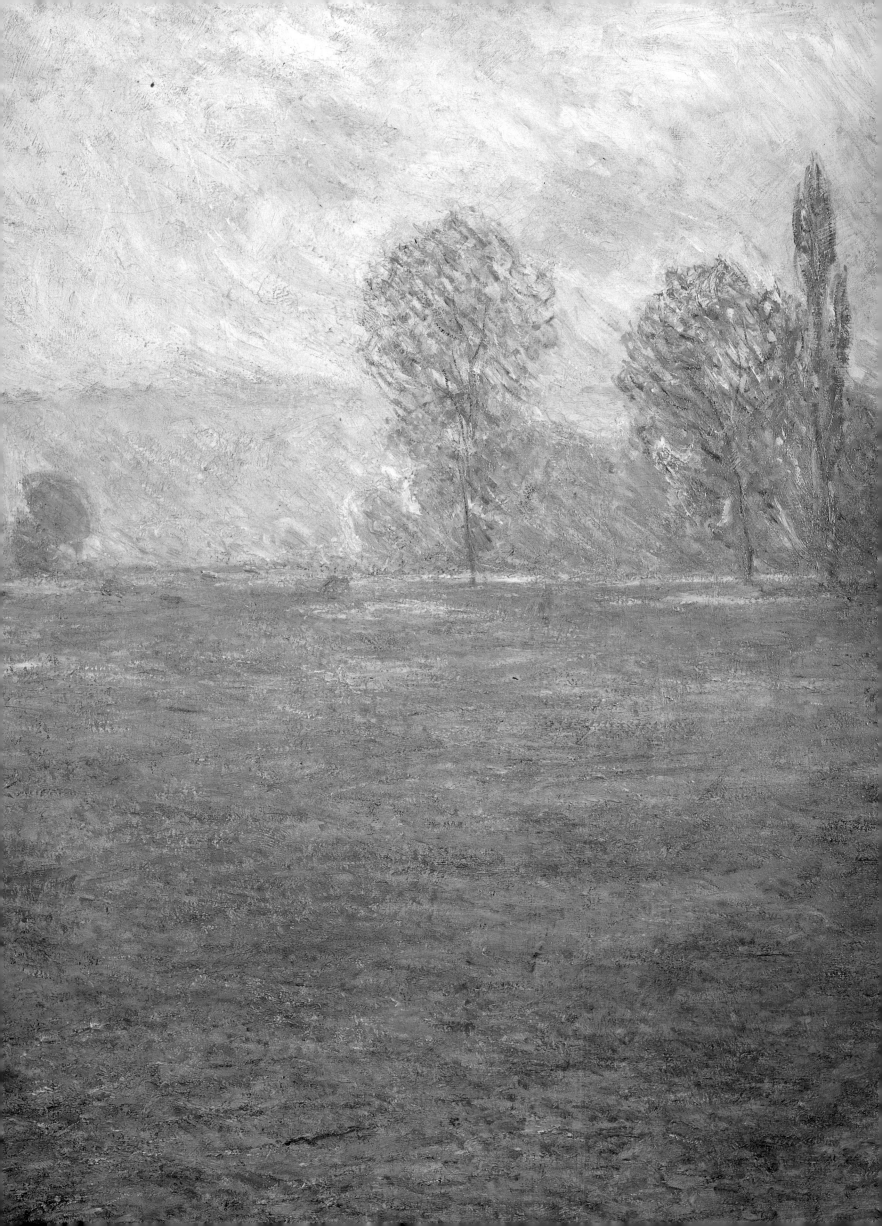

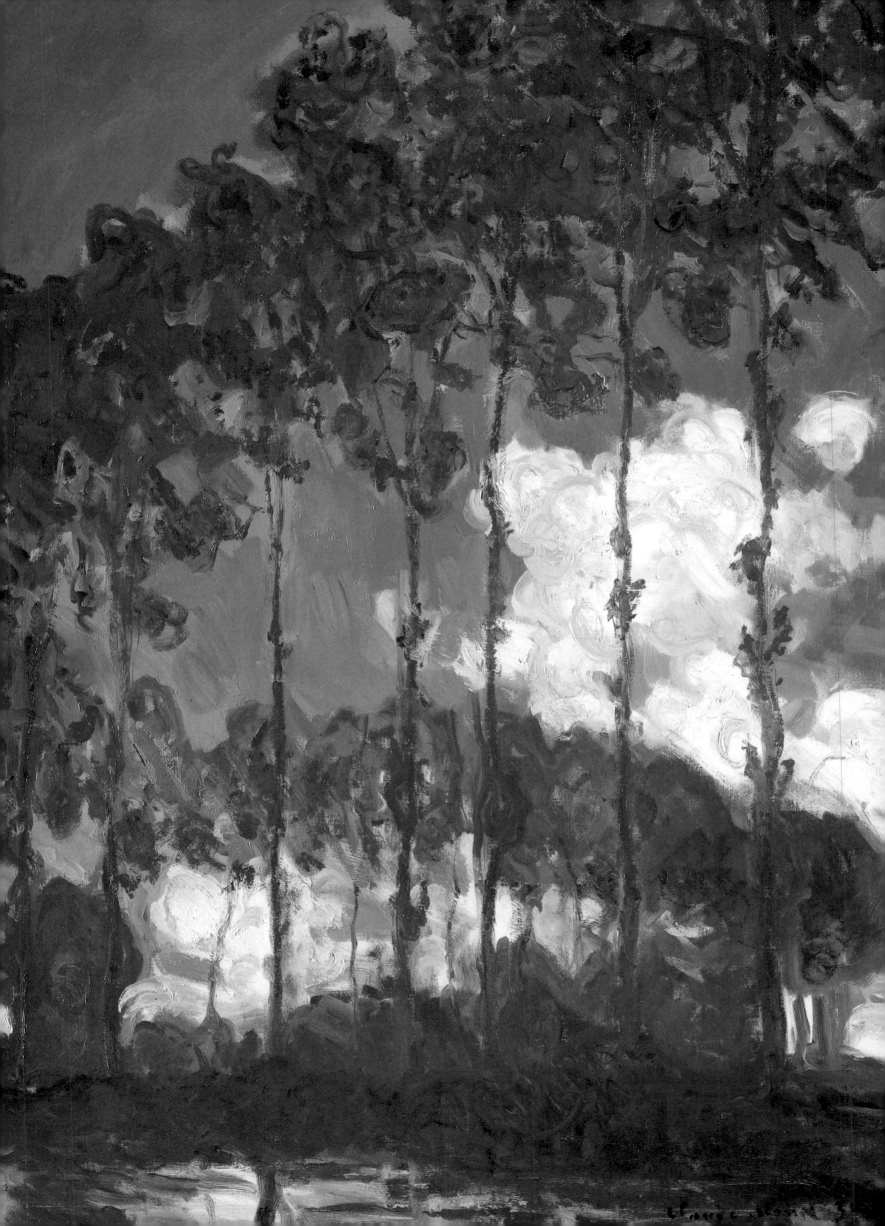

CHAPTER 4

THE 1890s AND BEYOND

The year 1890 marked a turning point in Monet's oeuvre. Late in the summer of that year the artist embarked on a new path: his series paintings, which were to occupy him throughout the decade and ultimately until the end of his life. The first series was that of haystacks, a motif that had its predecessor in those painted several years earlier. This motif was now picked up again with great verve.

A Fruitful Period

Never before had Monet been so immersed in his work at Giverny and never had he seemed so pleased with what he was doing. A long period of beautiful weather which continued into the winter allowed him to make constant progress on his work. "I am in the thick of work. I have a huge number of things going and cannot be distracted for a minute, wanting above all to profit from these splendid winter effects," Monet wrote to Durand-Ruel on January 21, 1891. Monet had bought the house in Giverny in November 1890; becoming a landowner for the first time in his life might have contributed to his revived interest in the agrarian character of his environment. The chance to purchase the house delighted the artist, since the idea of leaving Giverny worried him a great deal.

When Durand-Ruel came to visit the studio in February, he saw at least twenty-five paintings with the grainstack motif. While the size of the canvases were not identical, the compositions were remarkably similar, consisting of one or two stacks set on a field beyond which stretches an irregular line of trees and houses that are silhouetted against distant hills, with a strip of sky closing off the top. Monet composed these scenes following geometric considerations. Fields, hills, and sky are treated as horizontal bands, which stretch in most

cases over the entire canvas, with the fields occupying about half of the surface and the hills and sky a quarter each. At the exhibition at Durand-Ruel's in Paris between May 4 and May 18, 1891, the fifteen canvases which Monet had selected for the show made a strong impression with their powerful and elemental motifs. The show was a great success.

Grainstacks

Monet had always been interested in the depiction of changing atmosphere and light, as he demonstrated earlier in his paintings of the Gare Saint Lazare (1877) and *Ice-Floes on the Seine* (1880). Comments about and reactions to his grainstack series have led to some misconceptions about Monet's intentions, though the artist himself was partially responsible for it. He told his later

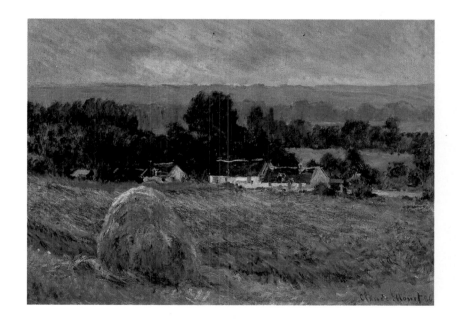

Poplars on the Epte
1891; *oil on canvas*; 36 3/8 x 29 in. (93 x 76 cm.).
London, Tate Gallery.
This is one of a series of twenty-three paintings of the poplars on the left bank of the Epte river near Giverny. When the township sold the trees to a lumber dealer while Monet was still working on the subject, the artist contributed a share of the purchase price on the condition that the trees were left standing for a few more months.

Haystack at Giverny
1886; *oil on canvas*; 24 x 31 7/8 in. (61 x 81 cm.).
St. Petersburg, Hermitage
Several layers of horizontal lines are rhythmically repeated, from the field in the foreground to the group of houses, the trees in the distance, and finally the sky. The idyllic setting is dominated by a calm and contemplative mood. Several years later, Monet painted a series of haystacks around Giverny, where he settled in his later years.

biographers that during one particular day while he was painting the grainstacks on a field near his home, he asked his stepdaughter to run back to the house a number of times to fetch a new canvas, since the transitory effects of the weather compelled him to abandon one canvas after another and to start a new one, thus capturing the change of light each time. It is sufficiently clear, however, that Monet did not follow the passage of the sun in an attempt to create a kind of chronometer of the fleeting atmospheric conditions. Neither is it true that the idea of series paintings was born out of the specific experience of a particular day as has long been assumed. Instead it was implanted in Monet's mind a long time before and it was only then, in 1890, when he had found economic independence, that he was able to fully carry out such projects.

Another misconception is the widespread belief that Monet always painted faithfully what he saw before his eyes. He certainly selected the motifs and began the canvases outdoors, but he can hardly have finished them all there given the overall atmospheric conditions. Although his stepdaughter Blanche Hoschedé repeated-

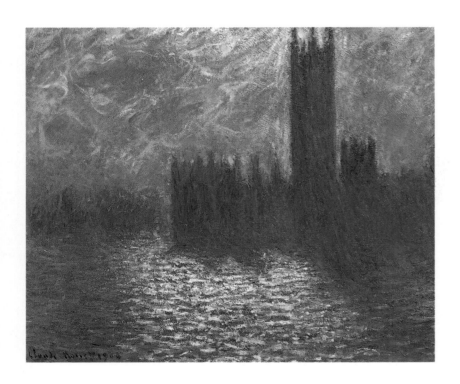

The Parliament in London
1904; *oil on canvas*; 32 1/8 x 36 1/2 in. (81.5 x 92 cm.).
Lille, France, Musée des Beaux-Arts.
Often keeping several canvases around him at the same time, Monet moved from one to the other whenever the changing atmosphere required a different approach to the same scene. During several winter months in London he painted the Parliament building with the river Thames. The canvases were later finished and retouched in his studio in Giverny.

ly declared that all of Monet's paintings were executed in front of the subjects, there is enough evidence from Monet's own remarks alone that he was in the habit of finishing paintings in his studio during inclement weather conditions. It was there that, after retouching and "harmonizing" the canvases, he signed and dated the paintings, which sometimes happened several years after their conception.

Furthermore, the choice of viewpoint is in some cases improbable, as are the color schemes. In *Grainstacks* (Sunset, Snow Effect), for example, the sky is of a bright orange and yellow, hardly a color one might see on a winter day. Also, the arrangement of stacks and houses in the background of some of the paintings is also too perfectly geometric to be true. The slopes of the conical stacks and the edges of the roofs of the farm buildings are always parallel, thus bringing these two elements into a meaningful relationship. Monet obviously intended to link the peasants' presence with the result of their labor, a fact that might have achieved a renewed significance for the artist since he purchased his own house and land.

Stéphane Mallarmé, the poet and a close friend of Monet's in the 1890s, noted that an art work should "evoke an object little by little in order to reveal a state of mind," which is exactly what is happening with Monet's paintings. Devoid of any specific topographical reference, and lacking any narrative elements such as workers or animals, the grainstack series encourages contemplation and spiritual insight into nature. The intangible element of air and light is given more prominence and painterly attention than the physical presence of the grainstacks, fields, or buildings. Monet himself encouraged such readings by telling a visitor to the exhibition of the series in 1891 that "a landscape hardly exists at all as a landscape, because its appearance is constantly changing; it lives by virtue of its surroundings—the air and light—which vary continually."

The exhibition was a tremendous success, artistically as well as financially. The painter Camille Pissarro complained about a month after the show that everybody wanted nothing but Monets. "Worst of all, they all want 'Grainstacks in the Setting Sun'! Always the same story, everything he [Monet] does, goes to America at prices of four, five, and six thousand francs ... Life is hard."

Poplars

In the spring of 1891 Monet started a new series with a motif of poplar trees. The trees lined the river Epte, just a few miles outside of Giverny at the village of Lamas. When it was decided that the trees would be felled and sold as lumber, Monet intervened with the Mayor to stop the process, without success. When the trees were publicly auctioned off, Monet made a deal

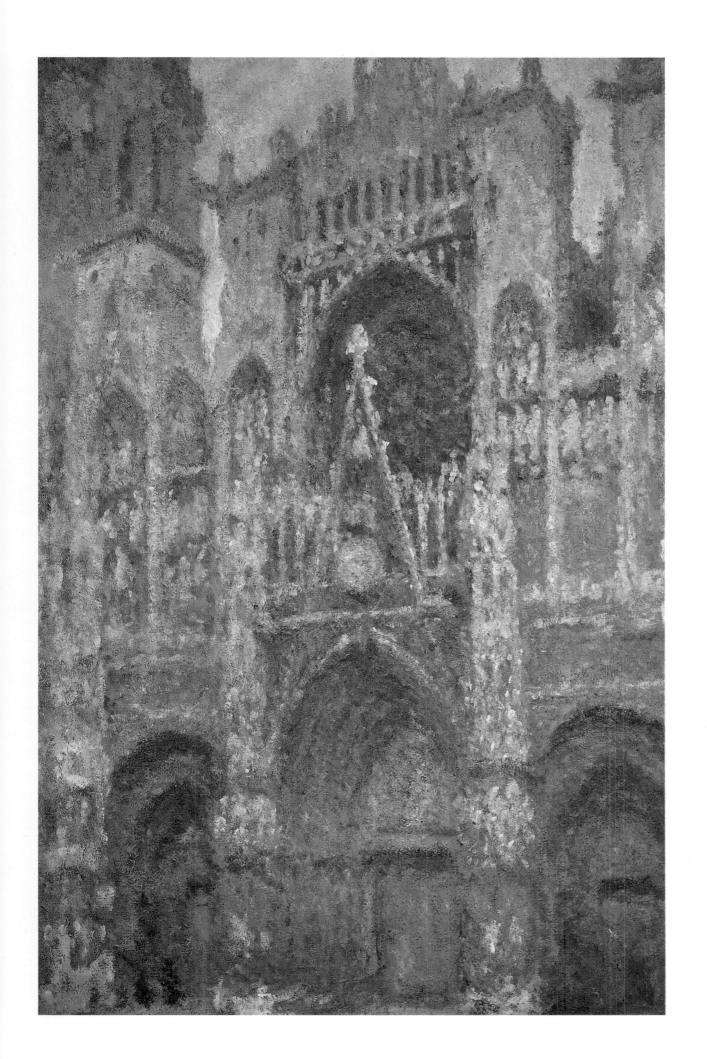

Rouen Cathedral, Façade (Gray Day)
1892–1894; *oil on canvas;* 39 3/8 x 25 5/8 in. (100 x 65 cm.). Paris, Musée d'Orsay. *Monet began his cathedral series in the months of February through April 1892, returning to the site at the same time the following year in order to have the same light and weather conditions. He then reworked the earlier canvases like the present one, which captures the effects of a gray, overcast day. Monet actually preferred this type of atmospheric condition.*

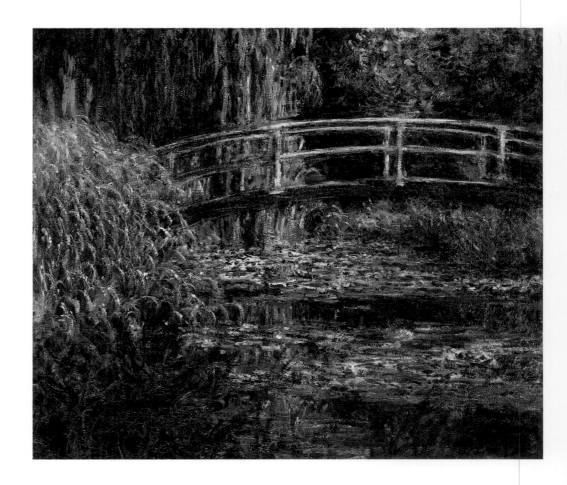

The Water Lily Pond: Pink Harmony

1900; *oil on canvas;* 35 x 39 3/8 in. (89 x 100 cm.). Paris, Musée d'Orsay. *Beginning in 1893, Monet constructed a water garden in Giverny. He made careful plans for the pond, the trees, and the flowers, which were attended by several gardeners. The branches of the weeping willows behind the Japanese bridge are reflected in the water at the time of the sunset, when everything is cast in a pinkish light.*

with a wood merchant and became eventually co-owner of the poplars on the condition that the trees would be left standing for a few more months. These events attest to Monet's deep involvement with his motifs and the personal and aesthetic significance he attached to them. Beyond that, the poplar tree had also a national and patriotic meaning for a Frenchman, as it had been chosen as the "tree of liberty" during the French Revolution and had remained a symbol of the nation ever since. The confidence Monet had gained with the Grainstack paintings might explain the fervor with which he pursued the new motif. He was uncharacteristically happy while working on the Poplar pictures.

The poplar trees along the Epte had been planted at an equal distance of about eight feet in order to maximize their growth. Poplars were known as a fast-growing species that absorb a great deal of water, diminishing the risk of flooding in the area along the river. Furthermore, the wood had a monetary potential as lumber or scaffolding for the construction trade. The trees also acted as an effective wind barrier. Their impressive height and dominating character had led people to use them to demarcate property lines or simply to line roads and entrances to estates.

It was not the first time, however, that Monet painted poplar trees and they appear frequently in his views of fields around Argenteuil from the 1870s, as in *Poplars, near Argenteuil*. But now his approach was more elemental and disciplined, his efforts to paint even more refined effects more compelling. He retained the compositional simplicity of the grainstack series, but focused on the two-dimensional grid created by the trees rather

than on the surface as in the previous paintings. Naturally, most of the poplar canvases are of a vertical format, stressing the inherent qualities of the poplars as elegant trees full of graceful movement. By careful choice of a vantage point at an S-shape bend in the river, the line of the trees seemed to rise and fall as they moved in front of the artist. In some canvases, however, Monet positioned himself frontally before a group of trees, as in *Poplars*.

Rouen Cathedral

After the Poplar paintings, Monet immersed himself in his next project, a series of views of Rouen Cathedral. Beginning in late January or early February of 1892, Monet exclusively focused, as never before, on a single motif, the façade of the Gothic building. He had of course painted architectural elements before, as in the Gare Saint-Lazare series, but here he paid tribute to a historic monument of great artistic and national importance. When twenty paintings of the series were shown, they caused a great sensation. The subject was immediately recognized as something specifically French. By choosing this motif, Monet also placed himself in the mainstream of a religious and mystic revival of considerable proportions, which Pissarro called "superstitious beliefs."

Rouen was a well-known city in France, one of the largest in Normandy and with important historical links to France as a whole. During the Middle Ages it was the site for coronation ceremonies of the kings of France, and Joan of Arc was burned at the stake there. It was only about forty miles away from Giverny and could be

easily reached by train. Monet knew the city well, since his brother Léon lived in one of its western suburbs.

The cathedral façade had fascinated other artists before Monet, such as the English romantic painter J. M. W. Turner. Due to its lengthy period under construction, it offered a survey of the Gothic style from its beginnings in the twelfth century to its full splendor in the late fifteenth and sixteenth centuries. By choosing the southwestern vantage point, Monet had the best view of the building, when the early morning sun rises behind the left tower, the Tour d'Albane, throwing a magic light on the Gothic pinnacles. He rented the front rooms of a draper's shop in the square in front of the cathedral, which allowed him to see the façade at an angle, as it appears in most of the paintings from this series.

The inherent artistic difficulties notwithstanding, Monet was ultimately very pleased with the results. And so was the public. The critic Georges Clemenceau devoted the entire front page of his newspaper *La Justice* to an article about the "Cathedrals" when they went on view in May of 1895. He ended his homage by publicly calling on the French president Félix Faure to go see the series and buy them for the nation: "Why has it not occurred to you to go and look at the work of one of your countrymen on whose account France will be celebrated throughout the world long after your name will have fallen into oblivion? ... Remembering that you represent France, perhaps you might consider endowing [her] with these twenty paintings that together represent a moment for art, a moment for mankind, a revolution without a gunshot." Unfortunately, Clemenceau's premonition proved to be correct. The president did not make any move to purchase the "Cathedral" paintings, which subsequently were scattered throughout the world.

Water Lilies

During the 1890s Monet began to work on a project which would occupy him for the rest of his life, the creation of his famous water lily pond. In 1891 he received a visit from a Japanese gardener, but the decisive step in the development of his garden was the purchase of a strip of land adjacent to his property, on the other side of the road and the local railway, in February of 1893. The pond, with its now well-known footbridge, was originally quite small, as can be gathered from the series paintings of the "Water Lily Pond." It was only after 1900 that Monet greatly enlarged it to the extent as it appears in the monumental *Water Lily Decorations* of his last years.

But as with so many other paintings, the real subjects are the light and the weather. "The effect varies constantly," as Monet keenly pointed out, "not only

from one season to the next, but from one minute to the next, since the water flowers are far from being the whole scene; really, they are just the accompaniment. The essence of the motif is the mirror of water whose appearance alters at every moment, thanks to the patches of sky that are reflected in it, and which give it its light and movement." Monet stressed this statement by referring to his water lily paintings as "Water Landscapes."

Monet's insistence on strictly limited subject matter, waterlilies and the water's surface with it's reflections of light, together with his ambitious expansion towards large-scale compositions, opened the path towards subsequent developments in painting, in which the power of the brushstroke itself became the main motif as the carrier of lyrical expression.

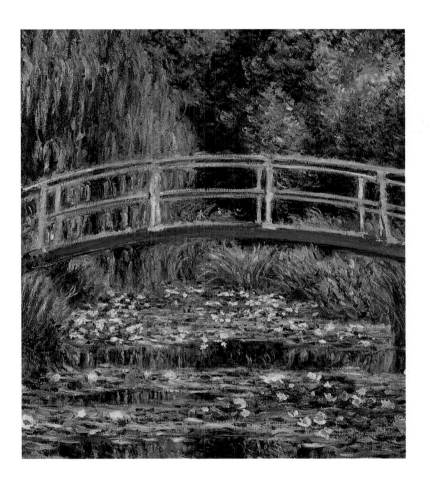

White Water Lilies
1899; *oil on canvas*; 35 x 36 1/2 in. (89 x 93 cm.).
Moscow, Pushkin Museum of Fine Arts.
This canvas is among the earliest depictions of the series of the water lily pond at Giverny. It shows virtually the same motif as the two versions of The Water Lily Pond (Pink Harmony and Green Harmony) *at the Musée d'Orsay in Paris. Having abandoned his previous interest in the ephemeral effects of light and natural forces, Monet focused increasingly on the decorative qualities of his motifs.*

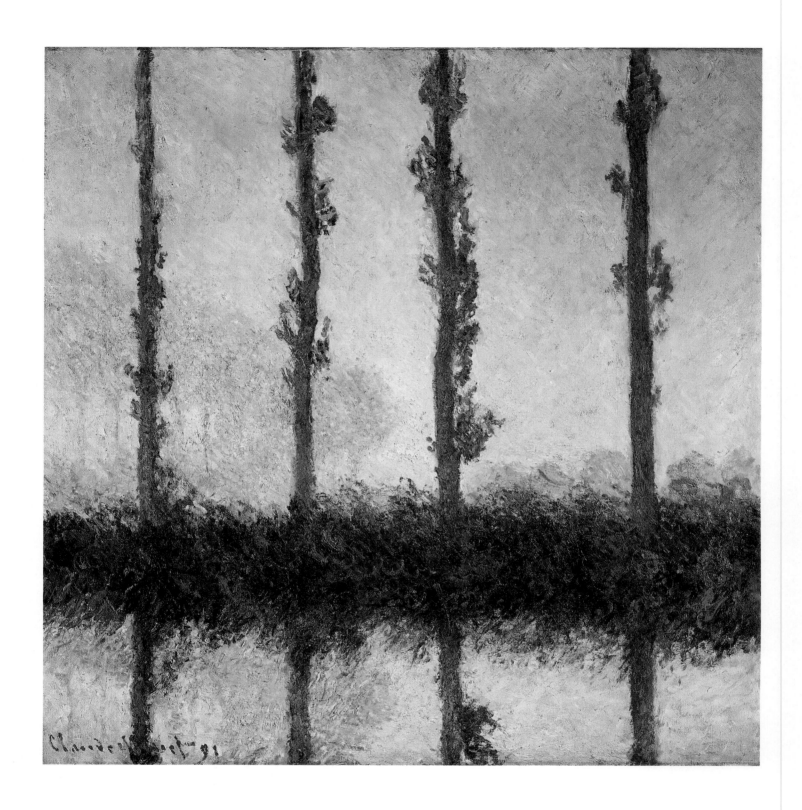

Poplars
1891; *oil on canvas;* 32 1/4 x 32 1/8 in. (81.9 x 81.6 cm.).
New York, The Metropolitan Museum of Art.
*Following the series of the grainstacks, Monet began to paint the poplar
trees along the Epte river near Giverny in the summer of 1891.
Here, four single trees in shadow are used as a grid, set against other
groups of trees in bright sunlight further in the distance. Monet's signa-
ture on the bottom left picks up the darker blue tones of the foreground.*

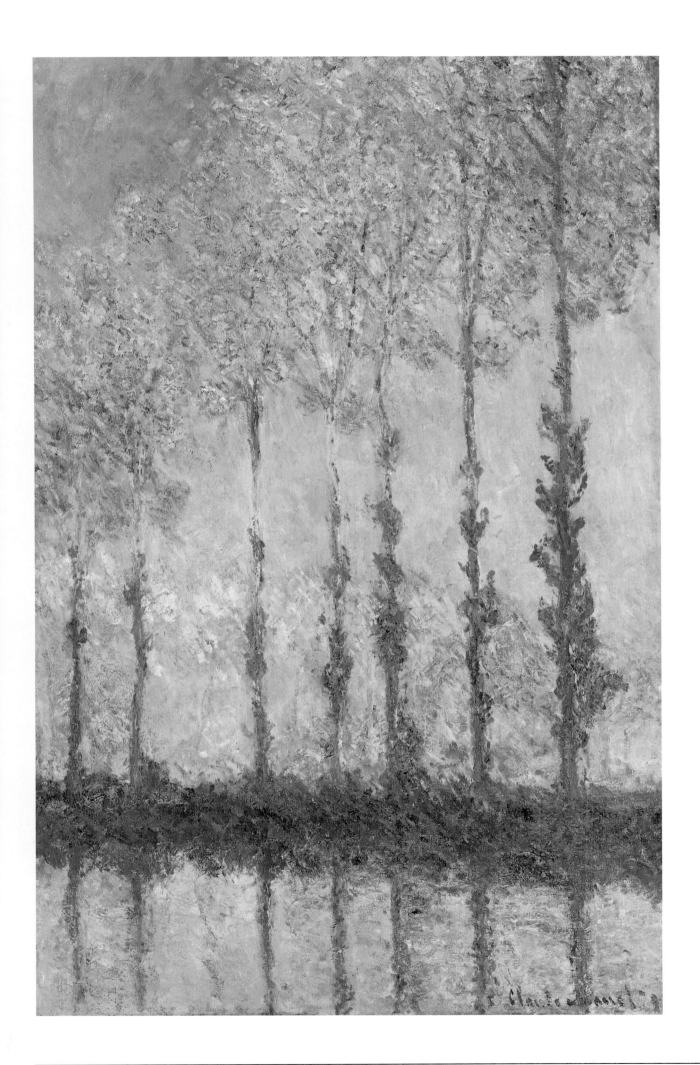

Poplars
1891; *oil on canvas;*
39 3/8 x 25 5/8 in.
(100 x 65 cm.).
Philadelphia, Pennsylvania,
Museum of Art.
Seen in a zig-zagging
perspective, the poplar
trees along the Epte are
painted with an autum-
nal effect, although it
was still summer when
Monet worked on this
canvas. The reason for
this unusual procedure
was that the trees were
about to be felled and
Monet wanted to create
a series of seasonal effects.

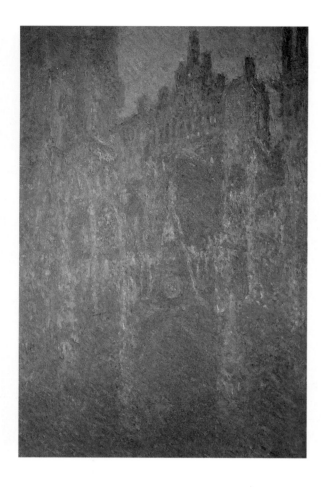

Rouen Cathedral in the Fog

1892–1894; 39 7/8 x 26 in. (101 x 66 cm.).
Essen, Germany, Folkwang Museum.
The atmospheric conditions of fog and haze had
fascinated Monet for many years. In Impression-
Sunrise *of 1872 he had already treated this*
particular subject, which he was to explore even
further in his views of the Parliament in London.

The Houses of Parliament in London
(Patch of Sun in the Fog)

1904; *oil on canvas*; 31 7/8 x 36 1/4 in. (81 x 92 cm.).
Paris, Musée d'Orsay.
Monet visited London several times, preferring
the winter months when the fog covered the city
with a dreamlike, unreal mystery. From 1900
to 1903, he painted the Thames in various
states of light and atmosphere. In this canvas,
the sun is attempting to break through the misty
shroud engulfing the Houses of Parliament.

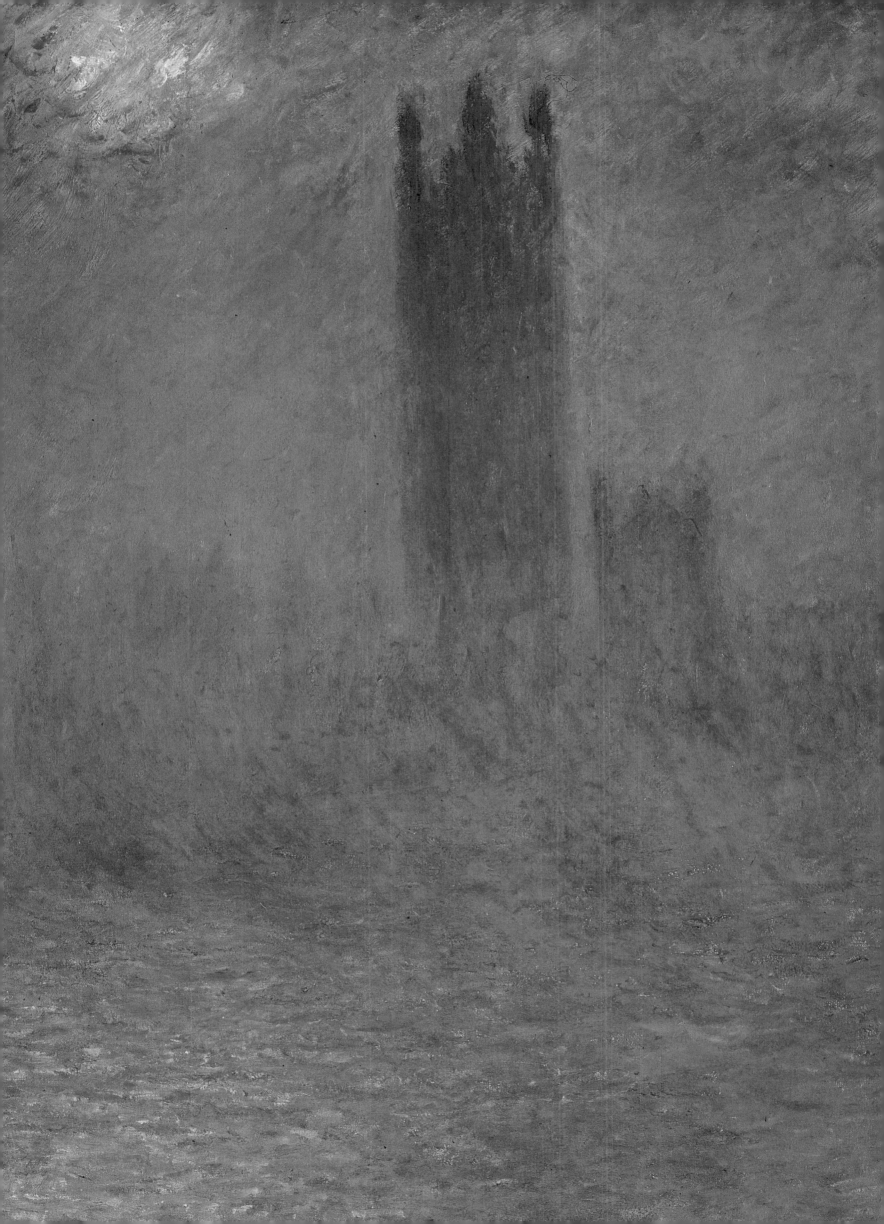

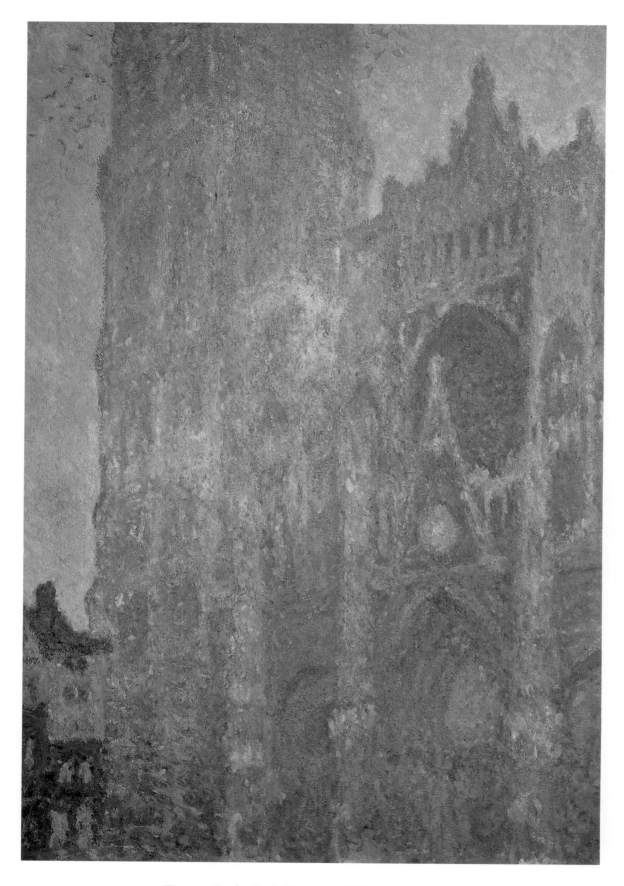

Rouen Cathedral, Morning: White Harmony

1892–1894; *oil on canvas*; 41 3/4 x 28 3/4 in. (106 x 73 cm.). Paris, Musée d'Orsay.

An early riser, Monet especially appreciated the transitional light of the morning hours.
Often spending the entire day at the window of his rented studio space opposite the cathedral,
he observed the change of light and atmosphere across the façade in all its phases.

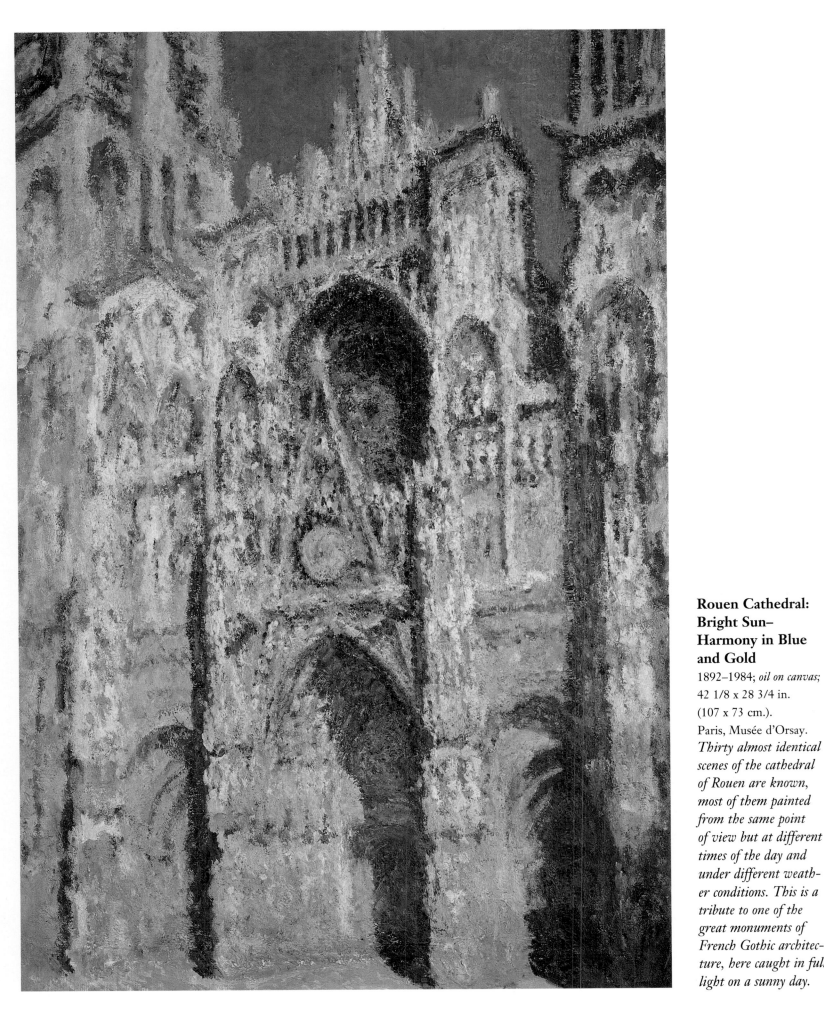

Rouen Cathedral: Bright Sun– Harmony in Blue and Gold
1892–1984; *oil on canvas; 42 1/8 x 28 3/4 in. (107 x 73 cm.). Paris, Musée d'Orsay. Thirty almost identical scenes of the cathedral of Rouen are known, most of them painted from the same point of view but at different times of the day and under different weather conditions. This is a tribute to one of the great monuments of French Gothic architecture, here caught in full light on a sunny day.*

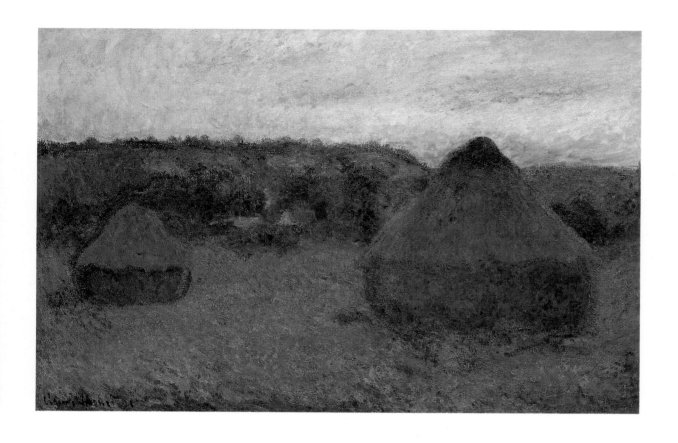

Grainstacks (End of Day, Autumn)
1891; *oil on canvas;* 25 7/8 x 34 3/4 in. (65.7 x 88.3 cm.). Chicago, The Art Institute. *In this autumn view, the top of the large grainstack on the right breaks the horizon to push into the sky. The shape of the cone has been outlined with brushstrokes which highlight the stacks' undulating edges. The roofs of the farm buildings, echoing the slopes of the cones, are indicated in the distance.*

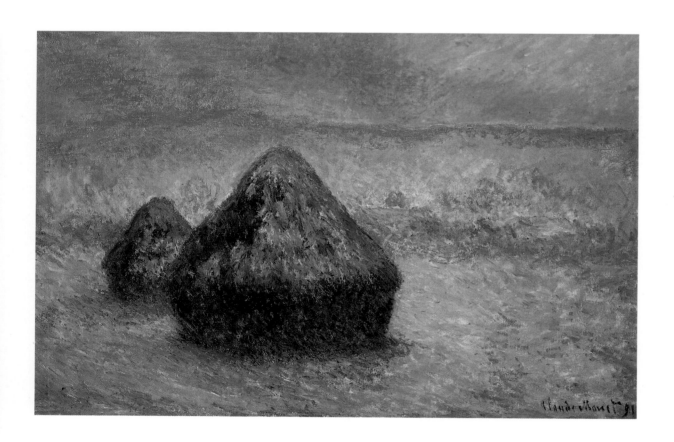

Grainstacks (Sunset, Snow Effect)
1891; *oil on canvas;* 25 x 39 1/2 in. (63.5 x 100.3 cm.). Chicago, The Art Institute. *Although all the paintings in the Grainstacks series were certainly started out-of-doors, they were all later reworked and "harmonized" in the calm of Monet's studio, where the artist would adapt the color and compositional schemes to his aesthetic conceptions. It is hard to imagine, for example, that the winter sky would indeed offer such an extraordinary pink color.*

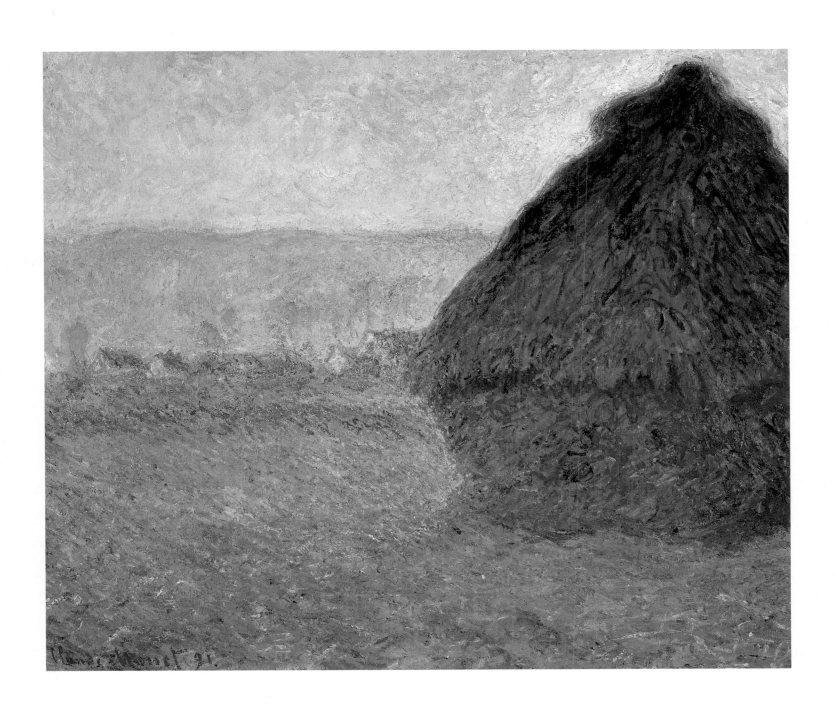

Grainstack (Sunset)
1890–1891; *oil on canvas;* 28 7/8 x 36 2/3 in. (72.3 x 92.7 cm.). Boston, Museum of Fine Arts.
*Later canvases of landscapes resembling the present one make no reference
to the presence of humans or the actual cultivation of the countryside.
The grainstacks, however, which Monet painted in endless variations of atmospheric
light and color, can be perceived as the result of the unseen farmer's labor.*

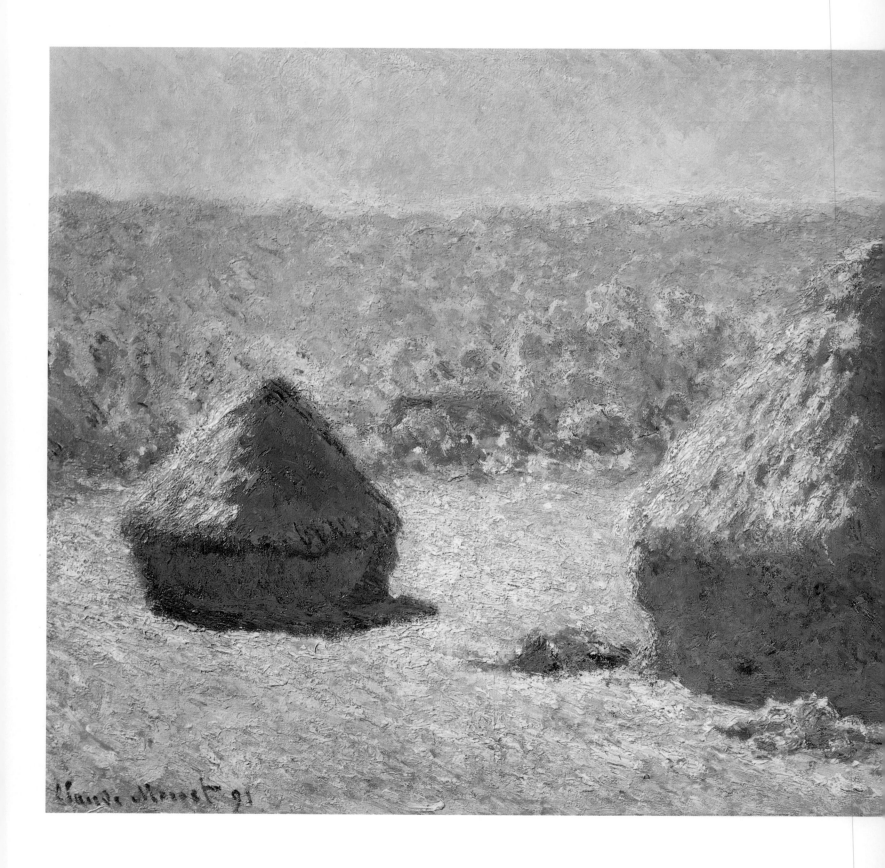

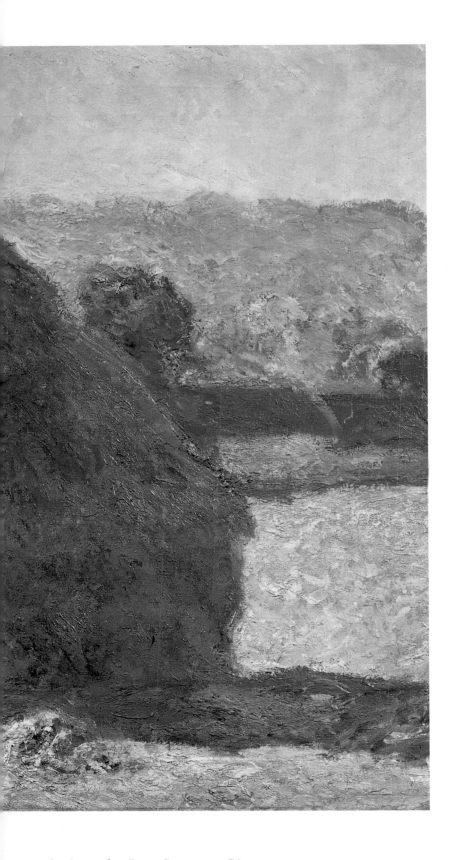

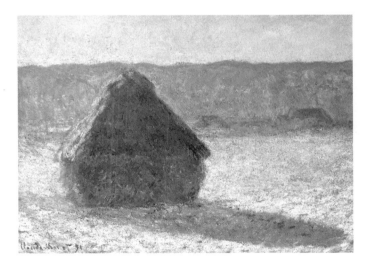

Grainstacks, Late Summer, Giverny

1891; *oil on canvas*; 23 3/4 x 39 1/2 in. (60.5 x 100.5 cm.).
Paris, Musée d'Orsay.

*In his series paintings of the 1890s, Monet explored the
unlimited variety of light and atmospheric conditions by using the
same view over and over again. Here, a moment of a late summer
afternoon with its pastel-like colors has been captured at a specific
moment, when the grainstacks cast longer afternoon shadows.*

Grainstack (Snow Effect)

1890-1891; *oil on canvas*; 25 3/4 x 36 3/8 in. (65.4 x 92.4 cm.).
Boston, Museum of Fine Arts.

*Monet intended the grainstacks as tangible symbols of
the land's fertility and the care of the peasants who
keep it productive throughout the year. An early morning
sun envelopes this grainstack which, although inanimate,
seems almost to have turned its face to greet it.*

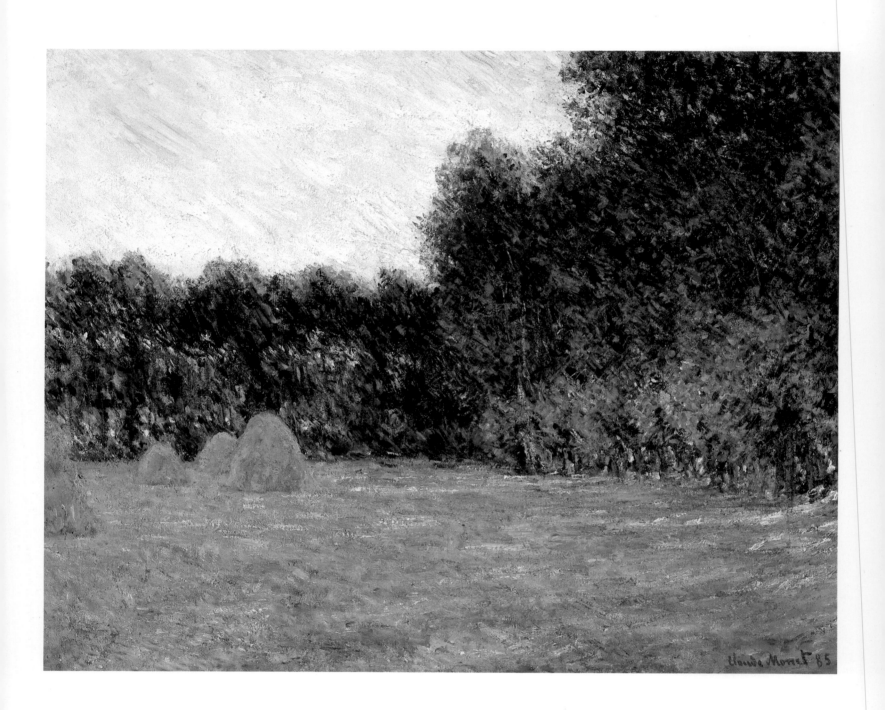

Meadow with Haystacks near Giverny
1885; *oil on canvas;* 28 7/8 x 36 7/8 in. (73.5 x 93.5 cm.). Boston, Museum of Fine Arts.
An intense and complex composition, this meadow is animated by lively contrasts of
lighter and darker hues. Some patches of sunlight penetrate the trunks of the trees
with their dark foliage, while a soft yellow sky serves as a backdrop. The haystack,
cut off by the picture frame, is a hint that the meadow continues further to the left.

Poppy Field in a Hollow near Giverny
1885; *oil on canvas*; 25 5/8 x 31 7/8 in. (65 x 81 cm.). Boston, Museum of Fine Arts.
*Frequently, Monet focused on less obviously picturesque subjects, such as simple meadows with
trees. The composition, dominated by varied textures of grass and foliage, is virtually symmetrical.
The colors are carefully chosen: dashes of deep green and soft blue zones in the grass, a salmon
pink stroke on the hillside, and red touches for the few separate poppies at bottom right.*

Poppy Field (Giverny)
1890–1891; *oil on canvas;* 24 x 36 3/4 in. (61 x 93 cm.). Chicago, The Art Institute.
The horizontal format of this painting foreshadows Monet's late decorations
of water lilies and immediately precedes the grainstack series. Evenly weighted
spots of color, often applied with broad strokes, have acquired an encrusted,
homogeneous surface after a long process of elaboration and revision.

A Bend in the Epte River, near Giverny
1888; *oil on canvas*; 28 3/4 x 36 1/4 in. (73 x 92 cm.). Philadelphia, Museum of Art.
The small river Epte near Giverny offered Monet many motifs. Here, the
homogeneous textures of the leaves of the poplar trees are rendered with a regular
network of brushstrokes creating a single overriding rhythm. Endless variations
of hues and brushwork create the gentle diagonal rhythm of the sunlit trees.

The Seine at Port-Villez
1894 (dated 1885);
oil on canvas; 25 3/4 x 39 1/2 in. (65.4 x 100.3 cm.).
London, Tate Gallery.
This view of the Seine, with its effects of morning mist, was painted at Port-Villez near Giverny. When the artist sold the painting many years later to his dealer Durand-Ruel, he erroneously placed a wrong date on the canvas. It is likely that Monet painted the picture from a boat.

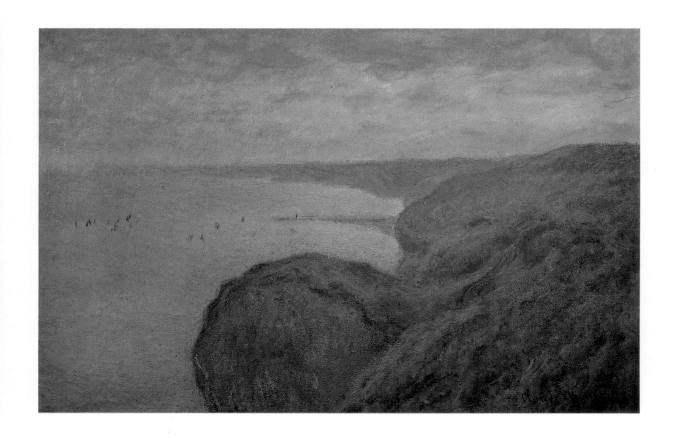

Val Saint-Nicolas, near Dieppe (Overcast Day)
1896–1897; *oil on canvas; 25 5/8 x 39 3/8 in. (65 x 100.5 cm.).*
St. Petersburg, Hermitage.
In 1896, Monet visited the coast of Normandy once again, where he painted several canvases from atop the bluffs, looking east toward Dieppe and the Val Saint-Nicolas. The land rises and falls in subtle movements, pushing occasionally out toward the sea. The elements of this motif are treated with near-abstraction.

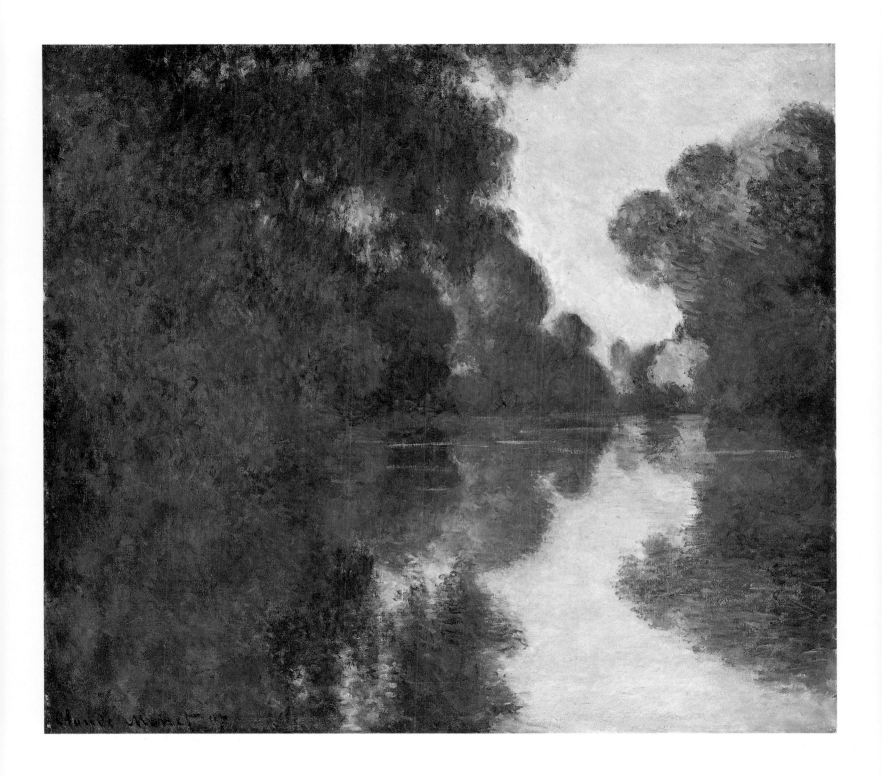

Morning on the Seine near Giverny
1896–1897; *oil on canvas*; 32 1/8 x 36 5/8 in. (81.6 x 93 cm.).
New York, Metropolitan Museum of Art.
The purple and green contrast with a creamy yellow at an early morning hour
on the river. The paint has been applied with thin layers and is animated by
delicate surface strokes. Although the artist considered this to be an easy subject,
he devoted two summers, 1896 and 1897, to painting a series of this scene.

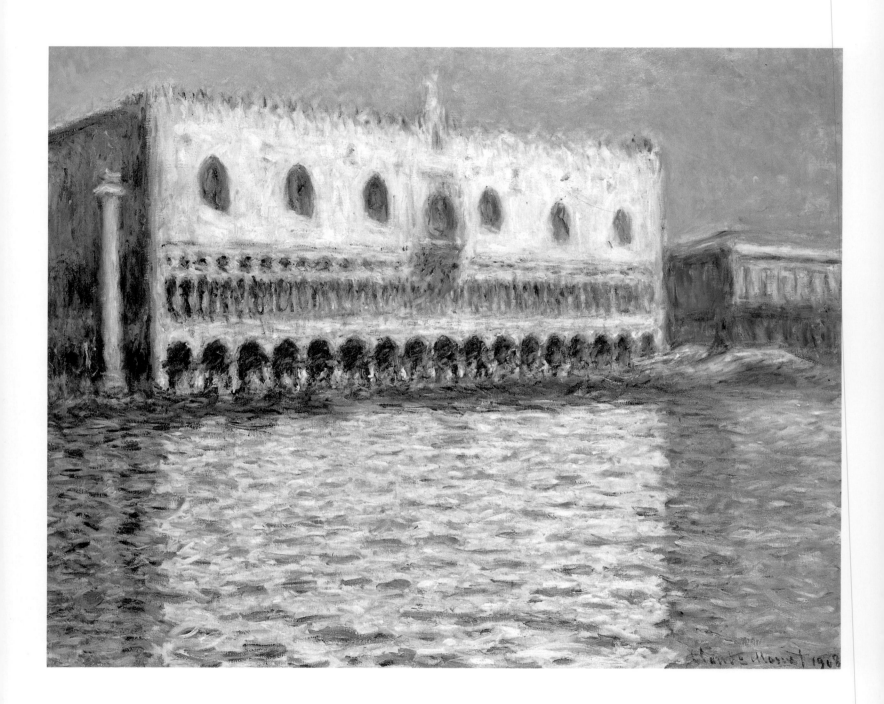

Venice, The Ducal Palace

1908–1912; *oil on canvas*; 31 7/8 x 39 3/8 in. (81 x 100 cm.). New York, The Brooklyn Museum.
During a visit to Venice in 1908 Monet began a number of canvases, which he finished
over the years in his studio at Giverny. Not knowing the climate of the city well,
he used mostly oranges and blues. Unhappy with the results, Monet later remarked:
"It is detestable... I finished from memory, and nature has had her revenge."

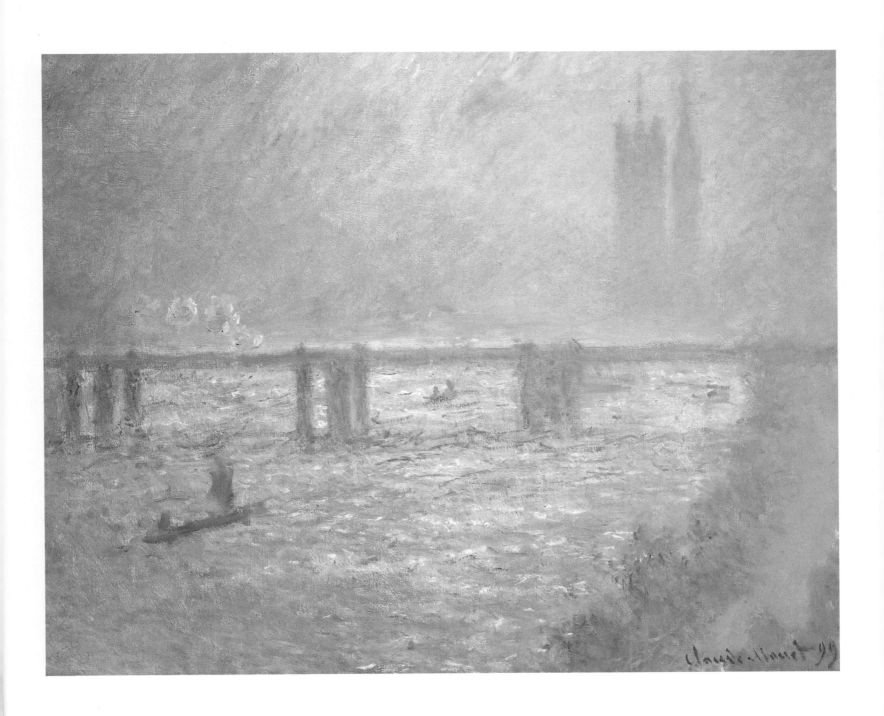

Charing Cross Bridge

1899; *oil on canvas;* 25 1/8 x 31 3/8 in. (65.7 x 81.6 cm.). Santa Barbara, Museum of Art.
During a six-week trip to London in 1899, Monet painted this monumental view
of the Charing Cross Bridge, enveloped in the haze of the Thames river. The
variability of London's climate posed critical problems for the painter, who at times
felt he was in a country that would not submit to his Impressionist technique.

**The Artist's Garden
at Giverny**
1900; *oil on canvas*;
31 7/8 x 36 1/4 in.
(81 x 92 cm.).
Paris, Musée d'Orsay.
*After he had become more
successful and prosperous,
Monet bought a house and
some land in Giverny, where
he immediately set up a garden
and created a floral paradise.
He himself carefully selected
the color of the flowers to
plant so that they would create
specific coloristic effects that
he captured on his canvases.*

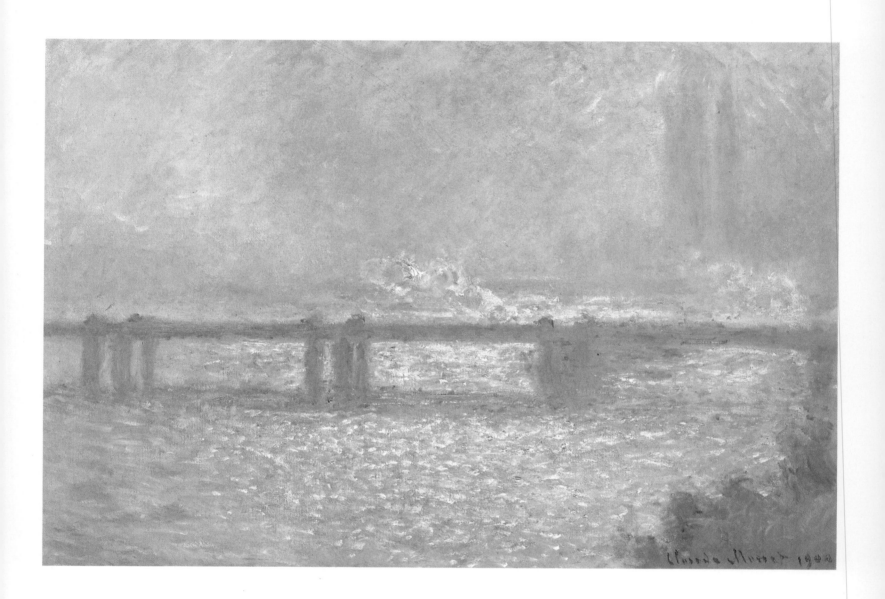

Charing Cross Bridge (Overcast Day)
1899–1900; *oil on canvas*; 23 7/8 x 36 in. (60.6 x 91.4 cm.). Boston, Museum of Fine Arts.
While in London, Monet selected contemporary motifs for the first time
in twenty years. The Parliament building and the Charing Cross
Bridge spanning the Thames are bathed in the glistening light
of the sun breaking through the mist. Both the subject as well
as the atmosphere relate this painting to Impression-Sunrise of 1872.

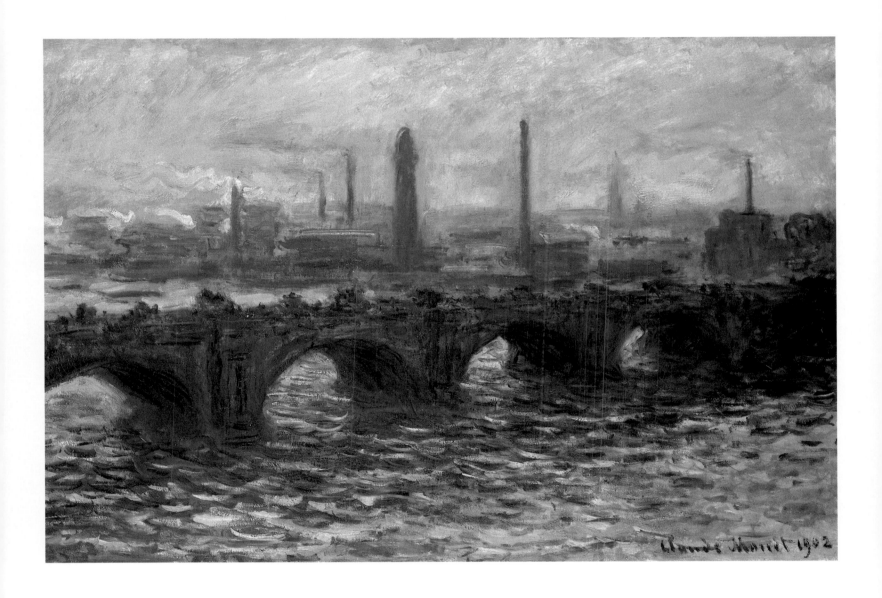

Waterloo Bridge, Overcast Weather

1902; *oil on canvas*; 26 x 39 3/8 in. (66 x 100 cm.). Hamburg, Germany, Kunsthalle.
*Monet's London paintings are characterized by keynotes based on blues
and mauves, with touches of green and occasional orange. The artist had
a special liking for the winter season with its fog in that city. Here he
caught a view of the Waterloo Bridge with industrial sites in the background,
while many crisp touches define the traffic crossing the river.*

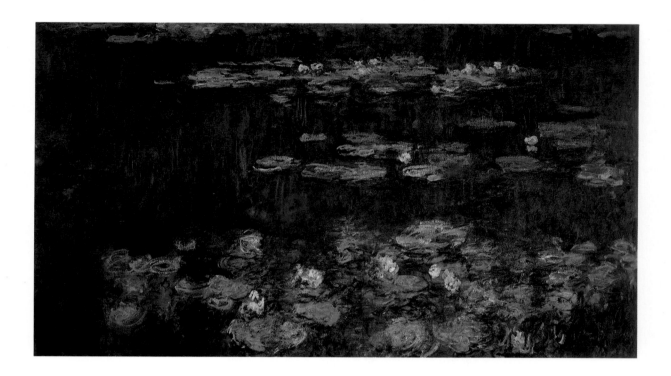

Water Lilies: Green Reflections

1914–1918; *oil on canvas on two panels;* 77 1/2 x 333 1/2 in. (197 x 847 cm.). Paris, Musée de l'Orangerie.
After the death of his second wife Alice in 1911 and that of his eldest son, Jean, in 1914, Monet led a reclusive life at Giverny during the years of World War I. When visitors came in 1918 to see the new paintings the artist had been working on in secret, they had the experience of seeing art that was entirely new and fresh.

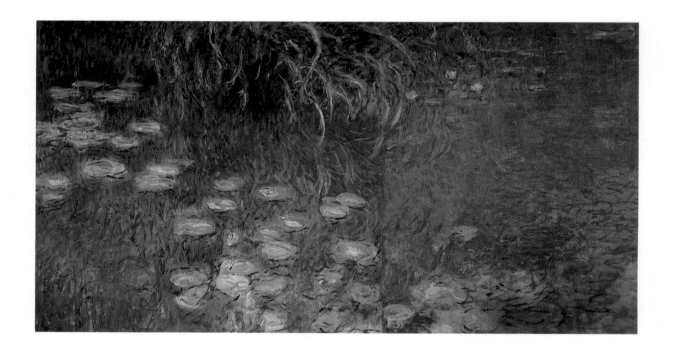

Water Lilies, Morning

1916–1926; *oil on canvas on three panels;* 78 3/4 x 502 in. (200 x 1275 cm.). Paris, Musée de l'Orangerie.
The extended horizontals of the late water lily decorations reflect Monet's interest in traditional Japanese screen painting, where the scenes are too wide for the eye to take in through a single glance. Monet concentrated exclusively on the water covered with flowers, avoiding any reference to the surrounding bank of the pond. The idea of applying his art to decorative purposes had been on his mind for some years, at least since the 1890s.

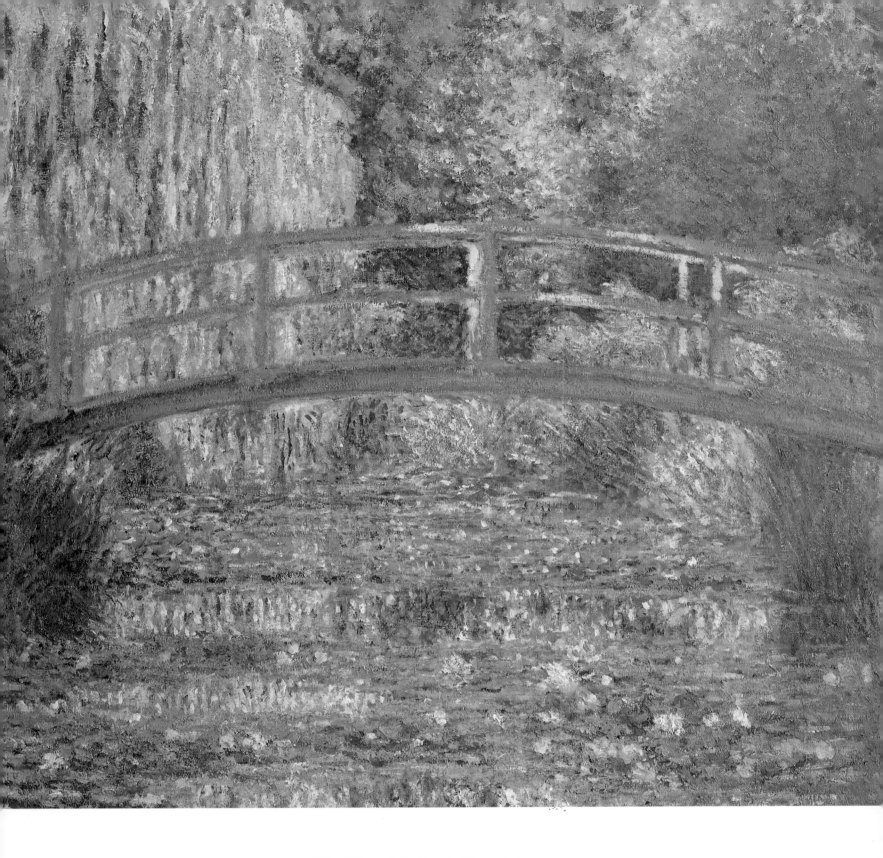

The Water Lily Pond: Green Harmony
1899; *oil on canvas*; 35 1/4 x 39 7/8 in. (89.5 x 100 cm.).
Paris, Musée d'Orsay.
The small bridge in Japanese style spanning his water lily
pond at Giverny became one of the most successful motifs
in Monet's later works. He rendered it several times in
almost identical versions, each time in different tonalities.

CREDITS

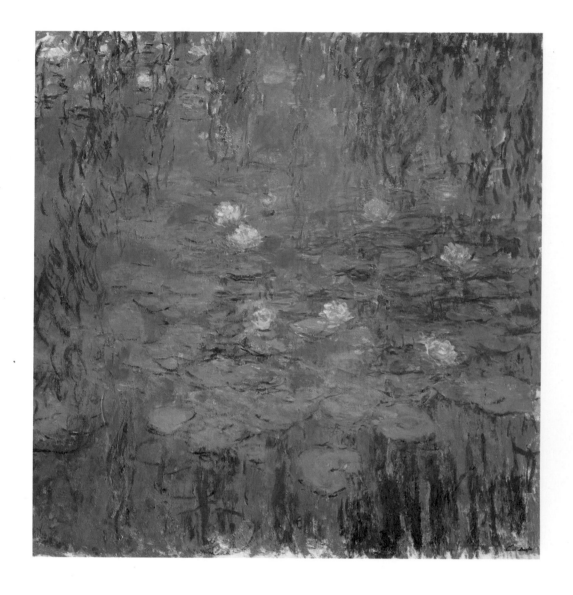

Blue Water Lilies

1916–1919; *oil on canvas*; 78 3/4 x 78 3/4 in. (200 x 200 cm.). Paris, Musée d'Orsay.
At the same time he was occupied with his large decorative panels of water lilies,
Monet also painted separate canvases of the same subject which are not part of the cycle.
It is hard to say if he intended to sell them individually, although once his wartime
paintings became known they were immediately sought after by critics and collectors.